PHOTOSHOP Blending Modes Cookbook
for Digital Photographers

PHOTOSHOP
Blending Modes Cookbook
for Digital Photographers

John Beardsworth

ILEX

Photoshop Blending Modes Cookbook for Digital Photographers
Copyright © 2005 The Ilex Press Limited

First published in the United Kingdom by

I L E X

3 St Andrews Place
Lewes
East Sussex
BN7 1UP

ILEX is an imprint of The Ilex Press Ltd
Visit us on the web at www.ilex-press.com

This book was conceived by:
ILEX, Cambridge, England

ILEX Editorial, Lewes:
Publisher: *Alastair Campbell*
Executive Publisher: *Sophie Collins*
Creative Director: *Peter Bridgewater*
Managing Editor: *Tom Mugridge*
Editor: *Kylie Johnston*
Art Director: *Tony Seddon*
Designers: *Chris & Jane Lanaway*
Junior Designer: *Jane Waterhouse*

ILEX Research, Cambridge:
Development Art Director: *Graham Davis*
Technical Art Director: *Nicholas Rowland*

British Library Cataloguing-in-Publication Data
A catalogue record for this book is available from The British Library.

ISBN 1-904705-68-5

Manufactured in China

For more information, and to download image files from the workthroughs in this book,
please visit www.web-linked.com/blenuk

Contents

GETTING STARTED WITH BLENDING MODES

Introduction to Blending Modes

One reason why Photoshop has become such a powerful and popular image editor is that it allows you to work on a series of layers during the editing or creation of your images. The way these layers interact with one another is governed by Photoshop's blending modes. Blending modes first appeared when layers were introduced in Version 3, but had their earlier origins in the program's tool blending capabilities. But how often should you use blending modes? How useful are they?

Using Photoshop

Photoshop has so many palettes, brushes, filters, gradients, and other tools that it's possible to be a proficient Photoshop user without ever using more than a fraction of the program's extensive feature set. For example, some users experiment with different techniques using layers and delete them if they don't work, while others prefer the History brush to undo work; or you might select all sorts of complex shapes with the Lasso tool and not be aware that the Pen tool is a better choice. In other words, you can achieve great results by using just a sliver of Photoshop's power—after all, outside certain circles there are no prizes for knowing features for their own sake.

The main ingredients

With Photoshop offering so many features, you might not even notice the presence of blending modes. Or, if you do, you experiment with them, don't see too much of immediate interest, and use the one or two modes with which you're most familiar when you need them for a specific result.

The purpose of this book is to show you how powerful and incredibly useful blending modes can be. Instead of being a flavoring, occasionally sharp, but at other times subtle and barely noticeable, in *Photoshop Blending Modes Cookbook*, blending modes are the main ingredients.

Self-blends

Primarily, the recipes in this book show you what happens when you blend an image with copies of itself, and then change their blending modes. In these so-called "self-blends," you'll be amazed at the range of results you can achieve from simply inverting a layer (turning it from a positive to a negative) or from adjusting its layer and fill opacities. Even more variations result from operations such as converting a copy of a color layer to black and white, blurring it, and then combining it with the original color layer using blending modes and different opacities to achieve an entirely new perspective on the original image. And when you combine several blend layers, the number of possible outcomes is enormous. The purpose of this book is to show you how you can turn what are now "happy accidents" with blend modes into a more successful, intuitive, and intentional process.

Filters, styles, and tools

It's also worth saying a little about what this book does not cover. As you flick through the recipes, you might at first imagine that they are the product of filters, styles, or Photoshop's retouching tools. In fact, other than Gaussian Blur, very few filters are used in the recipes. Even when some recipes use the Find Edges filter to create line drawings, others accomplish the same thing with blending modes—in the case of creating line drawings, you'll learn how Color Dodge and Color Burn can do a very good job. In this sense, *Photoshop Blending Modes Cookbook* is partly about using blending modes to create your own filters or original image treatments.

Using this book

The book is arranged into three parts. This first section describes where blending modes are found, how to use them, and how they work. Blending Modes in Detail, page 20, describes each mode more closely and shows the result of various self-blends and opacity changes. Here I also point out interesting applications of a specific blending mode—using Overlay to add lens flare, for example. Then it's on to the Recipes, page 62, the book's third and biggest section, featuring step-by-step instructions and examples.

Following the recipes

Each recipe stands on its own; so leaf through, select one that might suit your needs, and apply its steps to your chosen picture. I'd encourage this approach, rather than working through from the first to the last. Every image is different, and your reason for "cooking" one with a blending mode recipe will also be unique. You may want subtle, natural-looking corrections, or, alternatively, you may want to transform a photograph so radically that your friends and colleagues lose sleep figuring out which filter or plug-in you used. The result may be hung quietly on the wall, or scream out loud on a poster. So, find a recipe that looks promising and experiment.

I'm a big cook, and like most cooks I've a shelf of often-inspiring recipe books. Life though is far too short to follow recipes in minute detail. Every so often, you might add precisely the amount of chili that the author recommends, but most of the time it's much more fun to improvise. After all, what good cook has never asked, "What if I use twice as much?"

Mask or cut out parts of the
top layer.

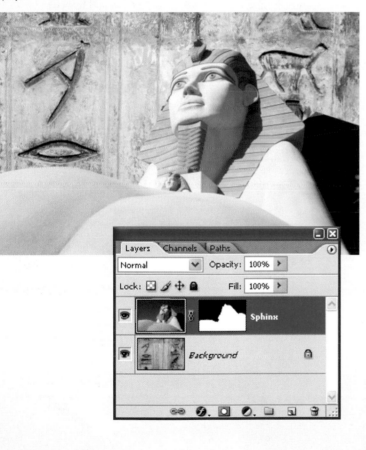

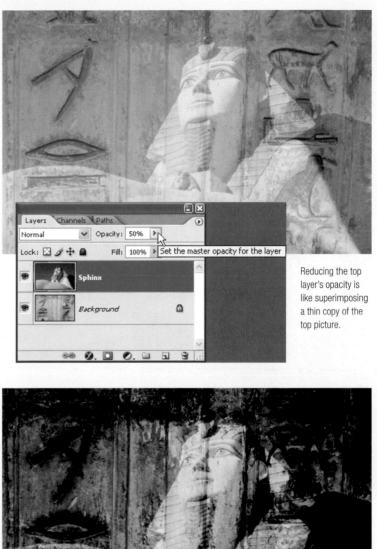

Reducing the top
layer's opacity is
like superimposing
a thin copy of the
top picture.

Change the top
layer's blending
mode and it's
more like
mixing paints.

So, when and why do you use blending modes? One way to think about them is either as a flavor or as the entrée in the same way that eggs can be used to either bind and color homemade pasta or be made into an omelet—a meal in itself. Another analogy is that they can be used either as a tactical flavoring or a strategy. Let's first take a brief look at "tactical flavoring," because it's easier to understand and can be put to immediate use. Then we'll get into the entrée: blending modes as a strategic ingredient, central to a larger creative process.

Blending modes as a flavoring

Perhaps the most common reason for applying a specific blending mode to a layer is to achieve a certain result or to fix a specific problem. For instance, duplicate an image, switch the duplicate layer's blending mode to Multiply, and the result is always darker—as if you're holding up to the light two registered copies of a slide. Switch the blending mode to Screen, however, and the result is always lighter—as if you're projecting two copies of the same slide onto a wall. Here, you already have a quick recipe to fix overexposure and one for underexposure.

Another example: the Luminosity blending mode is frequently used with Curves adjustment layers because, while Curves fix image contrast, they can also cause visible color shifts that the Luminosity blending mode will help to eliminate.

How about fixing wrinkles and skin blemishes by setting the Clone tool or Healing brush to the Lighten blending mode? With this mode the tools only affect pixels darker than the "good" skin you sampled. Alternatively, copy such areas onto a new layer and use the tool in Normal mode, then set the layer's blending mode to Lighten.

These are just a few ways in which blending modes can be used as a means to an end—and that's what I mean by "flavoring" or "tactical" use.

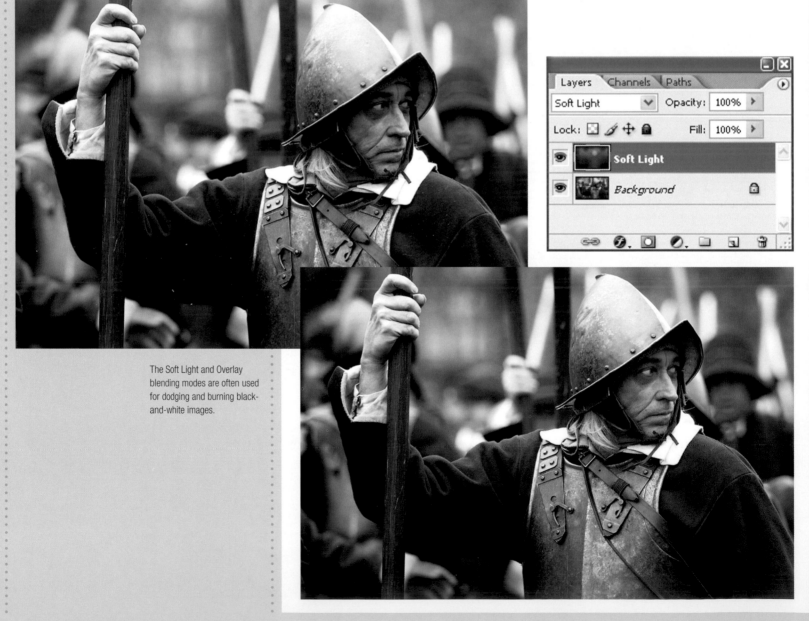

The Soft Light and Overlay blending modes are often used for dodging and burning black-and-white images.

10

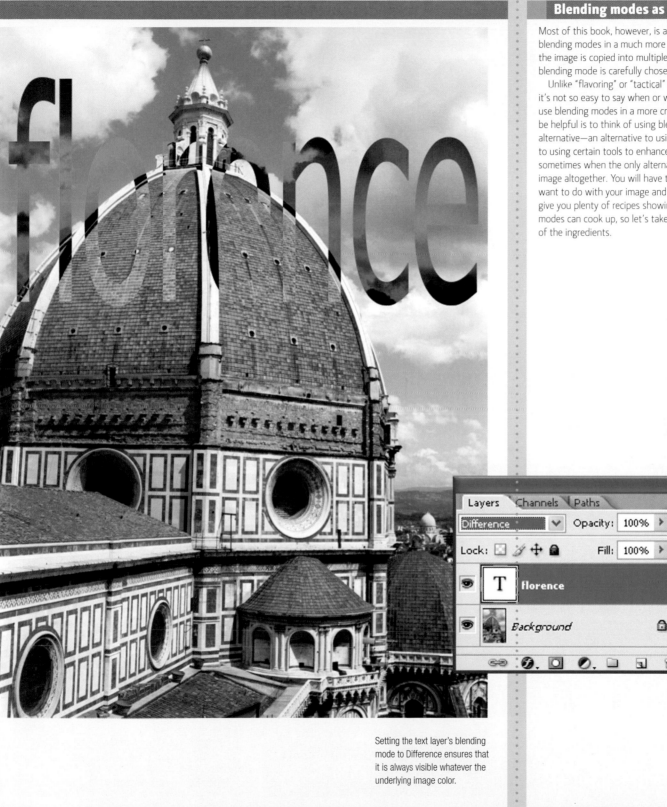

Blending modes as the entrée

Most of this book, however, is about using layer blending modes in a much more creative way—where the image is copied into multiple layers and each layer's blending mode is carefully chosen.

Unlike "flavoring" or "tactical" use of blending modes, it's not so easy to say when or why you might want to use blending modes in a more creative way. What might be helpful is to think of using blending modes as an alternative—an alternative to using filters, an alternative to using certain tools to enhance an image, or even sometimes when the only alternative is discarding an image altogether. You will have to decide what you want to do with your image and why. This book will give you plenty of recipes showing what blending modes can cook up, so let's take a closer look at some of the ingredients.

Setting the text layer's blending mode to Difference ensures that it is always visible whatever the underlying image color.

Blending mode groups

The more recent versions of Photoshop have about 20 blending modes, and these fall into roughly six groups. The first group is useful when you're painting an image—of these, some are only available with painting tools and date from Photoshop's prelayer days. Other blending modes fit neatly into groups that either darken (such as Darken or Multiply), lighten (such as Lighten or Screen), or increase the contrast of an image (such as Overlay or Hard Light). There are also the two "comparative" blending modes (Difference and Exclusion), which output a color based on the difference between the color of the blend layer and that of the underlying image.

Blending modes don't just blend a greeny blue in one layer with a pale orange in another. They look at each pixel individually, and most modes assess the brightness value in each channel before outputting the blend value.

The sixth group is known as the Hue, Saturation, and Luminosity (HSL) group. Unlike the previous groups, the HSL group doesn't look at channel brightness values. Instead, it examines luminosity—Photoshop's assessment of the combined red, green, and blue values—before working out the output color.

This may all sound very daunting at first, but having a vague understanding of how each blending mode works will help you to decide which blending mode is likely to achieve the result you're looking for.

Neutral colors

Most of the blending modes have "neutral colors" and some expert users also speak of the Lighten, Darken, or Contrast-increasing groups as the "black," "white," and "mid-gray" groups.

What this means is that the image does not change if you paint black onto a layer that has Lighten as its blending mode, or if you paint white onto a layer that has a blending mode in the Darken group. Similarly, if a layer's blending mode is in the Contrast group, painting with mid-gray has no effect, while black darkens and white lightens the picture.

It's important to keep the neutral color in mind for a couple of reasons. First, this lets you work more intuitively, sensing what effect a certain mode might have on the composite image—bleaching the highlights or reversing the shadows.

Second, there are occasions when you can exploit the neutral color. For instance, you may want to add a texture to a picture, so you fill the top layer with a pattern using **Edit > Fill**, and then set the layer's blending mode to one, the neutral color of which eliminates some of the colors in the pattern. Various techniques exploit this behavior—check out this book's recipe for adding raindrops on page 160.

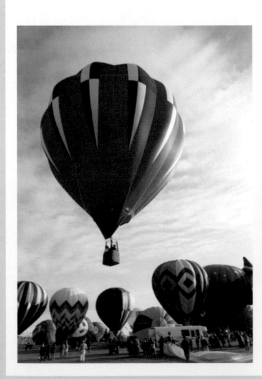

12

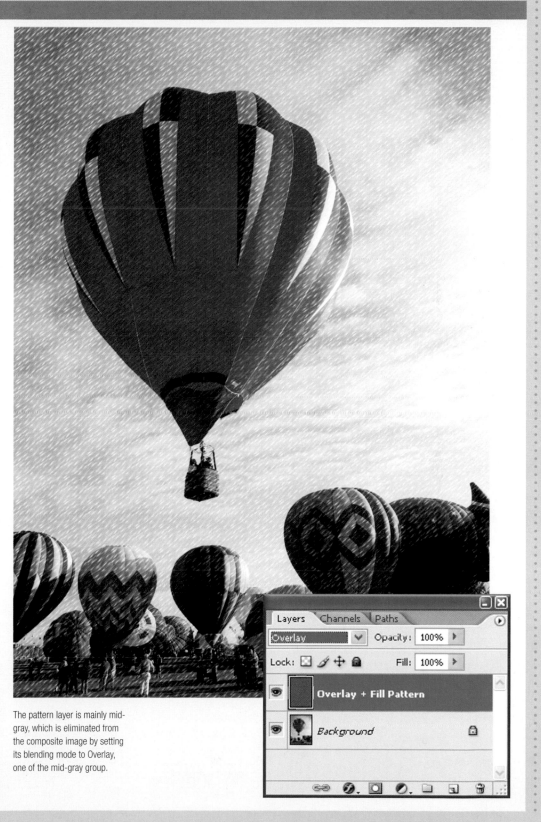

The pattern layer is mainly mid-gray, which is eliminated from the composite image by setting its blending mode to Overlay, one of the mid-gray group.

I'm a big fan of keyboard shortcuts, and each of the blending modes has its own shortcut letter. Let's say you want to switch a layer to use the Linear Light blending mode. You could select it from the drop-down box at the top of the Layers palette. However, you may find it faster to use the keyboard shortcut: if you're using a Windows PC, hold down the Alt and Shift keys, and then hit the letter "J;" on a Mac, use Option, Shift, and J. In this book, I'll write shortcuts as Alt/Opt-Shift-, with the letter for the appropriate mode at the end. As you can see from the table on this page (there's a larger version in this book's Appendix, see page 164), most of the letters correspond to a letter in the mode's name.

Often it's useful to toggle back and forth between blending modes. You may want to compare the effect of using Lighten and Screen, or just cycle all the way through seeing what each does. There are a couple of keyboard shortcuts that make this easy. To move to the next mode in the list, hold down the Alt/Opt and Shift keys and use the plus (+) key. To move back, use the Alt/Opt and Shift keys together with the minus (-) key. In the recipes, I'll write these as Alt/Opt-Shift-Plus and Alt/Opt-Shift-Minus.

A WORD OF CAUTION
Sometimes you use the keyboard shortcut and nothing seems to happen in the Layers palette; the picture doesn't change as expected. Don't panic, because there's a fair chance that one of Photoshop's painting tools is active and that your shortcut has changed the painting tool's blending mode rather than the layer's.
If this happens, just hit the M key to activate the Marquee selection tool and then enter your shortcut.

Group blending mode shortcuts

Opt-Shift	Lightening	Comparative
Next mode +	Lighten G	Difference E
Previous mode -	Screen S	Exclusion X
	Color Dodge D	
Painting	Linear Dodge W	**Hue Saturation**
Normal N		**Luminosity**
Dissolve I	**Contrast-**	Hue U
Behind Q	**increasing**	Saturation T
Clear R	Overlay O	Color C
	Soft Light F	Luminosity Y
Darkening	Hard Light H	
Darken K	Vivid Light V	
Multiply M	Linear Light J	
Color Burn B	Pin Light Z	
Linear Burn A	Hard Mix L	

Keyboard shortcuts

Photoshop rarely has just one way of doing each task, and what works well for one person often seems counterintuitive to another. This is true of layers and blending modes, and you will find that the recipes generally include both mouse and keyboard shortcut methods.

To duplicate a layer, drag it onto the "Create a new layer" icon at the bottom of the Layers palette. Alternatively, Windows users can hold down the Ctrl key (Mac users, the Cmd key), while at the same time hitting the letter J.

You can change a layer's blending mode with the mouse.

Previews versus actual pixels

Unless you have a huge screen or you work with small images, it's likely you'll use the Ctrl/Cmd-o keyboard shortcut and zoom images to fit Photoshop's window. There are times when this zoomed image may be misleading.

This image is a self-blend where the top layer is inverted and uses the Hard Mix blending mode.

Color modes

This book uses RGB images throughout. This is partly for consistency, but it's also because this mode supports the most complete set of blending modes. For example, the Color Dodge, Color Burn, Lighten, Darken, Difference, and Exclusion blending modes do not work on Lab images.

Some blending modes aren't available when you're working in Lab mode.

What is happening is that when you zoom to fit the window, Photoshop shows a preview image on your monitor. It's not the actual pixels scaled down, as you might expect, and sometimes the preview looks very different from the actual image. Such differences are not exclusive to blending modes—I've also seen them when image adjustments are applied. With blending modes, one symptom might be a picture that is unusually grainy, or when you flatten an image there may be a noticeable brightness difference between the flat and the layered versions.

Nothing is actually wrong, and this can be confirmed by viewing the image at 100% and repeating the adjustment or image flattening. When working with blending modes, I recommend occasionally using the command View>Actual Pixels or Alt/Opt-Ctrl/Cmd-0 to check that the preview accurately represents the image pixels.

Flattened images

You may notice that all this book's recipes begin with a single layer "background" image. This is because I prefer to work with a copy of the original picture so that I don't overwrite a favorite image. I also use Layer>Flatten Image to ensure a common starting point for all recipes—this really helps if I want to record a recipe as an action. Lastly, I always leave the original background image in the file, sometimes hidden, just in case I ever need to make another copy of it.

Actions

I just mentioned actions and should add that none of this book's recipes involves them. It certainly makes sense to record favorite recipes as actions, and I do so myself. But actions are about working efficiently and reproducing your work, and can be seen as "magic bullets" that keep people from exploring for themselves and creatively using layers and blending modes. So, apart from encouraging you to use them, that's the last I'll say on the subject.

Viewed at 50%, Photoshop's preview is surprisingly pixelated.

At 100%, the image shows the expected results.

This action records a blending mode recipe.

Other Ways to Use Blending Modes

While we tend to think of blending modes in terms of the pull-down options in the Layers palette, they also come into play in other areas of the application. Several of the brush tools support a choice of blending modes, as do layer styles and certain commands under the Image and Edit menus. The projects in this book concentrate on the blending mode options in the Layers palette, but we will explore these other possibilities from time to time, and they may be invaluable to your own adjustments and manipulations.

Tool blending modes

Many of Photoshop's tools support blending modes, and these behave very much as you might expect. One of the easiest ways to see this is by painting directly onto an image. Set the foreground color to a dark gray, select the Brush tool (Shortcut B), set its blending mode to Darken, and paint on the image layer. You will see that the brush paints pixels that are lighter than your gray color, but leaves darker pixels untouched. Because Darken works on a channel basis, it's slightly more complicated than that, but this concept extends to many tools.

With a little skill and forethought, you can exploit the blending modes in all sorts of other tools. For example, you might use the Close tool or the Healing brush in combination with the Lighten blending mode to remove wrinkles from a portrait, sampling from an area of soft skin and pasting the blemishes.

While tool blending modes have advantages, my own preference is to restrict any blending mode changes to actual layers. That way, it's much easier to isolate the edits and reverse or fine-tune them. You can open the file again and change the layer's blending mode, make a subtle switch from Lighten to Screen, or vary the edit layer's opacity. Tool blending modes change the affected pixels forever and you won't be able to fine-tune them at a later date.

The Fade command

Under Photoshop's Edit menu, the Fade command is another place where you will find blending modes. Think of Fade as a percentage version of Undo, with the added power of blending modes.

To get an idea of how you might use it, think of how many times you apply a filter and realize right away that you've used too strong a setting. You might undo and repeat the work, but consider activating the Edit menu and seeing if Fade is available. It will be active immediately after any Photoshop "painting" work—for example, after you paint with a brush, fill a selection with a pattern, use **Image>Adjustments**, apply **Edit>Transform** to a selection, or after you apply a filter. Fade will usually be active after such painting, and will stay available until you make further changes to pixels.

Found under Photoshop's Edit menu, Fade can moderate the effect of your most recent painting activity.

Many Photoshop tools also support their own blending modes.

I set the Brush tool's blending mode to Dissolve, its opacity to 50%, and then painted with gray on the lower left-hand side of the picture. This caused a random 50% of the pixels in that area to be gray.

The Clone Stamp is a tool that experts often use with blending modes.

16

Fade is rather like putting your filter, brushstrokes, or other painting work on a layer. The **Edit>Fade** dialog has an Opacity slider, a Mode drop-down menu, and a Preview check box. The slider is a simple percentage control—set it at 50% and half of the painting work's effect is undone, as if the layer is 50% transparent. Similarly, Mode changes the effect of the painting work by applying your chosen blending mode.

Remember that Fade's opacity setting is a bit cruder than the layer opacity. Fade only has an overall percentage while layers have separate layer and fill opacities, which you can use to fine-tune modes such as Hard Mix.

Also, Photoshop's painting isn't always so simple that percentage Undo is the right choice, so I'd encourage you to toggle Fade's preview and consider what effect you are trying to reduce. For example, you may be better off completely undoing the Unsharp Mask filter and altering one of its three settings, while Fade may be the right solution if you have blurred a layer and filled a selection with color.

Fade's dialog features the full set of blending modes.

Layer Styles

Layer Styles are an increasingly popular way to add special effects to pictures. A style consists of a layer's blending mode, opacity, drop shadows, texture patterns, and many other properties. You can save a style and apply it to other images, and you can import into Photoshop styles that other people have created and shared on websites, such as Adobe's Studio Exchange (www.adobestudioexchange.com). Some of these are very complex and clever, and produce amazing results.

Layer blending modes are not the main reason for choosing to save a style. After all, what's inefficient about selecting the blending mode from the Layers palette's drop-down box? It's more that the Layer Style dialog box has blending modes for each of its properties. Therefore, you can define that a Pattern Overlay will blend with the rest of the layer using the Lighten blending mode. The layer itself may have a totally different blending mode to control how it blends with the underlying image.

Nearly all properties of the Layer Style dialog box have blending mode options.

Image Calculations and Apply Image

In the days before Photoshop introduced layers, Calculations was one way to composite images. It merges two channels and produces a flattened image, and some users still use it as a way of converting a color picture into black and white. Also under Photoshop's Image menu is Apply Image, which overwrites the active image with itself or a channel.

Both dialog boxes include blending modes. Layers and adjustment layers offer much more flexibility, and, while Calculations and Apply Image may still be useful if you are tight on disk space, in these days of massive hard drives they're a bit of an anachronism. I will mention that Katrin Eismann's book, *Photoshop Masking and Compositing,* includes examples for using these commands in very sophisticated masking techniques.

Image Calculations has blending mode options and can be used to merge two channels to a new channel or a black-and-white image.

Apply Image overwrites the active image and also has blending mode options.

17

How Blending Modes Work

For many readers, it may be enough to work through the book, looking at the various blending modes and how they can be used effectively for a multitude of recipe combinations. That's absolutely fine. However, if you would like to know something more about how the blending modes work, this is the section for you. It is a survey of how blending modes are made and calculated and, unsurprisingly, it involves a little bit of math. But don't let that put you off!

Base and blend colors

Photoshop's documentation usually describes blending modes in terms of base and blend colors. For instance, this is Adobe's definition of Color Dodge.

"Looks at the color information in each channel and brightens the base color to reflect the blend color by decreasing the contrast. Blending with black produces no change."

Let's clarify what this actually means. Imagine a two-layer image. The bottom layer is the base, and the top layer (also known as the blend layer) contains the blend color. Changing the blend layer's blending mode affects how Photoshop renders colors that have come from the underlying image. In Color Dodge's case, if the top layer is black, the underlying image is unchanged. This is what is meant by "blending with black."

This is a single pixel. Color Dodge makes Red and Green values brighter, but because the Blue channel's blend value is Black, the Blue remains unchanged.

Master opacity and fill opacity

The Layers palette has two opacity sliders. The top one is labeled "opacity" and is called the master (or layer) opacity. It controls the percentage opacity of the entire layer, including any blending modes or layer styles. The lower slider is the fill (or interior) opacity and affects pixels painted on a layer without affecting the opacity of any layer effects.

Adjusting these sliders affects some blending modes differently. The effect of the Dissolve blending mode isn't visible at all until you reduce either of the opacity percentages below 100%. On the other hand, when the fill opacity is reduced, the Hard Mix blending mode behaves differently than when you reduce the layer opacity. Most recipes use one or the other of the opacity sliders to fine-tune the result.

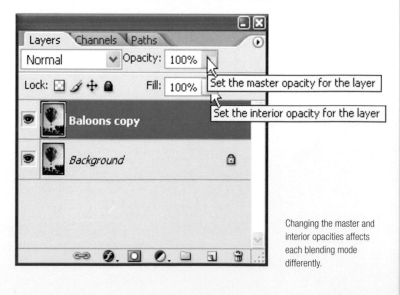

Changing the master and interior opacities affects each blending mode differently.

Blending modes and math

Adobe doesn't publish precisely how blending modes are calculated, but if you are interested, it is possible to work out what each blending mode is doing. Some websites document the mathematical formulas.

The Color Dodge calculation is a simple example. For each RGB channel, Photoshop calculates an output color by dividing the base color by the inverse of the blend color. To check this for yourself it's best to work with color values on a 0–1 scale where 0 is black and white is equal to 1.

OUTCOME—BASE / (1—BLEND)

In Color Dodge's case, if the blend color is black or 0, then the base color will be divided by 1, so Photoshop outputs it unchanged. You can prove all the other blending modes in this way.

Create a simple two-layer RGB image and fill the base layer with one color, the top layer with another, and change the top layer's blending mode. Then use the Color Picker tool to sample the resulting color.

How Hue works

While Color Dodge is based on dividing one color value by another, Hue belongs to another group of blending modes where Photoshop calculates the output color by maintaining the base layer's "luminosity." Based on the eye's sensitivity to the colors, Photoshop calculates the base color's Luminosity as 30% Red, 59% Green, and 11% Blue and then creates an output color with the same overall Luminosity.

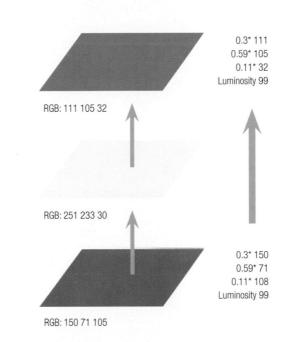

0.3* 111
0.59* 105
0.11* 32
Luminosity 99

RGB: 111 105 32

RGB: 251 233 30

0.3* 150
0.59* 71
0.11* 108
Luminosity 99

RGB: 150 71 105

19

BLENDING MODES IN DETAIL

Normal and Dissolve

This chapter looks at blending modes in detail, so that when you reach the chapter on using blending modes for individual recipes (see page 62), you will have some contextual understanding of their effects. The first blending mode in this section is Normal, Photoshop's default blending mode. Dissolve offers more creative possibilities, which enables you to create grainy, mottled effects with your images.

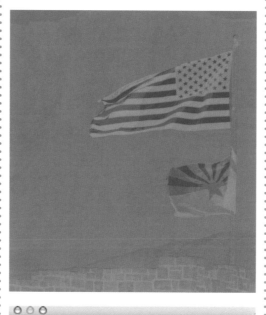

Original image.

Normal

KEYBOARD SHORTCUT
Windows: Alt+Shift+N
Mac: Option+Shift+N

Photoshop's default blend mode is Normal, and although useful when creating basic montages, as a "creative" blending mode it has little to offer. However, as the illustration below shows, it can be used to reduce the contrast when you blend an image with an inverted copy of itself. With the inverted blending layer set to 100% opacity, only the negative of the image is visible. However, reducing the opacity first brings down the negative's contrast, resulting in a totally gray screen at 50% opacity, after which lowering the opacity further progressively restores a low-contrast version of the original image.

Here, a duplicate copy of the target image was inverted, resulting in a document with a negative and positive version of the image. As the opacity percentage of the inverted layer approaches 50%, the image becomes increasingly gray.

Dissolve

KEYBOARD SHORTCUT
Windows: Alt+Shift+I
Mac: Option+Shift+I

When you set the blending mode to Dissolve, Photoshop randomly selects the blending layer's pixels or those from the base layer, the proportion of each depending on the blend layer's opacity. The result, governed by the blending layer image, is usually like stippling an image and creates a grainy, mottled effect that can be used in all sorts of ways to degrade an image or add noise.

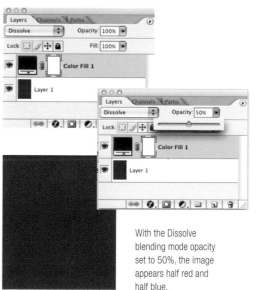

With the Dissolve blending mode opacity set to 50%, the image appears half red and half blue.

The most effective way to see the Dissolve blending mode in action is to create a very simple two-layer image. Create a new document and fill it with red. Then select **Layer > New Fill Layer** to create a blue layer above the background red layer. Next, switch the blue layer's blend mode to Dissolve.

At first you'll notice no difference. The resulting color is blue because the blend layer is at 100% opacity, so Dissolve outputs a random selection consisting of 100% of the blend layer (blue) and none of the base (red). But reduce the opacity to 90% and roughly a tenth of the pixels now appear red; reduce the opacity to 50% and the image appears half red and half blue. The Dissolve layer has been desaturated.

Self-blends and changing the opacity

If I use Dissolve to create a simple self-blend—blending a layer with a copy of itself—I know that I will see no change in the image. It obviously makes no difference which layer's color Photoshop displays.

For the blend to have an effect, I need to change the blend layer in some way—blurring it, offsetting it by a few pixels, or removing the color, for example. Straightaway, the base layer starts to show through like a stippling or dropout effect.

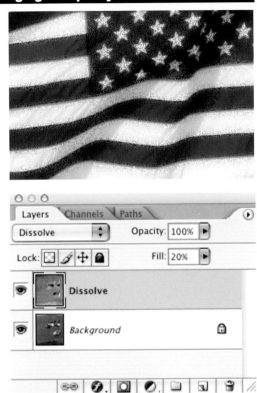

More of the base layer shows through as I reduce the blend layer's opacity.

In this detail from a picture of the U.S. Arizona flags, I desaturated the Dissolve blend layer. At 90% opacity, the colored stars and stripes are barely visible. Reducing the opacity means more color shows through. Notice too how it appears completely random.

This detail of the Arizona flag is desaturated at 90% opacity, making the stars and stripes barely visible.

Using Dissolve

Dissolve can be used in many ways, but especially when you want to degrade an image. The picture becomes like a big mosaic that's missing lots of its small tiles with background tiles showing through. This isn't limited to making the picture look old or damaged and a lot depends on the image. What's useful to note is that, unlike applying a filter, with a blending mode you can always fine-tune the result afterward.

Use the Move tool to offset the blend layer by just a few pixels.

One technique is to use the Move tool to offset the Dissolve layer by a few pixels. When a picture has strong colors and lots of contrast, setting the layer's opacity at a middle value ensures that both base and blend layers contribute to the blended image. With the example of the flag shown here, it's a little like looking through frosted glass.

Here, a Gaussian blur amount of 10 softened the colors.

Applying Gaussian blur is another possibility. This tends to soften the contrast and colors, but is only one of many things you can try. The combination of offset with blur produces an effect that looks like steam on frosted glass, as described above.

With both offset and Gaussian blur applied to the Dissolve layer and then combined with the base layer, a "steam-on-frosted-glass" effect is achieved.

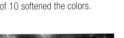

23

Non-Layer Blending Modes

While this book is primarily about Layer blending modes, Photoshop also has some blending modes that don't apply to layers but that are applied with painting tools, the Edit > Fill, Edit > Stroke commands, or via other specific dialog boxes. It may be that you never use these "non-layer" blending modes, particularly if you use Photoshop as an image-editing tool. However, for those of you who undertake a lot of painting work using Photoshop, they're described here.

Behind

KEYBOARD SHORTCUT
Windows: Alt+Shift+Q
Mac: Option+Shift+Q

The Behind blending mode applies to the **Edit** > **Fill** and **Edit** > **Stroke** commands and to painting tools such as the Brush and Paint Bucket tools. When a painting tool's blend mode is set to Behind, that tool will paint only on the transparent pixels on a layer, as if painting underneath or behind any colored pixels. If a pixel is semitransparent, the paint is reduced proportionately. Remember, though, the Behind blending mode won't work if the layer's transparent pixels are locked via the Lock Transparency box in the Layer palette.

Clear

KEYBOARD SHORTCUT
Windows: Alt+Shift+R
Mac: Option+Shift+R

Like the Behind blending mode, the Clear blending mode applies to the **Edit** > **Fill**, **Edit** > **Stroke** commands and to painting tools such as the Brush and Paint Bucket tools. It works in much the same way as the Eraser tool and makes pixels transparent.

When the Brush tool's blending mode is set to Clear, it acts just like the Eraser.

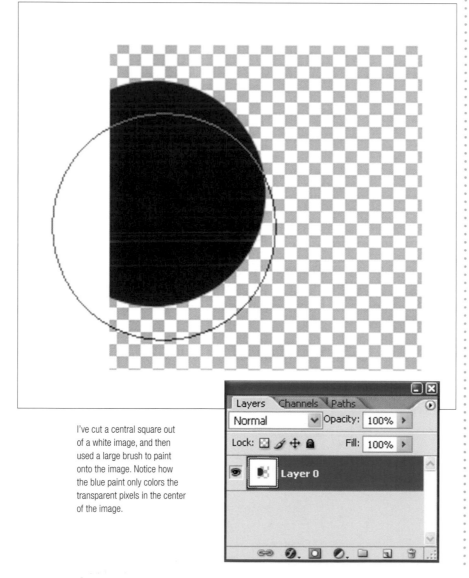

I've cut a central square out of a white image, and then used a large brush to paint onto the image. Notice how the blue paint only colors the transparent pixels in the center of the image.

24

Add

The Add blending mode is accessed via the **Image** > **Apply Image** and **Image** > **Calculations** dialog boxes. In the Apply Image dialog, you can either select all RGB channels, or an individual color channel to be added to the background image. In the Calculations dialog box, you have the option of adding the pixel values from two color channels and outputting them to create a new image or a selection mask. In both cases, the resulting image will usually be brighter than the individual channels.

If you select **Image>Calculations**, you'll bring up a dialog box where, in this particular example, the Add blending mode has been selected to output a monochrome image based on two channels.

Subtract

Unsurprisingly, the Subtract blending mode is the opposite of Add. Like Add, it is used only in the Apply Image and Calculations dialog boxes. As a blending mode, in general it enables you to subtract one or more color channels from an image in order to create a specific selection mask or to create a new image. Naturally enough, the resulting image will usually be darker than the individual channels.

Some people use the Subtract blending mode in the Calculations dialog box to convert a color image to black and white. Try it if you like, but it's more complicated than using the Channel Mixer, which works in much the same way. If the Add or Subtract modes have a common use, it is probably in advanced masking techniques, which are beyond the scope of this book.

Pass Through

Pass Through applies only to layer groups and is a layer group's default blending mode. When applied to a group, the individual layers' blending modes, adjustment layers, and styles will affect all the layers below the layer group. It is possible, however, to set the layer group's blend mode independently, such as Multiply, in which case that blend mode will only apply to the layer group's stack of layers.

Although Pass Through is a layer group's default blending mode, you can apply a specific blend mode that will affect only the layer group. Here, I chose Dissolve and reduced its opacity, resulting in Dissolve's typical grittiness to the image.

Darken

The Darken, Multiply, Color Burn, and Linear Burn blending modes can usefully be thought of as a group of blending modes, all of which darken the underlying image, and which have white as their neutral color—in other words, blending with white has no effect.

The Darken blend mode creates an output color by examining each channel in the base and blend layers before selecting the darker of the base or blend color value. As the blend color becomes darker, so the blend's final effect becomes more obvious. Lighter blend colors have less effect, and blending with white has no effect at all.

Original image.

Self-blends

In a simple self-blend, the base and blend colors are identical, so the picture remains unchanged. Now try adding a little Gaussian blur to the blend layer. The Darken blending mode results in a darker image, with shadow tones that bleed into lighter areas and with less overall contrast. Compare this with the Lighten blending mode, which has exactly the opposite effect—brightening the image and producing soft halos around the highlight areas.

A detail with no blur.

Notice the halo around the rock where Lighten uses the lighter color from the blurred layer.

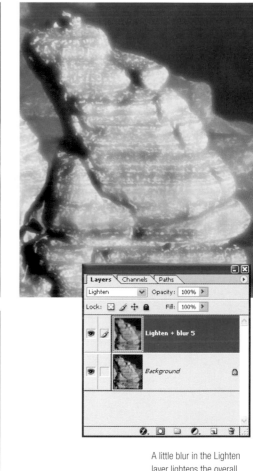

A little blur in the Lighten layer lightens the overall image and causes light tones to bleed into darker areas.

A little blur in the Darken layer darkens the overall image and causes dark tones to bleed into lighter areas.

26

Inverting a Darken layer

Inverting the Darken blend layer produces strange reversal effects. Because Darken looks at each channel individually, you should expect color shifts; but with a little thought, it's possible to predict the reversal's outcome. In a negative or inverted image, the highlights are dark, so applying the Darken blending mode to the layer means that these reversed highlights become apparent in the composite image. The original shadow tones remain because they are darker than their reversed counterparts in the blend layer, while midtones remain relatively unaffected.

Inverting a Darken blend layer reverses the highlights, while midtones are unaffected.

Layer styles

An interesting problem occurs when you set a text layer's blending mode to Darken. If parts of the underlying image are darker, they show through, rendering invisible some parts of the letters, or indeed entire letters.

To make the text more legible, you could always choose another color, or you might want to outline the letters with a stroke of contrasting color, but doing the latter would mean losing the ability to edit the text.

A great alternative is to add a layer style to the text layer. Click the Layer palette's style icon (at the bottom left of the Layer palette) and select drop shadow, stroke, or any other style. You now have a wide range of ways to outline the text. If you select drop shadow, you can also control the shadow's blending mode independently of the text layer.

When a text layer's blend mode is set to Darken, some letters vanish into the canyon's darker shadows, which is not really the result I'm looking for.

Outlining the letters using a layer style will make the lettering much more legible. Furthermore, the drop shadow layer style has its own independent blending mode drop-down menu.

27

Multiply

The Multiply blend mode is another of the Darken group of blending modes. Like Darken, the Multiply blend mode also compares the base and blend layer's pixels channel by channel, but rather than selecting the darker of the two, Multiply creates a darker image by multiplying the base color by the blend color. Multiplying with black will always result in black, while multiplying with white has no effect. It doesn't matter if the blend is darker or lighter than the base color—the result is always to darken the underlying image.

While you can easily imagine mixing blue and red paints, the concept of "multiplying" colors may seem strange at first. Try making a simple two-layer image. Fill both layers with the same midrange color—a light gray is best. Now switch the top layer's blending mode to Multiply, and you'll notice that the blend color is a much darker gray.

Self-blends and changing opacity

If you blend an image with a copy of itself, and make the top layer's blending mode Multiply, the resulting image becomes darker. Shadows, midtones, and highlights are not affected equally. It's more like a Curves adjustment where shadows are made darker and highlights show little change. This is because in a Multiply self-blend, Photoshop multiplies (in this case, squares) the base and blend color values. As with all blend modes, the effect varies in proportion to the opacity percentage. However, there seems little point using Multiply for a simple self-blend. You could achieve the same end result with a Curves adjustment layer, and the resulting file size would be much smaller.

Using Curves in this instance will produce a smaller file size.

Adding Gaussian blur to the blend layer produces an effective soft-focus effect. Because Multiply works more strongly in the shadows and midtones, the outcome is more moody, with darker tones bleeding into the highlight areas. Unlike simply blurring an image layer, you can adjust, fine-tune, and reverse the results long after you save and close the file.

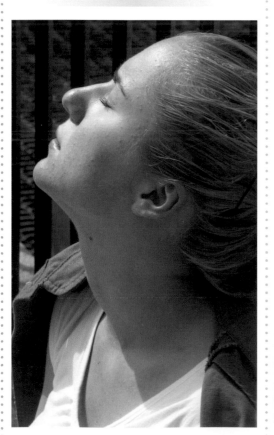

Original image.

Notice straightaway how a Multiply self-blend darkens the image, especially the shadows.

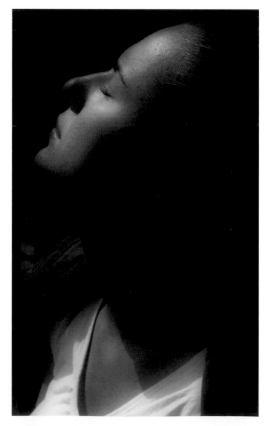

Blur a Multiply blend layer and shadows bleed into the highlights.

Special effects

An excellent use for Multiply is to add color to line drawings. It really doesn't matter if, like me, you can't draw—just take a photograph and make a self-blend. Turn the lower layer into a line drawing by selecting **Filter** > **Stylize** > **Find Edges**. Next, blur the top layer and set its blending mode to Multiply. Finally, reduce the top layer's opacity until you're happy with the results.

You can also try optional steps, such as desaturating the line drawing, strengthening it using Curves, or dragging it on top of the Multiply layer.

Other blending modes can produce similar effects, but I prefer Multiply because large areas of the line drawing are white and have no effect on the result. So, using the Multiply blending mode produces an image that most closely matches the original image's tonality.

Fine-tune the image by blurring the Multiply layer and varying its opacity.

With the same amount of blur, the original is barely recognizable.

A great use for Multiply is to add color to a line drawing.

Color Burn

Color Burn is the third member of the Darken group of blending modes. It works by inspecting each channel and then darkens the base color to reflect the blend color by increasing the base color's contrast. So, applying the Color Burn blending mode to a layer makes the picture darker and increases contrast. Again, blending with white produces no change.

KEYBOARD SHORTCUT
Windows: Alt+Shift+B
Mac: Option+Shift+B

Self-blends and changing the opacity

A simple Color Burn self-blend results in the darkening of all colors and greater contrast. The increased saturation and contrast become obvious even with a very soft image. If it's too strong, you can reduce the effect by dragging the blend layer's opacity slider. For a simple self-blend, this may be useful, but you could produce similar results with a Curves adjustment layer, and, furthermore, you could control each channel and tonal value individually, and the final file size would be smaller. To make the most of Color Burn, use it with composite images.

Original image.

Color Burn has saturated the colors and increased the contrast.

30

With Color Burn, it's worth noting that changing the layer's master opacity and its fill opacity produces slightly different results. The master opacity simply reduces the layer's transparency and its effect proportionately. Reducing the fill opacity maintains more contrast.

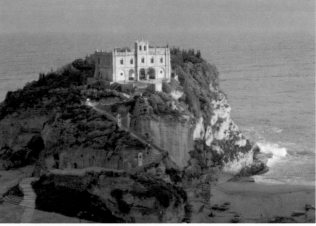

Original image.

Interesting effects happen with Color Burn when Gaussian blur is applied to the background image. To a certain extent, with its contrast-decreasing effect, blur works against Color Burn. However, the contrast-decreasing effect of blur is offset by Color Burn's characteristic image-darkening. Of course, much depends on the image, but typically blur makes the dark areas encroach into the lighter areas, creating a gloomy, brooding effect. For something even stranger, try inverting the blend layer—the dark areas will be surrounded by halos.

Reducing the Color Burn layer's fill opacity maintains a high-contrast result.

Here, a lot of blur on the inverted layer causes Color Burn to create a halo around dark areas.

The Color Burn layer's master opacity softens the picture.

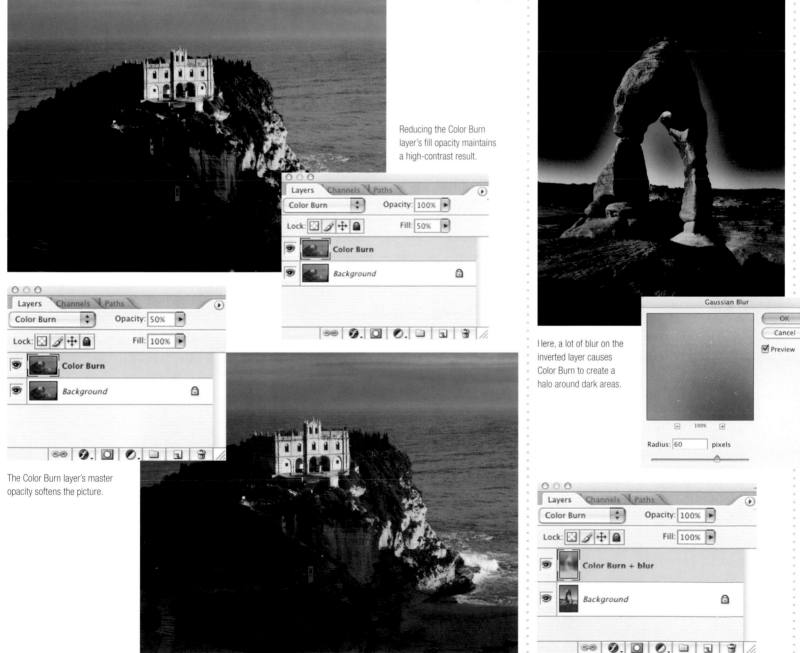

Linear Burn

Like many of the Darken group of blending modes, Linear Burn also inspects each channel on the base and blend layers. It darkens the base color to reflect the blend color by decreasing the brightness. Because its neutral color is white, highlights in a Linear Burn blend layer have no effect on the underlying image.

Linear Burn is similar to Color Burn in that both darken the base color to reflect the blend, so the effect Linear Burn creates depends on which color is on top. The difference is that, while Color Burn works by increasing the contrast, Linear Burn decreases the brightness.

Linear Burn is also similar to Multiply in that the blend layer lets the base color show through; however, Linear Burn darkens the base color and produces more blacks.

KEYBOARD SHORTCUT
Windows: Alt+Shift+A
Mac: Option+Shift+A

Linear Burn

The best way to appreciate Linear Burn is by comparison with the other members of the Darken group of blending modes.

Duplicate an image layer (Ctrl/Cmd-J), and set the new layer's blending mode to Linear Burn. The resulting image is much darker and appears more saturated. Now use Alt/Opt-Shift-Minus to cycle back through the other Darken blending modes, and Alt/Opt-Shift-Plus to cycle forward.

A simple Linear Burn self-blend is enough to make a noticeable darkening of the image—unlike the Darken blend mode, which has no effect on a self-blend. Compared with Multiply, Linear Blur produces a much harsher result and is uniformly darker. Lastly, it always darkens the picture more than Color Burn. Think of Linear Burn as the darkest and harshest of the Darken modes.

A Linear Burn self-blend produces a darker, harsher result than Color Burn or Multiply.

Original image.

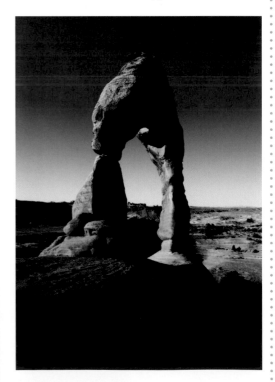

With Color Burn, the sky in the horizon is lighter than with Linear Burn.

The effect of opacity

Changing the layer and fill opacity isn't the same thing. While the Layer Opacity slider affects any layer styles and blending modes applied to the layer, the Fill Opacity slider doesn't change any layer effects that may have been applied. So, in the case of Linear Burn, reducing the layer opacity makes the result much more like the original, but softer and brighter. However, if the fill opacity is reduced to the same percentage, the image looks much more like a typical Linear Burn layer.

Reducing the layer opacity produces a softer, brighter result than reducing the fill opacity percentage.

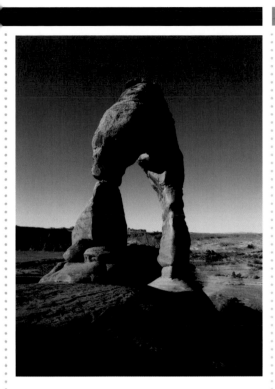

Multiply self-blends produce a softer result than Linear Burn.

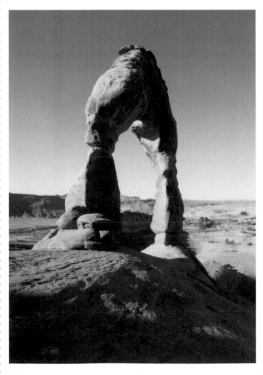

With a Darken self-blend, there is no discernible difference.

Lighten

LIGHTEN

The next four blending modes—Lighten, Screen, Color Dodge, and Linear Dodge—all lighten the underlying image, and for this reason they are often referred to as the Lighten group. Just as the Darken modes have white as their neutral color, the Lighten group of modes have black as their neutral color, which is why they are also sometimes known as the neutral black group.

The Lighten blending mode is the exact opposite of the Darken mode. Both create a new output color by comparing the base and the blend color information in each channel. While Darken selects the darker of the base or blend color, Lighten chooses the lighter of the base or blend color. Its effect is more obvious with lighter blend colors.

KEYBOARD SHORTCUTS
Windows: Alt+Shift+G
Mac: Option+Shift+G

Inverting and blurring

If you use Lighten to blend a layer with a copy of itself, because the base and blend colors are identical, the picture will remain unchanged. For the Lighten blend mode to work, you need to introduce some difference between the base and blend layers. Inverting the blend layer transforms the image, resulting in strange color shifts and reversals of the shadows. By also adding a Gaussian blur to the blend layer, a halo is added around the now-light shadows.

Adding Gaussian blur to the Lighten blend layer lightens and blurs the image, and creates a rim or halo around the reversed shadows.

Original image.

Applying Lighten to an inverted copy reverses the shadows.

34

Inverting the blend layer incurs unusual shifts in color, producing a negative-like image.

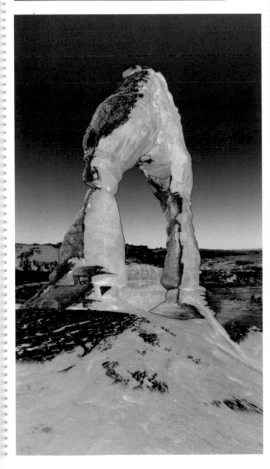

Removing dust spots

Dust spots can be the bane of most digital SLR photographers' lives. I would usually retouch spots manually with the Clone tool or Healing brush tools. These tools offer greater precision. But in evenly toned areas that are not critical to the image, such as clear skies, there is another, quicker method.

This shot was taken at the end of a trip. Unfortunately, the digital SLR's sensor had collected particles of dust, which have become especially visible in this picture of southern Utah's clear, blue sky.

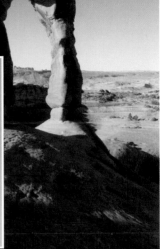

4a

4b

Applying a Lighten mode to a slightly offset duplicated patch of sky results in Photoshop selecting the lighter color from the base and blend layers, thus banishing the darker spots.

1 Select the area containing the dust spots.

2 Feather the edges of the selection.

3 Copy your selection to a new layer using **Layer > Layer via Copy** (Ctrl/Cmd-J).

4 Change layer's blend mode to:

a Lighten for dark spots.

b Darken, if spots are lighter than their surroundings.

5 Zoom in close.

6 Select the Move tool (V).

7 Use the arrow keys to nudge the duplicate layer a few pixels until the spots disappear.

Screen

Screen, the second of the Lighten group of blend modes, is often likened to projecting multiple transparencies onto the same screen. As Screen's neutral color is black, this blending mode will leave black unchanged. Dark colors marginally brighten the picture, but as the blend color lightens, the image becomes increasingly lighter. This can make certain images look bleached or overexposed.

KEYBOARD SHORTCUT
Windows: Alt+Shift+S
Mac: Option+Shift+S

Original image.

Self-blends and changing the opacity

A self-blend simply lightens the image, especially in brighter areas, resulting in an image that appears overexposed. Experiment with the Blend If slider in the layer's Blending Options—you can restore contrast or limit the blend mode's effect to the shadows or to the midtones and highlights.

Blending with an inverted self-blend produces a partially reversed effect where formerly dark tones are now washed out, while mid- and lighter tones are brightened—the overall effect is curious.

Here, the Blend If slider has restored the shadows.

36

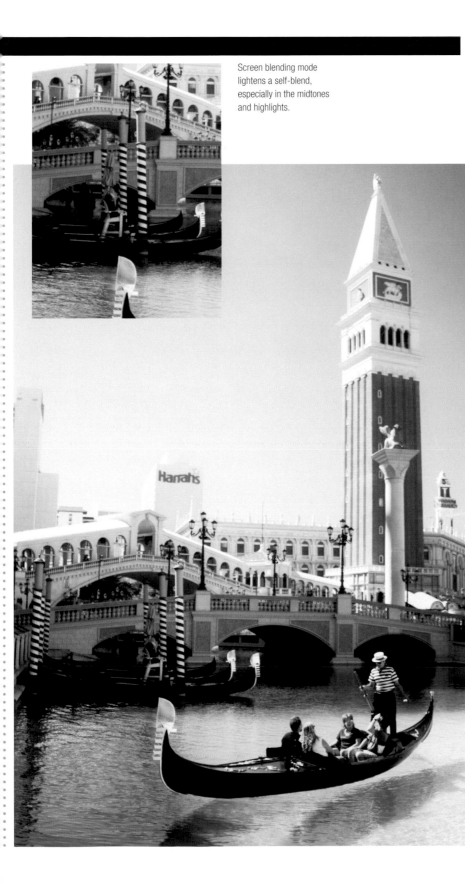

Screen blending mode lightens a self-blend, especially in the midtones and highlights.

An interesting use of the Screen mode is to apply it to a lens flare. Fill a new layer with black and change its blend mode to Screen, then apply the lens flare. Screen renders the black invisible, and adjusting the black layer's opacity allows you to fine-tune the flare's strength. Of course, you could do the same if you had applied the flare to a copy of the image layer. But this technique is really useful if you later decide to move the flare—all you need to do is move the black layer. Just watch out for borders if you add so much flare that it overlaps the image edge—the way around this is to temporarily increase the canvas size.

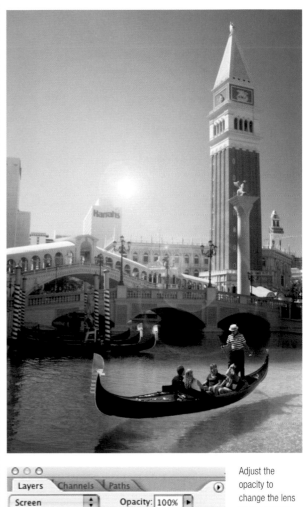

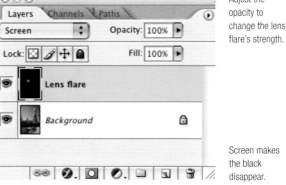

Adjust the opacity to change the lens flare's strength.

Screen makes the black disappear.

Color Dodge

olor Dodge is the third of the Lighten group of blending modes—it's also my favorite member of the group because it's the only one that preserves blacks. Color Dodge inspects each color channel and then brightens the base color to reflect the blend color by decreasing the contrast; in fact, it's the exact opposite of Color Burn (see pages 30–31). However, one aspect of Color Dodge's definition is misleading. This is where it refers to "decreasing the contrast," because, just like dragging the Levels' white point, selecting Color Dodge actually increases the overall contrast of the image.

Rather than focusing on this strict "textbook" definition, remember that what Color Dodge actually does is lighten the image and increase contrast in brighter areas, while preserving the blacks.

KEYBOARD SHORTCUT
Windows: Alt+Shift+D
Mac: Option+Shift+D

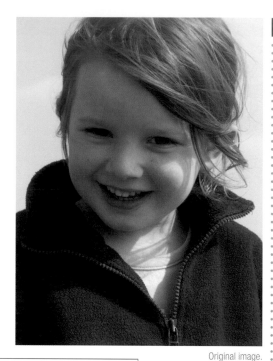

Original image.

Inverting and blurring

Blending the base layer with an exact but inverted copy of itself results in an all-white image. However, apply a little Gaussian blur to the picture and things become a little more interesting. Because blacks are preserved, using a small Gaussian blur radius with an inverted copy of the image will result in a line-drawing effect. Color Dodge therefore allows you to build your own Find Edges filter that to some extent you can fine-tune afterward by increasing the blur. Once it's applied, you can control its strength by reducing the layer's opacity. However, you can't reverse the blur itself unless you step back through the History or use the History brush. So, add Gaussian blur a little at a time and build up the line-drawing effect until you've created the desired result.

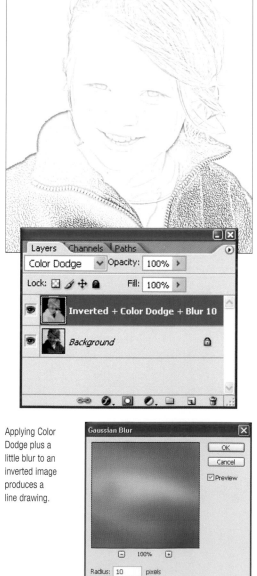

Applying Color Dodge plus a little blur to an inverted image produces a line drawing.

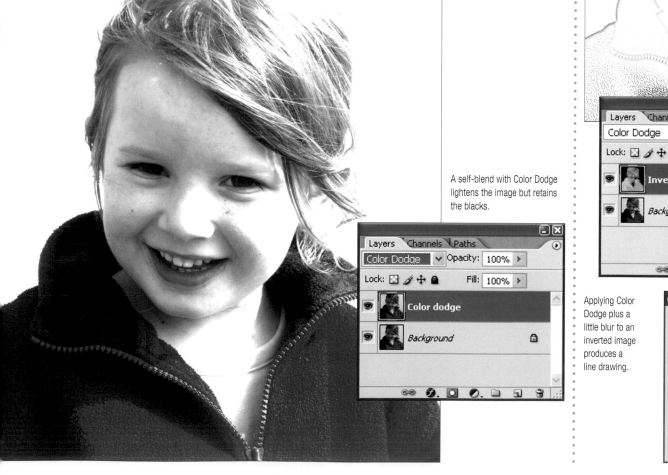

A self-blend with Color Dodge lightens the image but retains the blacks.

As you increase the blend layer's Gaussian blur, Color Dodge makes some partial reversals. The original image's highlights become dark in the inverted layer, and are ignored, while the rest of the image is brightened.

As well as simply inverting and blurring the blend layer, try desaturating it. Alternatively, you can always toggle between a negative and a positive view with Ctrl/Cmd-I.

Color Dodge ignores the blacks in the inverted blend layer.

Sometimes unexpected details can emerge from experimenting—here, I had no idea that there were reflections of text in the window.

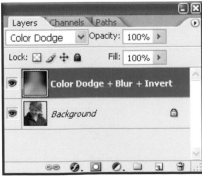

Linear Dodge

Linear Dodge also belongs to the Lighten group of blending modes; it will always lighten the picture and blending with black has no effect. Linear Dodge can be seen as a combination of Color Dodge and Screen, but it's a more powerful blending mode than either. Like Color Dodge, Linear Dodge can clip highlights, which does not happen with Screen, but Linear Dodge differs from Color Dodge in that it lightens black.

Linear Dodge inspects each color channel and brightens the base color to reflect the blend color by increasing the brightness. Does this definition sound familiar? If so, that's because Linear Dodge's definition is the exact opposite of Linear Burn (see pages 32–33). While Linear Dodge lightens the base to reflect the blend color by increasing brightness, Linear Burn darkens the base by decreasing brightness.

KEYBOARD SHORTCUT
Windows: Alt+Shift+W
Mac: Option+Shift+W

Using Linear Dodge

You can produce interesting results by inverting the blend layer and applying small amounts of Gaussian blur. At first, the image is completely white, but as you increase the Gaussian radius, you will see a line drawing begin to emerge. In this picture of the girl, a little blur washes out the image, around 10–15 produces a weak line drawing, while pushing the radius up to around 25 produces the most balanced effect.

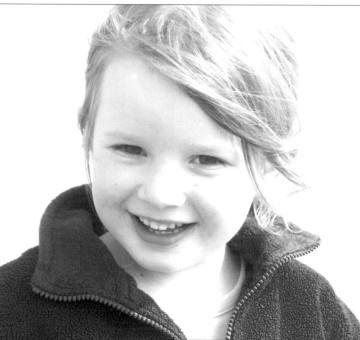

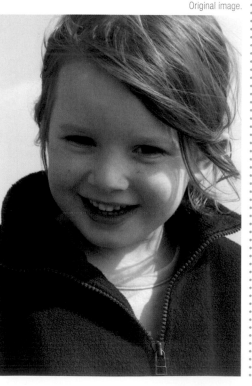

Original image.

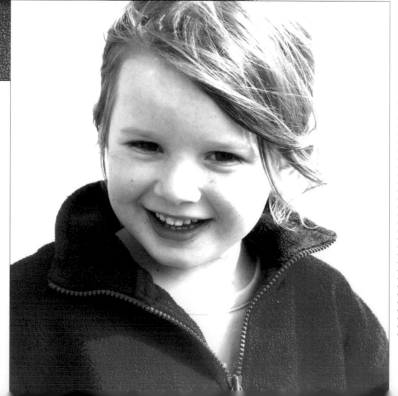

Notice how Linear Dodge produces a brighter result than Color Dodge, but also notice how Linear Dodge, unlike Color Dodge, lightens the blacks.

40

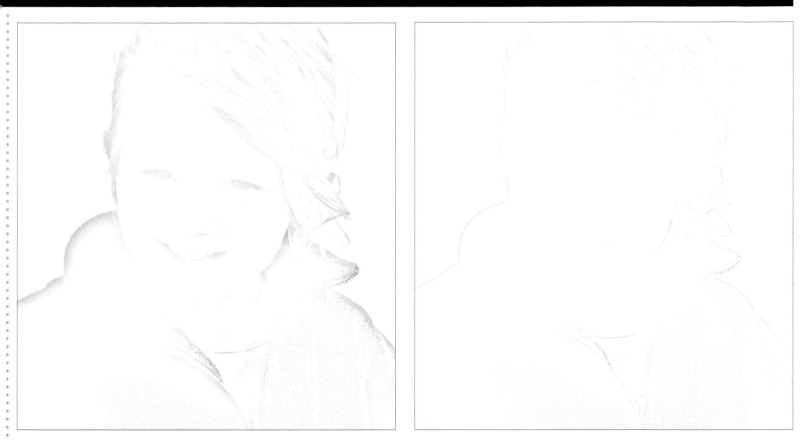

Applying Linear Dodge and Gaussian blur with a radius of 25 to an inverted image produces a balanced combination between a line drawing and a bleached photograph.

Here, I applied blur to the blend layer before inverting it. This isn't really a good idea as I can't see my final result. So, try to change the blending mode and do any inversion before applying blur.

A smaller amount of blur (here, I've used a value of 10) produces a weak line drawing without the need for filters.

Overlay and Hard Light

Having looked at groups of modes that either lighten or darken, let's move on to a group of blending modes that both lighten and darken at the same time—known as the Contrast group.

The first two in the group, Overlay and Hard Light, are so similar that it makes sense to look at them together, but you should also bear in mind that much of what applies to Overlay and Hard Light applies to Soft Light too. All three belong to the contrast-increasing group of blending modes. These darken shadows, lighten the highlights, and have mid-gray as their neutral color, so blending with gray has no effect. Overlay and Hard Light both darken shadows by multiplying the image and lighten highlights by screening the image. Soft Light is their softer, more subtle sibling.

Original image.

Overlay

OVERLAY KEYBOARD SHORTCUT
Windows: Alt+Shift+O
Mac: Option+Shift+O

Overlay and its close cousin, Hard Light, are very similar. The main difference is that Overlay won't clip the highlights to a pure white or the shadows to a pure black.

Hard Light

HARD LIGHT KEYBOARD SHORTCUT
Windows: Alt+Shift+H
Mac: Option+Shift+H

Hard Light produces much higher-contrast results than Overlay. Like Overlay, it darkens shadows, lightens highlights, and has mid-gray as its neutral color.

A simple Overlay or Hard Light self-blend increases image contrast.

Here, I added just a little Gaussian blur, using a radius of 10.

42

Using Overlay and Hard Light

Simple Overlay or Hard Light self-blends can be used to boost contrast. However, you can easily increase contrast with a Levels or Curves adjustment layer, which would also let you control each tone individually (and results in a smaller file size).

Try inverting the blend layer, adding blur, maybe desaturating it too or applying other filter effects, text, and shapes, and you'll see how Overlay or Hard Light allows the image to show through.

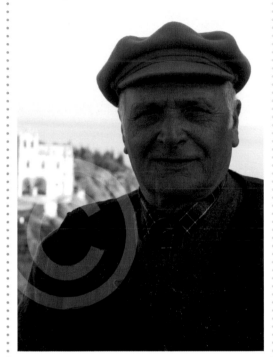

If you add text or shapes to an image and change the blending mode to Overlay or Hard Light, the image shows through.

Correcting poorly exposed images with Overlay

One popular use of Overlay is to create a dodge-and-burn layer:

1 Click the arrow in the top right-hand corner of the Layers palette and select New Layer (Ctrl/Cmd Shift N).

2 In the New Layer dialog box, select Overlay from the mode drop-down box and ensure that you check the Fill with Overlay-neutral color.

3 Click OK.

Such ideas come together in a quick technique for correcting images whose subject is too dark, maybe due to poor camera metering. The advantage of this technique is that, unlike Photoshop CS's Shadow/Highlights adjustment, you can fine-tune this adjustment later. The steps are easy enough:

1 Duplicate the image layer.

2 Switch the new layer's blending mode to Overlay (Alt/Option-Shift-O).

3 Invert the duplicate layer (Ctrl/Cmd-I).

4 Desaturate the duplicate layer (Ctrl/Cmd-Shift-U).

5 Apply Gaussian blur to the duplicate layer.

6 Select the highlights (Alt-Ctrl-~/Option-Cmd-~).

7 In the Layer palette, Alt/Option-click the Add Vector Mask icon.

An inverted Overlay self-blend used in conjunction with a highlights mask can help lift shadows.

Soft Light

Photoshop describes the Soft Light blending mode as "similar to shining a diffused spotlight onto the image." Like a softer version of Overlay and Hard Light, Soft Light belongs to the same contrast-increasing group of blending modes that have mid-gray as their neutral color. Essentially, Soft Light blending mode dodges the image if the blend color is lighter than 50% gray, and burns the image if the blend is darker.

Deciding between these three modes is always a case of applying your judgment to the image you're working on, but there are good reasons why you might want to choose Soft Light to increase contrast. Unlike Overlay, Soft Light can clip colors to a pure white or black, something you can also do with Hard Light. Its name also gives us a clue to the other main reason for selecting Soft Light—of these three modes, Soft Light produces the softest contrast.

KEYBOARD SHORTCUT
Windows: Alt+Shift+F
Mac: Option+Shift+F

Original image.

Using Soft Light

While gently increasing contrast is an obvious use for Soft Light, it also has a couple of other uses that are really worth investigating—dodging and burning, and making your own Shadow/Highlights filter.

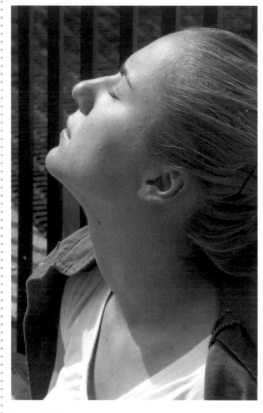

This candid shot was taken with strong afternoon sunshine falling directly on the girl's face.

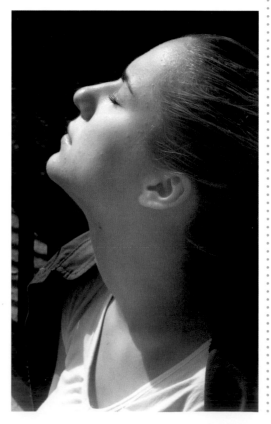

Adjust the opacity or mask to fine-tune the image.

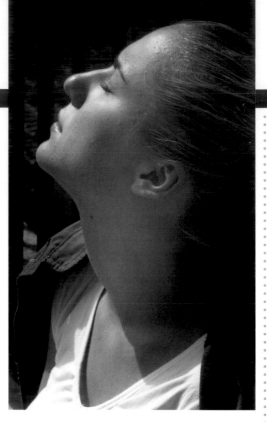

Dodge and burn by painting onto a new layer set to Soft Light.

Soft Light dodging and burning also works well with black-and-white pictures.

44

My favorite use of Soft Light is for dodging and burning an image (a similar method was used with Overlay, see pages 42–43). Of course, you can use the Dodge and Burn tools to achieve the same results, but the drawback with these tools is that they work directly on the image layer. With this Soft Light technique, you create a new layer, set its blend mode to Soft Light, and use the Brush tool to paint onto it. Normally, you would use black to darken the image, and white to lighten it. However, try experimenting with any color that looks right for the picture. The big advantages of this method are that you can save the file and adjust it another day, finely control the dodge-and-burn layer's effect by varying opacity or masking, and you can use the Layer Style dialog and the Blend If slider to apply the dodge-and-burn layer to specific tonal ranges.

DIY contrast control

Another great use of Soft Light is as a do-it-yourself contrast control, rather like Photoshop's Shadow/Highlights filter. It takes just a few simple steps to create:

1 Duplicate the image layer.

2 Switch the duplicate layer blending mode to Soft Light (Alt/Option-Shift-F).

3 Invert the duplicate layer (Ctrl/Cmd-I).

4 Desaturate the duplicate layer (Ctrl/Cmd-Shift-U).

5 Add Gaussian blur to the duplicate layer.

The inversion causes lighter image areas to darken and brings up the darker colors. Play with eliminating the desaturation step—while it prevents some ghastly color shifts, that may be exactly what you want. To restore contrast and apparent sharpness, add some Gaussian blur to the inverted layer.

Overlay can be used in the same way, but it produces a harsher result

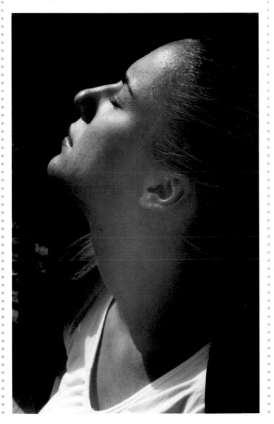

Shadows can be lifted in a high-contrast image by using an inverted, desaturated, and blurred Soft Light self-blend.

ivid Light and Linear Light are two very similar blending modes, which is why I've chosen to include them here together. They are both contrast-increasing modes, but Vivid Light combines the effects of Color Burn and Color Dodge, while Linear Light combines the effects of Linear Burn and Linear Dodge.

Original image.

Vivid Light

KEYBOARD SHORTCUT
Windows: Alt+Shift+V
Mac: Option+Shift+V

Vivid Light is a contrast-increasing blending mode that combines the effects of Color Burn and Color Dodge. If the blend color is darker than mid-gray, Vivid Light darkens or burns the image by increasing the contrast. Otherwise, the image is lightened or dodged by decreasing the contrast.

A Vivid Light self-blend produces high-contrast output and clips both shadows and highlights.

Self-blends

A simple Vivid Light self-blend isn't that useful—the result is a high-contrast image. But one curiosity of the contrast-increasing blending modes is that they can produce interesting halos when inverted and combined with some Gaussian blur. At the image edges, the blur bleeds one image area's tonal values into its neighbor, and the blending mode can then produce some strange tonal reversals.

With an inverted Vivid Light self-blend, a Gaussian blur radius of 4 produces an embossed effect, while a radius of 60 produces strange shadow tone reversals.

46

Linear Light

Linear Light is another strong contrast-increasing mode. Where Linear Light differs from Vivid Light is that Linear Light is a combination of Linear Burn and Linear Dodge, and adjusts brightness rather than contrast. If the blend layer color is darker than mid-gray, Linear Light darkens the image by decreasing its brightness. Blend colors lighter than mid-gray result in a brighter image due to increased brightness. Blending with mid-gray doesn't change the image.

KEYBOARD SHORTCUT
Windows: Alt+Shift+J
Mac: Option+Shift+J

Fact File

With an inverted Vivid Light self-blend, a Gaussian blur radius of 4 produces an embossed effect, while a radius of 60 produces strange shadow tone reversals.

Don't forget the histogram's expanded view. With these self-blends, Vivid Light's mean or average brightness value is 60.57—slightly brighter than the 59.30 produced by Linear Light.

Using Linear Light

There's not much to add to using Linear Light that hasn't already been mentioned for Vivid Light. Again, inverting the blend layer and adding some Gaussian blur can produce some interesting effects.

Linear Light produces a higher-contrast image than Hard Light or Overlay.

47

Pin Light

Although Pin Light, like Vivid Light and Linear Light, is a contrast-increasing blending mode, it behaves slightly differently. While you can use Pin Light for boosting contrast, because in effect Pin Light is a combination of the Darken and Lighten modes, it is more suited to creating special effects.

KEYBOARD SHORTCUT
Windows: Alt+Shift+Z
Mac: Option+Shift+Z

Using Pin Light

We can pass quickly over simple Pin Light self-blends, as applying them has no result. Even if you apply Gaussian blur, there's little or no effect on the picture. The fun begins when you start inverting the layer.

Only after inverting and blurring the Pin Light layer do you begin to get some appealing results.

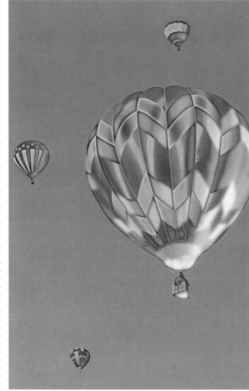

Use a Curves adjustment layer to make an inverted self-blend. This method results in a much smaller file size than creating an inverted copy of the original.

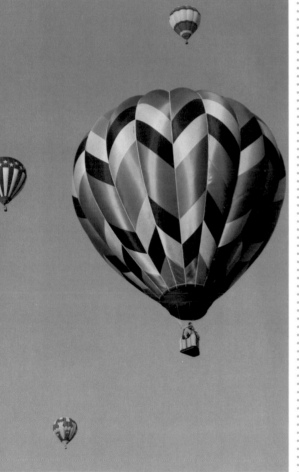

Original image.

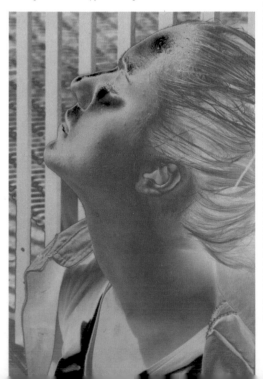

You could create a self-blend with an inverted copy, but remember you can make a self-blend using a Curves adjustment layer. Create the Curves adjustment layer, simply drag the curve's bottom end to the top left, and then drag the curve's top end down to the bottom right and click OK. The effect is the same as using an inverted image layer, but the resulting file takes up much less disk space. If you want, you can revisit the curve at any time and produce all sorts of tonal reversals.

Once you add a Curves layer, there's nothing to stop you experimenting with the curve.

Pin Light and Find Edges

Pin Light can be used to create a fun, colored, line-drawing effect. Other blending modes such as Multiply can darken the image, but of all the contrast-increasing modes, Pin Light will produce the most natural result.

1 Duplicate the image layer and apply **Filter > Stylize > Find Edges**.

2 Desaturate the Find Edges layer (Ctrl/Cmd-Shift-U).

3 Apply a Levels or Curves adjustment to fine-tune the line drawing's strength.

4 Duplicate the image layer again, and drag the Find Edges and Desaturated layer to the middle.

5 Switch the top layer's blending mode to Pin Light. Try inverting the blend layer and reducing the opacity until you're happy with the results.

A colored line-drawing effect can be achieved easily with a gently blurred Pin Light layer.

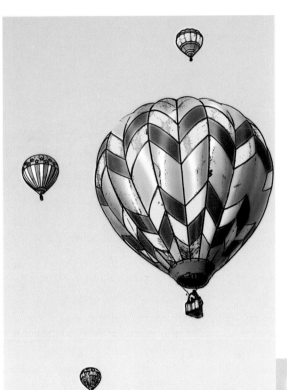

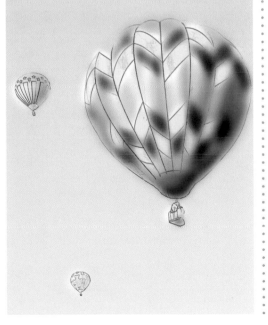

Push up the blur for a "tracing paper" effect.

Hard Mix

The Hard Mix blending mode, which first appeared in Photoshop CS, reduces an image to just eight pure colors. You can use this mode in a self-blend to posterize an image. To control the degree of posterization, try adjusting the fill opacity, or try applying some Gaussian blur and make it the base for radical image transformations. It also has a surprising use in sharpening—just combine it with some blur and reduce the fill opacity.

Self-blends

The Hard Mix blending mode works as expected when it's used in a self-blend with the opacity set at 100%. It produces an image with pure blocks of colors. In an image like these balloons, the posterization works well in the patterned fabric, but where there is a subtler change of tone, such as where the sky turns darker, the posterization appears coarse. Turning the fill opacity's percentage down a little can help in these situations.

As you reduce the fill opacity, the posterization effect becomes less apparent; the image still appears saturated, but graduated tones look more natural.

If you're ever near Albuquerque, New Mexico, look out for the annual balloon fiesta. I took this shot very early, before the sun had appeared over the hills.

KEYBOARD SHORTCUT
Windows: Alt+Shift+L
Mac: Option+Shift+L

Reducing the Hard Mix layer's fill opacity results in a more natural-looking appearance.

50

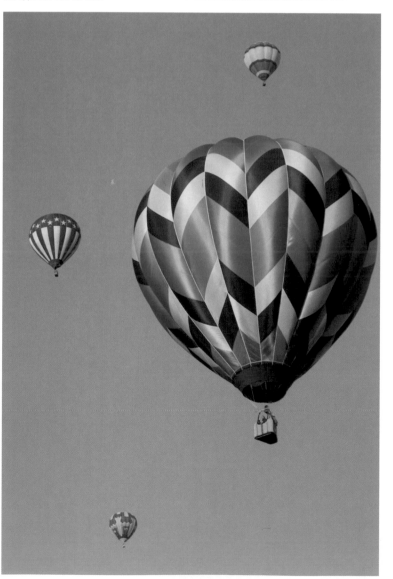

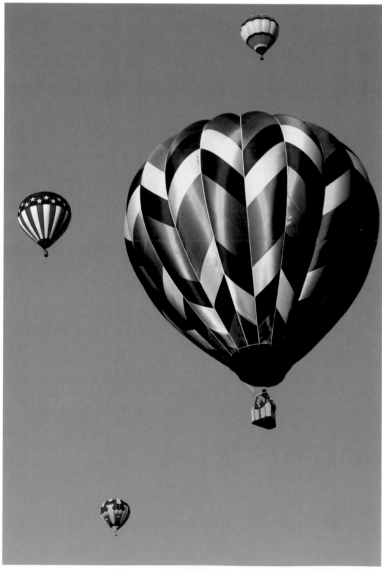

As you reduce the fill opacity percentage, an unexpected opportunity makes itself apparent. If you apply a little blur to the blend layer and make its blending mode Hard Mix, a surprisingly effective sharpening occurs. For the sharpening to work, you only need a small opacity value here, it is just 6%. Compare these two enlargements. In the first image I have simply self-blended, but in the second I have self-blended with a layer that has a Gaussian blur radius of just 3 pixels. There is already a noticeable sharpening effect.

With a Hard Mix self-blend applied, the image begins to degrade seriously where the sky begins to darken.

A self-blend with no blur.

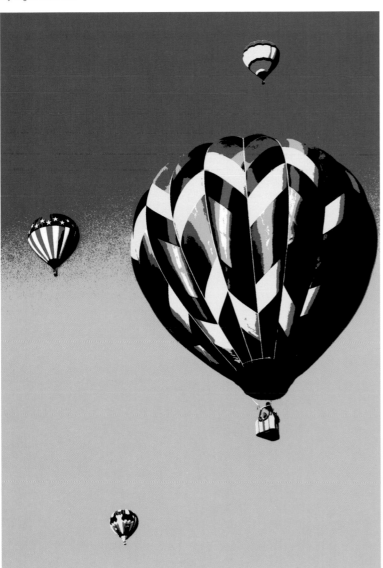

A self-blend with blur produces a sharper image.

Original image.

Difference

Difference is one of two comparative blending modes—the other being Exclusion. Both of these blending modes examine the difference between the base and blend color values. One of the easiest modes to understand, for each channel Difference outputs the difference between the blend and the base color. If the base and blend colors are identical, the difference is obviously 0 and the output color is black. Black is the neutral color, while blending with white inverts the image.

KEYBOARD SHORTCUT
Windows: Alt+Shift+E
Mac: Option+Shift+E

Using Difference

You already know that Difference produces black if you use it to blend a photograph with a copy of itself. But something interesting happens once you invert the blend layer. I find it easier to think of what happens to the original's tones when the image becomes a negative:

• The original's highlights become almost black in the blend layer, so they are darker but still show through.

• The original's shadows become bright, almost white in the blend layer, so they are inverted.

• Midtones are darkened because the difference between the positive and negative versions is small.

The original's highlights are darkened, shadows are lifted, and midtones become blacks.

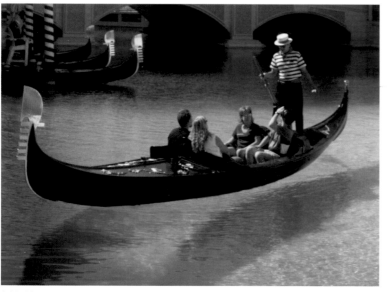

Original image.

When white is the blend color, the result is the same as inverting the image.

52

Instead of inverting the blend layer, try adding a little blur. This will work best on an image with plenty of detail. As the difference between the two layers grows around high-contrast edges, a line drawing begins to emerge from the black. With more blur, the line drawing becomes more like a halo and the image becomes brighter overall. It will still be rather gloomy, though, so it's often worth experimenting with inverting the blend layer or adding multiple inverted and blurred copies.

A little blur can reveal a line drawing from the black Difference self-blend.

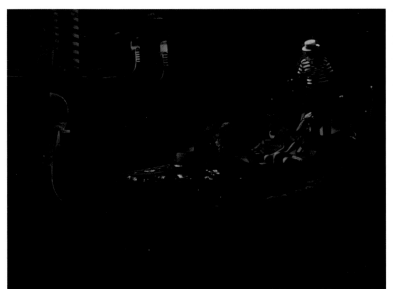

Sometimes I use Difference to quickly review the effect of editing a picture. With the original and edited versions as layers in the same image window, I hit Alt/Option-Shift-E and flick the top layer's blend mode to Difference. Now that the edits are visible, I can zoom in and hit Alt/Option-Shift-N to restore the Normal blend mode and compare the detailed edits by toggling the layer's visibility by clicking on the eye icon.

Another use for Difference is to help join two layers manually—such as when you need to make two scans of a photograph that's too large to fit on your flatbed scanner. Switch the top layer's blending mode to Difference and then start nudging it into place. When they align perfectly, there will be no difference between the two layers' pixels and the matched overlap will appear black.

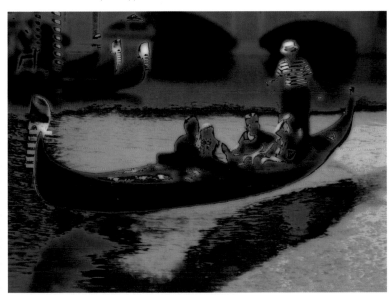

I'm not sure I like how this looks, but you can see the possibilities of stacking various combinations of Difference blend mode layers.

53

Exclusion

The second of the two Comparative blending modes is Exclusion. It is similar to Difference, but produces a lower-contrast result. Blending with white inverts the underlying image, while black is the neutral color and has no effect.

KEYBOARD SHORTCUT
Windows: Alt+Shift+X
Mac: Option+Shift+X

Using Exclusion

Apart from the fact that an Exclusion self-blend cannot produce black, much of what we know about using Difference also applies to Exclusion. Often one just toggles between these modes with keyboard shortcuts such as Alt/Option-Shift-plus or -minus. It's just a matter of how much contrast suits the picture.

An Exclusion self-blend doesn't produce black.

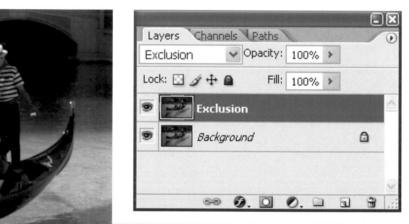

Original image.

Cycle through blending modes

I thought my hand must have slipped when I first discovered this: you can cycle through a layer's blending modes by selecting the Move tool and then using Shift + and Shift - .

54

Photoshop often provides more than one way to achieve the same result. We can add a halo to an image using a little blur, but another technique is to nudge either the base or blend layer so that it is offset. The result is similar, but more reminiscent of a rim around high-contrast edges than the soft halo produced by using blur. It makes no difference whether you move the base or the blend, and you might want to try varying the opacity too.

Exclusion's result is softer than Difference's output, especially in the midtones, which no longer go black.

Try nudging either the base or the blend layer. Here, I exaggerated the movement, but just a few pixels' movement produces rims around the subject.

Hue, Saturation, and Luminance (HSL)

Hue, along with Saturation, Color, and Luminosity, belongs to a group of blend modes that some call the Hue, Saturation, and Luminance group (or HSL). Others call the group Neutral, because none of these modes has a neutral color. My preference is the former, HSL, because it refers to the color space they all use to generate the output color.

KEYBOARD SHORTCUT
Windows: Alt+Shift+U
Mac: Option+Shift+U

The Hue blending mode colorizes an image with the blend color's hue, but leaves the base color's luminance and saturation unchanged. Loosely speaking, the underlying image shows through unchanged, but tinted with the color of the blend layer.

Using Hue

While it is useful enough, the Hue blending mode isn't the most exciting ingredient, certainly not after you've spiced up an image with Hard Mix. Self-blending has no effect—after all, hue, luminance, and saturation are identical in both layers.

Blurring the blend layer can produce interesting results where there is a dominant color, such as the blue of the sky. By pushing the Gaussian blur radius up to the maximum, the image is colorized with this blue. At lower levels of blur, color fringing occurs which may be useful, but reminds me of the chromatic aberration of some lenses.

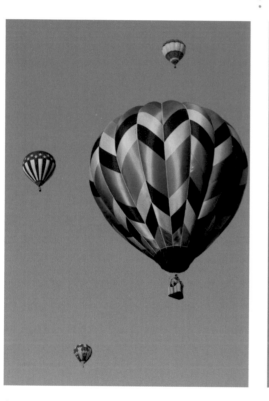

Original image.

Hue simply colorizes an image with the blend color.

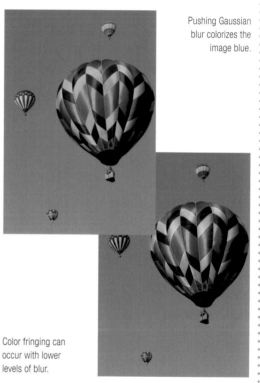

Pushing Gaussian blur colorizes the image blue.

Color fringing can occur with lower levels of blur.

Use the Color Picker to select your desired blend color.

56

Saturation

Saturation is another of the Hue, Saturation, and Luminance (HSL) modes, and applies the blend color's saturation to the underlying image, leaving the base color's luminance and hue unchanged. So again, loosely speaking, the underlying image's colors show through, but appear to be as saturated as the blend layer's colors.

Using Saturation

Like Hue, the Saturation blending mode is handy, but not exciting. A self-blend has no effect, and neither does inverting the blend layer. Apart from saturating an image, maybe its most interesting effects come from blurring the blend layer. Blurring is most obvious where there are high-contrast edges, not evenly toned areas, and is bound to reduce the saturation. So, blurring a Saturation blend layer results in desaturation around the image details.

Blurring a Saturation blend layer results in desaturation around the details.

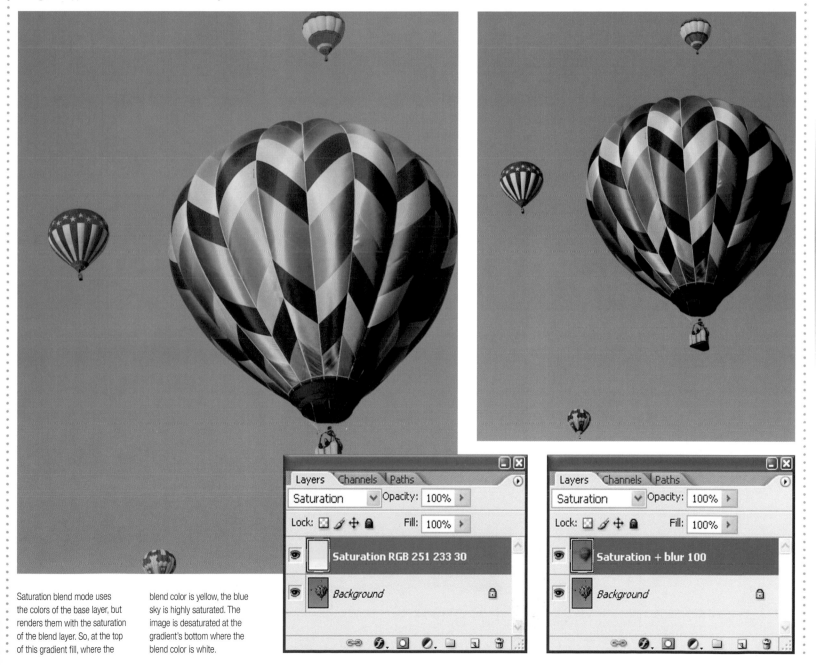

57

Saturation blend mode uses the colors of the base layer, but renders them with the saturation of the blend layer. So, at the top of this gradient fill, where the blend color is yellow, the blue sky is highly saturated. The image is desaturated at the gradient's bottom where the blend color is white.

Color

The Color blending mode is another variation of the Hue, Saturation, and Luminance group, and may be a little easier to understand intuitively than either Hue or Saturation. Color generates the output color by combining the base color's luminance and the blend color's hue and saturation. Its effect is stronger than Hue, and rather than tinting the image, Color colors it with the blend color. As with the other HSL modes, it has no neutral color.

Original image.

KEYBOARD SHORTCUT
Windows: Alt+Shift+C
Mac: Option+Shift+C

The Color blending mode really colors the underlying image, unlike Hue, which just tints the image.

Using Color

A popular use of the Color blend mode is to hand-color a photograph, often a black-and-white one. As usual, Photoshop provides more than one approach. If you're good at painting, you might select a brush, set its blend mode to Color, and then paint directly onto the image. That's fine, providing you never want to adjust your work afterward. I can't draw or paint and am always changing my mind later or using an image for another purpose, so I prefer to add a new Color blend layer for each color I use. Maybe weeks later I can reopen the image, Ctrl/Cmd click any layer, and fill its pixels with a different color, change its opacity, or fine-tune my work in a way I never imagined when I first worked on the image.

Another use of the Color blend mode is controlling the effect of adjustment layers. For instance, a Curves adjustment layer can tune a photograph's colors, but you may not care for the resulting image contrast. Switch the blending mode to Color and the base layer's luminosity is restored. For now, I'll only mention the idea. We'll look into it again in the section on Luminosity (see page 60–61), as my experience is that it's more likely you'll want to do the opposite—fix contrast without color shifts. The same principle applies.

In montage work, the component pictures may have been shot under different lighting conditions. A common color cast can help hide their disparate origins. To achieve this, use **Layer > New Fill Layer > Solid Color** and before clicking OK, set the mode to Color. Next, choose a subtle unifying tone. This technique works especially well when you want to add a natural color to monochromatic images. The silhouette of the man was shot in southern Italy, but the color came from a trip to southern Africa and so long ago that I can't recall if it was shot at sunrise or sunset. It only took a few minutes to crop the scanned slide, drag it onto the coastline, and set its blend mode to Color.

A scanned transparency of a sunset taken at Victoria Falls was dragged onto the Italian coastline image. I then switched its blending mode to Color and added a mask so that the silhouette's shadow tones remained grayscale.

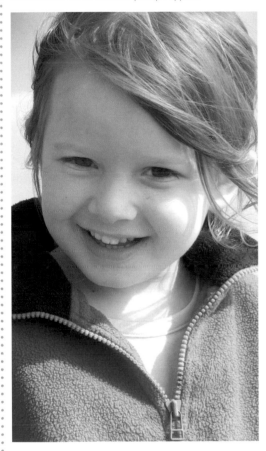

Hand-coloring is easy to adjust if you paint onto Color blend mode layers.

Luminosity

Luminosity is the last of the HSL blending modes. It takes the base color and outputs it with the luminosity from the blend color. You may notice that this is the opposite of the Color blend mode. So, while the Color mode saturates a picture's colors, Luminosity only alters the brightness values. While this has no use for self-blending, it can be really helpful to the photographer for controlling the effect of adjustment layers. When an adjustment produces unwanted color shifts, these shifts can be eliminated quickly by switching the layer's blend mode to Luminosity and then fine-tuning with the opacity percentage.

KEYBOARD SHORTCUT
Windows: Alt+Shift+Y
Mac: Option+Shift+Y

Self-blends and changing the opacity

Self-blending with the Luminosity blend mode has no effect. We would expect this because the base and the blend have identical luminosity. Consequently, varying the opacity also has no effect.

A self-blend with Luminosity has no effect.

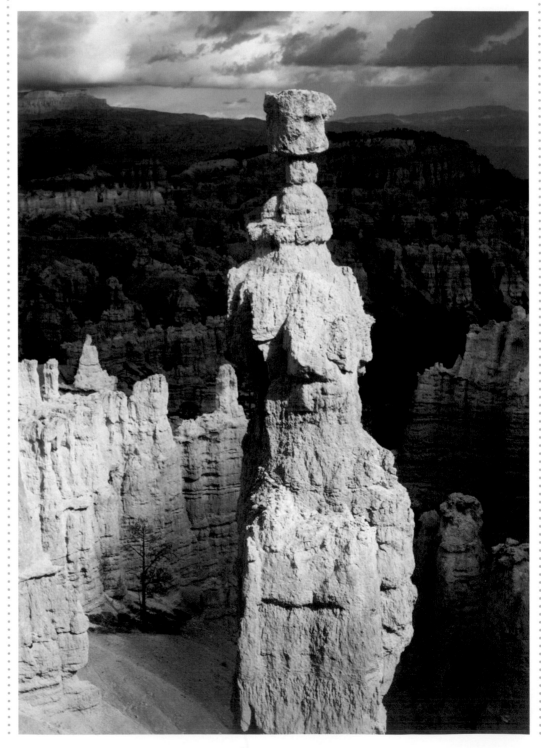

Adjustment layers

While self-blending isn't relevant, the Luminosity blend mode really comes into its own when adjusting the contrast of a color photograph. One of the best uses of the Luminosity mode is to ensure that adjustment layers don't shift the color balance.

Often a color image needs a little more contrast to add some punch, so to fix this you might add a Curves adjustment layer. An adjustment layer's blending mode defaults to Normal, and, while a gentle S curve may improve the picture's contrast, it can easily also change the image's colors. When you have just fine-tuned the image's color temperature and it matches other images, this is an unwelcome surprise.

To fix this, instead of using the Normal blending mode with the Curves adjustment layer, switch the blend mode to Luminosity. Try this whenever you see unwelcome colors appearing—it's quick and lets you use stronger adjustment layer effects without changing the color balance.

The initial image is too soft.

Although the Curves adjustment layer has improved the contrast, it has also added a red cast to the canyon, to the left of the hoodoo.

Changing the adjustment layer's blend mode to Luminosity has corrected this color shift.

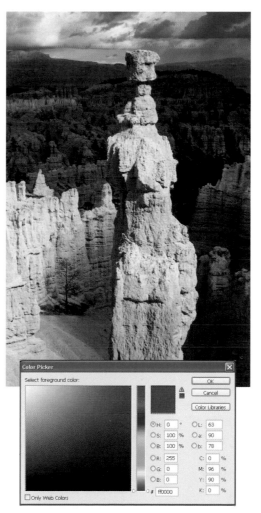

61

RECIPES

Quiet Cooling

Here's a quick technique for cooling down skin tones and softening them at the same time. The technique lightens faces by making a layer from the image's Red channel and setting its blending mode to Luminosity. If you want to harden skin tones, try using the Blue channel instead. While I would use this technique mainly for portraits, it can also work with other types of images.

1 Open the image and activate the Channels palette by selecting **Windows > Channels**. You'll see thumbnails of the composite RGB image, as well as thumbnails of the individual Red, Green, and Blue channels.

2 Ctrl/Cmd-Click the Red channel—this channel contains most of the skin's color values.

3 Go to **Select > Save Selection**. In the Save Selection dialog box, ensure that the New Channel radio button is checked and click OK. You will now see a new Alpha channel appear in the Channels palette. It should be called Alpha 1.

4 Select the new Alpha 1 channel either by clicking on the channel or using the shortcut Ctrl/Cmd-4 (or whatever number is shown next to the Alpha channel).

5 Select the entire channel (**Select > All** or Ctrl/Cmd-A) and copy it (**Edit > Copy** or Ctrl/Cmd-C).

6 Activate the RGB image by either clicking on the composite RGB thumbnail in the Channels palette or by using Ctrl/Cmd.

7 Paste the clipboard contents using **Edit > Paste** (Ctrl/Cmd-V).

8 Open the Layers palette; you should now see a grayscale layer. This is the Red channel. Switch this layer's blending mode to Luminosity using the pull-down blending mode menu (or Alt/Opt-Shift-Y) and rename this layer "Luminosity."

9 Select the image's luminosity using Ctrl/Cmd-Alt/Opt-Shift-~.

10 With the Luminosity layer active, click the "Add layer mask" icon at the bottom of the Layers palette.

11 At this point the image's red highlights may be too bright. If so, reduce the Luminosity layer's opacity to balance the image.

12 Blur the Luminosity layer if needed. Use **Filter > Blur > Gaussian Blur** and set a small radius (unless you want a really soft effect).

Softening features

The recipe toned down the warm evening light on the skin tones of this girl's face. No blur was needed to soften the girl's face.

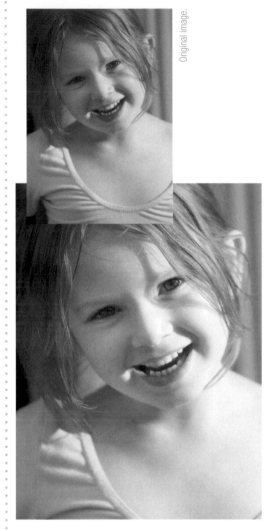

Original image.

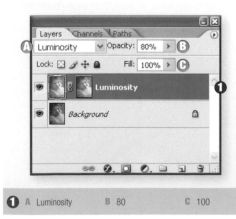

1 A Luminosity B 80 C 100

Reducing redness

This fisherman's face was too red. The recipe was used without any blurring.

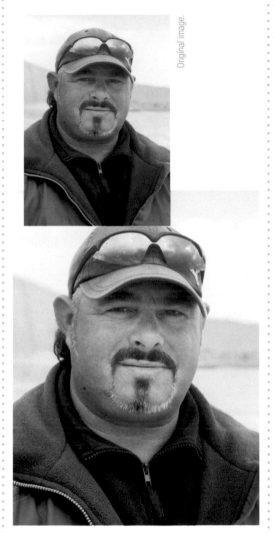

Original image.

1 A Luminosity B 75 C 100

64

Improving skin tones

The sun was directly in this woman's face. Using the Luminosity layer improved the skin tones, while the layer mask preserved the blacks.

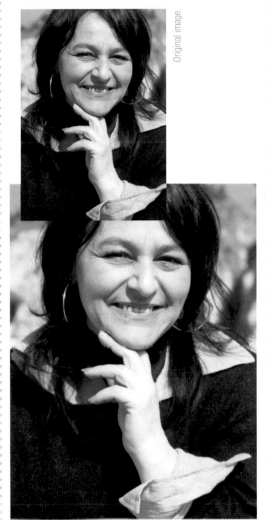

Original image.

A Luminosity	B 30	C 100

Adding a glow

Gaussian Blur was used with a radius of 2 to soften further the tones in this woman's face.

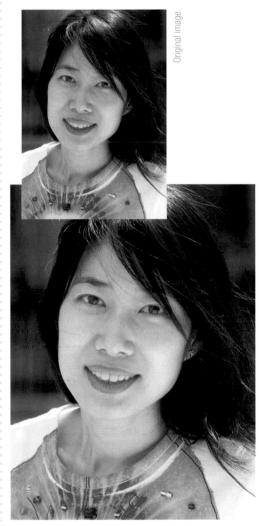

Original image.

A Luminosity	B 63	C 100

Emphasizing the moment

The Luminosity layer made this man's skin tone less red, and a slight blur was added to emphasize his pensive look.

Original image.

A Luminosity	B 70	C 100

Pure Bleach

Here's a recipe for a great bleaching effect that works well with almost any image. A pair of inverted Exclusion layers removes the shadows and midtones, while a blurred Color or Linear Dodge layer softens the effect. However, because the bleaching effect can make some details indistinct, I added a further layer to which I applied the Find Edges filter to bring back some definition.

1 In the Layers palette, duplicate the original image layer by dragging the background layer onto the "Create a new layer" icon, or use Ctrl/Cmd-J.

2 Using the blending mode pull-down menu in the Layers palette, change the duplicate layer's blending mode to Exclusion (or use the shortcut Alt/Opt-Shift-X) and rename it "Exclusion."

3 Invert the Exclusion layer using Ctrl/Cmd-I.

4 Use Ctrl/Cmd-J to make two duplicates of the Exclusion layer.

5 Using the blending mode pull-down menu in the Layers palette, change the top Exclusion layer's blending mode to Linear Dodge (or use the shortcut Alt/Opt-Shift-W) and rename it "Linear Dodge." (For a slightly different result, try Color Dodge.)

6 Invert the Linear Dodge layer using Ctrl/Cmd-I. The composite picture should now be positive.

7 Blur the Linear Dodge layer using **Filter > Blur > Gaussian Blur**. You don't need too high a radius—for a 300dpi image, 20 is about right.

Original image.

Heavy bleaching

The recipe produces a dreamy version of the image where only the shadows remain.

Light bleaching I

Color Dodge is a good alternative choice for the top layer's blending mode in this recipe, and results in the image being less bleached.

Original image.

❶	A	Linear Dodge	B	100	C	100
❷	A	Exclusion	B	100	C	100
❸	A	Exclusion	B	100	C	100

❶	A	Color Dodge	B	100	C	100
❷	A	Exclusion	B	100	C	100
❸	A	Exclusion	B	100	C	100

Light bleaching II

Again, using Color Dodge rather than Linear Dodge results in a slightly more saturated image.

Original image.

❶	**A** Color Dodge	**B** 100	**C** 100
❷	**A** Exclusion	**B** 100	**C** 100
❸	**A** Exclusion	**B** 100	**C** 100

Bleaching with added detail

In this example, the recipe bleached the image so much that the word "Peace" was barely visible. To remedy this, I added a layer transformed with the Find Edges filter.

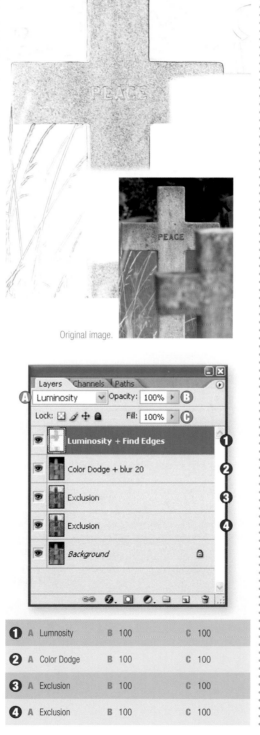

Original image.

❶	**A** Lumnosity	**B** 100	**C** 100
❷	**A** Color Dodge	**B** 100	**C** 100
❸	**A** Exclusion	**B** 100	**C** 100
❹	**A** Exclusion	**B** 100	**C** 100

Full-color bleaching

Here, the Find Edges filter was more useful to make a colored line drawing.

Original image.

67

❶	**A** Multiply	**B** 100	**C** 100
❷	**A** Linear Dodge	**B** 100	**C** 100
❸	**A** Exclusion	**B** 100	**C** 100
❹	**A** Exclusion	**B** 100	**C** 100

High-Contrast Sketch

Combining the Find Edges filter and the Overlay blending mode can produce a high-contrast sketch effect that works with many types of images. This recipe includes multiple Overlay layers, which boost contrast, so the recipe works particularly well with low-contrast images. In the recipe, I use three Overlay layers—you can use more or fewer, though more than three can produce excessive contrast. Another variation, if the result is too harsh, is to add some Gaussian Blur.

1 In the Layers palette, duplicate the original image layer by dragging the background layer onto the "Create a new layer" icon, or use Ctrl/Cmd-J.

2 Using the pull-down blending mode menu in the Layers palette, change the duplicate layer's blending mode to Overlay (or alternatively use the shortcut Alt/Opt-Shift-O) and rename it "Overlay 1."

3 Reduce the Overlay 1 layer's opacity to 60%.

4 Apply **Filter > Stylize > Find Edges** to the Overlay 1 layer.

5 Use Ctrl/Cmd-J to duplicate the Overlay 1 layer. Name the new layer "Overlay 2."

6 Use Ctrl/Cmd-F to apply **Filter > Stylize > Find Edges** to the Overlay 2 layer.

7 Repeat steps 5 and 6. An easy way to do this is to use Ctrl/Cmd-J followed by Ctrl/Cmd-F.

Direct contrast

This recipe always adds contrast to the image, which this early morning shot needed.

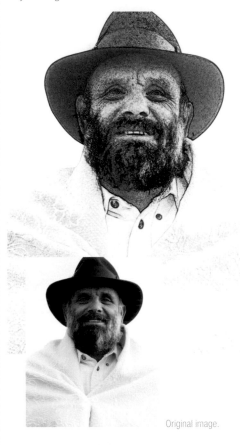

Original image.

Detailed contrast

Pictures with plenty of detail are naturally suited to the Find Edges filter.

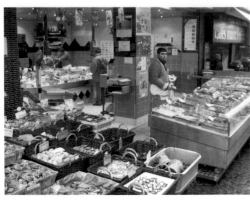

Original image.

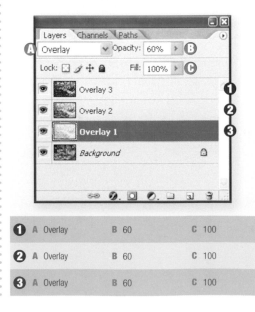

	A		B		C
①	A Overlay		B 60		C 100
②	A Overlay		B 60		C 100
③	A Overlay		B 60		C 100

	A		B		C
①	A Overlay		B 60		C 100
②	A Overlay		B 60		C 100
③	A Overlay		B 60		C 100

Soft contrast

Some subjects deserve a gentler treatment, so here I applied Gaussian Blur to the middle Overlay layer.

Original image.

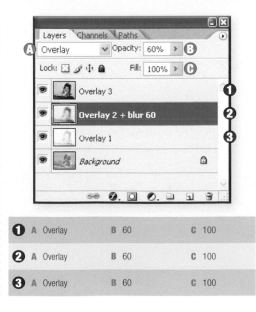

Stark contrast

This shot, taken in crisp, winter light, was already high-contrast, so I applied Gaussian Blur to the middle Overlay layer.

Original image.

Brassed off

As an alternative, I applied the Emboss filter on the top layer. This produced a more textured finish.

Original image.

69

Soft contrast — Layers panel

	A	B	C
❶	Overlay	60	100
❷	Overlay	60	100
❸	Overlay	60	100

Layers: Overlay 3 (❶), Overlay 2 + blur 60 (❷), Overlay 1 (❸), Background

Stark contrast — Layers panel

	A	B	C
❶	Overlay	60	100
❷	Overlay	60	100
❸	Overlay	60	100

Layers: Overlay 3 (❶), Overlay 2 + blur 60 (❷), Overlay 1 (❸), Background

Brassed off — Layers panel

	A	B	C
❶	Overlay	60	100
❷	Overlay	60	100
❸	Overlay	60	100

Layers: Overlay 3 + Emboss 135/20/125 (❶), Overlay 2 (❷), Overlay 1 (❸), Background

Repairing Highlights

If an image contains obtrusive hot spots or blown highlights, you can quickly restore detail or make the highlights less obvious by applying the Multiply blending mode to a copy of the image layer. This mode multiplies the brightness values and darkens the entire image. The trick is to find ways of quickly restricting its effect to just the areas you want to repair. Here is one way to do it, by painting on a mask, but look closely at the other examples on this page where the Color Range dialog and Photoshop's Blend If feature are used.

1 In the Layers palette, duplicate the original image layer by dragging the background layer onto the "Create a new layer" icon, or use Ctrl/Cmd-J.

2 Use the pull-down blending mode menu in the Layers palette to change the duplicate layer's blending mode to Multiply (or use the shortcut Alt/Opt-Shift-M) and rename it "Multiply."

3 In the Layers palette, hold down the Alt/Opt key and click the "Add layer mask" icon at the bottom of the Layers palette. This adds a black mask to the Multiply layer.

4 Check that the mask icon to the left of the thumbnail is showing and that the mask is active. Also ensure that the foreground color is white and the background is black.

5 Select the Brush tool (B), make sure its edges are soft, and then paint over the image's hot spots.

6 If painting with white makes too much of the blend image appear, don't just Undo—use **Edit > Fade** Brush tool or reduce the Multiply layer's opacity.

Hot spot

This was a Raw image file and the best overall conversion left a hot spot on the man's forehead. So I made a second, darker raw conversion and held down Shift as I dragged it on top of the first version to ensure that the two images aligned. I then added a black mask and painted with white.

Original image.

Color matching

In this example, I used the Color Picker to set the foreground color to the brightest areas on the top of the wall. When I then chose **Select > Color Range**, the dialog automatically selected the pixels matching the foreground color. I then clicked OK, and added a mask to the Multiply layer. This mask was automatically limited to my selection.

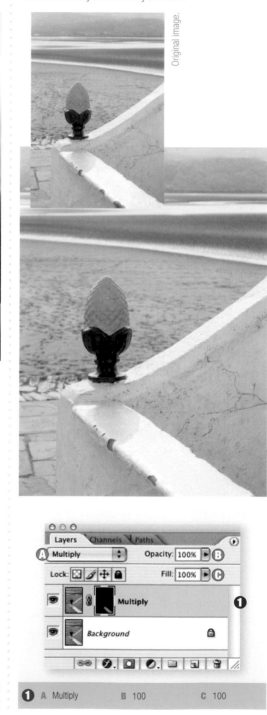

Original image.

1 A Multiply B 100 C 100

1 A Multiply B 100 C 100

Selective fine-tuning

Here, I used the Gradient tool (G) to paint the top layer's mask, so that the hut and beach were unaffected by the Multiply blend mode. I then fine-tuned the effect with the Brush (B) and a second Multiply layer.

Original image.

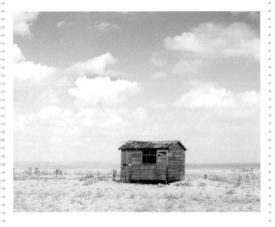

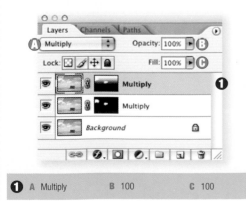

Fine highlights

With an image containing lots of fine highlights, the Color Picker was easily the fastest way to mask the Multiply layer.

Original image.

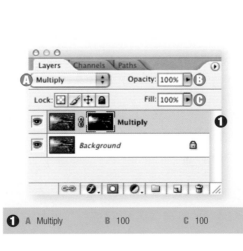

Exclusion zone

Instead of masking, here I used Blend If to exclude the darker red paint from the Multiply blend.

Notice that I also used a Curves adjustment layer along with the Multiply layer, but didn't change the curve. This has the same effect as a self-blend, but saves on disk space.

Used immediately after painting, the **Edit > Fade** Brush tool can partially reverse the effect of painting—you can even experiment with its blending mode.

Ice Cold

I've called this recipe Ice Cold after the effect it has on the picture of the architecture, right. The effect works especially well when the picture has lots of blues and greens. The first ingredient is a blurred, inverted Luminosity layer that inverts the highlights and shadows, but tends to leave midtones unaffected. A Hard Mix layer at 10–50% fill opacity restores the image's shape and a Screen layer chills the final result. Experiment with inverting or desaturating any or all of the layers, and applying varying amounts of Gaussian Blur.

1 In the Layers palette, duplicate the original image by dragging the background layer onto the "Create a new layer" icon. Alternatively, just use the keyboard shortcut Ctrl/Cmd-J. Name this layer "Luminosity."

2 With the Luminosity layer active, select Luminosity from the blending mode pull-down menu.

3 Invert the Luminosity layer by selecting Image > Adjustments > Invert (Ctrl/Cmd-I).

4 Apply a Gaussian Blur radius value of between 3 and 4 to the Luminosity layer.

5 Return to the original image, make another copy (Ctrl/Cmd-J), and call it "Hard Mix."

6 With the Hard Mix layer active, select Hard Mix from the blending mode pull-down menu.

7 Drag the Hard Mix layer to the top of the Layers palette and set the fill opacity to around 40%.

8 Return to the original image, make another copy (Ctrl/Cmd-J), and call it "Screen."

9 With the Screen layer active, select Screen from the blending mode pull-down menu, then drag the Screen layer to the top of the Layers palette.

Blue steel

This Tokyo building's windows were a mid- to dark blue and become a powdery light blue when inverted in the Luminosity layer. While this layer controls the overall color, it's the Hard Mix layer that has the most potential for fine-tuning the final result. When you set its fll opacity to above 50%, this powerful blending mode dominates the image, but below 50%, the Hard Mix layer is much more subtle, and applies a gentle sharpening effect.

Midtones are softened, while highlights and shadows are reversed.

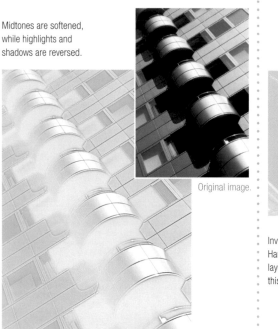

Original image.

Frosty gold

If the image doesn't contain many shadows or highlights, the resulting picture looks more natural and you don't get the obvious reversal that I achieved with the picture of the building. The inverted, blurred Luminosity layer softens and lightens the midtones. Again, Hard Mix restores some definition. For an alternative, try inverting the Hard Mix layer—this will often bleach the image.

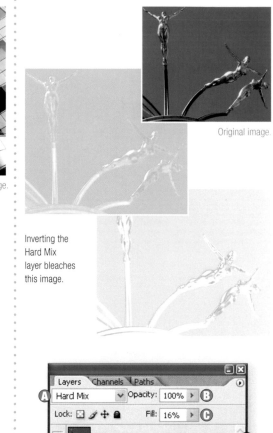

Original image.

Inverting the Hard Mix layer bleaches this image.

	A		B		C	
1	A	Screen	B	100	C	100
2	A	Hard Mix	B	100	C	41
3	A	Luminosity + blur 3.5+inverted	B	100	C	100

	A		B		C	
1	A	Screen	B	100	C	100
2	A	Hard Mix	B	100	C	16
3	A	Luminosity + blur 3.5+inverted	B	100	C	100

Adding a cold halo

Something else to try is varying the amount of Gaussian Blur on the Luminosity layer. Initially, I was happy with a blur amount of just 3.5, which made this replica of the Statue of Liberty appear slightly embossed. One idea led to another—sliding the blur up to 30 resulted in an effect like a drop shadow or penumbra. What's especially nice is that the Luminosity blend mode doesn't cause any color shift in the shadow area.

Original image.

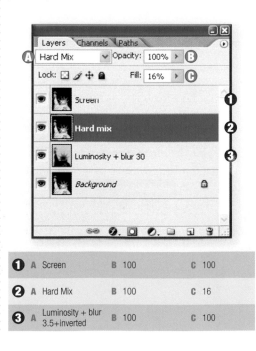

Applying large Gaussian Blur values to a reversed layer can produce a penumbra.

Subtle posterization

Ice Cold seems best suited to blues and greens, and this is another good example. This picture is pretty low-contrast and the inverted Luminosity layer reverses the islands' brownish shadows and turns them a pale pink. Coupled with the other soft tones, a more posterized outcome is the result.

Original image.

Experiment with desaturating the blending layers.

Cool portraits

I'm less happy with Ice Cold's effects on pictures of people, but it's always worth trying out an effect. This little girl's dark eyes and pale skin are reversed in tone, and while you can easily accept such inversion in other images, it's hard to see what it does for the subject. In addition to adding a penumbra in sharply defined pictures, greatly increasing the amount of Gaussian Blur can restore some realism to this picture.

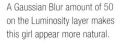
Original image.

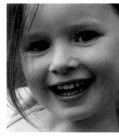

A Gaussian Blur amount of 50 on the Luminosity layer makes this girl appear more natural.

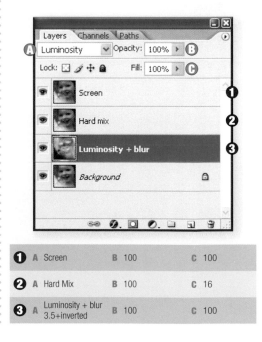

Ice Cold produces unnatural results with people.

Column 1 Layers panel

A: Hard Mix Opacity: 100% B Lock: Fill: 16% C

1 Screen
2 Hard mix
3 Luminosity + blur 30
Background

	A		B		C
1	Screen		100		100
2	Hard Mix		100		16
3	Luminosity + blur 3.5+inverted		100		100

Column 2 Layers panel

A: Screen Opacity: 100% B Lock: Fill: 100% C

1 Screen
2 Hard mix
3 Luminosity + blur 3.5
Background

	A		B		C
1	Screen		100		100
2	Hard Mix		100		16
3	Luminosity + blur 3.5+inverted		100		100

Column 3 Layers panel

A: Luminosity Opacity: 100% B Lock: Fill: 100% C

1 Screen
2 Hard mix
3 Luminosity + blur
Background

	A		B		C
1	Screen		100		100
2	Hard Mix		100		16
3	Luminosity + blur 3.5+inverted		100		100

Pin Light Bleach

Here's a simple recipe for producing a bleached, high-contrast image on a colored background. Highlights are progressively blown out by the Blend If slider, but a softer and more colorful result is achieved using Pin Light or another of the contrast group of blending modes.

1 In the Layers palette, create a new layer by clicking the "Create a new layer" icon, or use Ctrl/Cmd-J.

2 Fill the new layer with a color by selecting **Edit > Fill** and choosing Color in the Fill dialog box—white is a good starting point.

3 In the Layers palette, use Ctrl/Cmd-J to copy the original image. Drag the new layer to the top of the layer.

4 Using the pull-down blending menu in the Layers palette (or the shortcut Alt/Opt-Shift-Z), set the new layer's blending mode to Pin Light and name it "Pin Light."

5 Double-click the Pin Light layer's thumbnail image, and in the Layer Styles dialog box, drag the white triangle on the Blend If (This Layer) slider. The image's highlights will start to disappear.

6 Hold down the Alt/Opt key and drag the left half of the white triangle away from the right. Then adjust both halves to control the smoothness of the transition of the highlights.

High-key I

This recipe always produces a high-key result. The 126/210 on the Pin Light layer records the positions of the two white Blend If sliders.

Original image.

High-key II

For this high-key recipe I filled the middle layer with a beige pattern.

Original image.

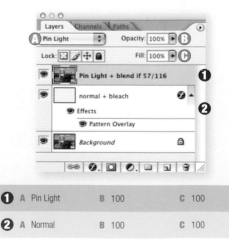

Black reduction

The blacks were so strong in this picture that I used the black Blend If triangle to remove shadows from the Pin Light layer.

Original image.

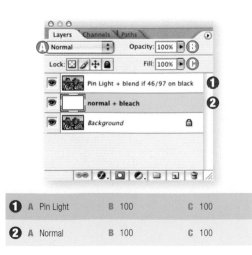

Spectral color

I added a light blue gradient to the middle layer to complement the yellows in the Pin Light layer.

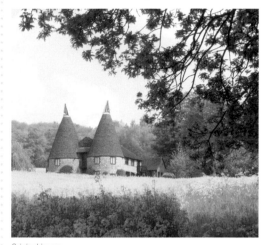

Original image.

Pin Light plus Difference

A few variations change this image completely—switching the Pin Light layer's blending mode to Difference, inverting it, and making the middle layer semitransparent.

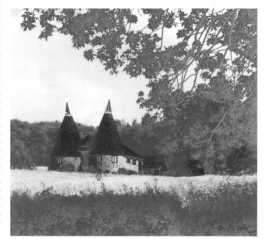

Original image.

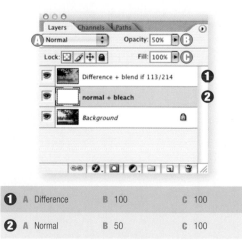

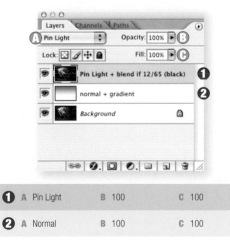

❶	A Pin Light	B 100	C 100
❷	A Normal	B 100	C 100

❶	A Pin Light	B 100	C 100
❷	A Normal	B 100	C 100

❶	A Difference	B 100	C 100
❷	A Normal	B 50	C 100

Layers panel (Black reduction):
Normal — Opacity: 100% — Fill: 100%
❶ Pin Light + blend if 46/97 on black
❷ normal + bleach
Background

Layers panel (Spectral color):
Pin Light — Opacity: 100% — Fill: 100%
❶ Pin Light + blend if 12/65 (black)
❷ normal + gradient
Background

Layers panel (Pin Light plus Difference):
Normal — Opacity: 50% — Fill: 100%
❶ Difference + blend if 113/214
❷ normal + bleach
Background

Hard Mix Magic

Of all the blending modes, my favorites for radically transforming images are Hard Mix and Dissolve. Hard Mix reduces a picture to just eight colors, while Dissolve produces a speckling effect as you reduce the layer's opacity. This recipe is a gentle mix of these two fascinating modes.

When you set the Hue/Saturation adjustment layer to Dissolve, the resulting image isn't really a blend, but a mix of pixels randomly selected from either the adjusted or the underlying image.

Hard Mix is such a brutal "all or nothing" blending mode that it can easily posterize areas with little detail. With the Hard Mix layer's fill opacity set at 100%, the sky became separated into two tones. You can address this by reducing the layer's fill opacity.

Original image.

Above Hard Mix reduces the picture to just eight colors.

Above right Reduce the layer's main opacity, not the fill opacity, to about 50%.

Original image.

1 In the Layers palette, duplicate the original image layer by dragging the background layer onto the "Create a new layer" icon, or use Ctrl/Cmd-J.

2 Using the pull-down blending mode menu, change the new layer's blending mode to Hard Mix (alternatively, use Alt/Opt-Shift-L). Rename the new layer "Hard Mix." At this point the image should be very high-contrast and contain just eight colors.

3 Reduce the Hard Mix layer's opacity to 50%.

4 Go to the Layers palette, and create a new Hue/Saturation adjustment layer. Check the Colorize box and adjust the Hue and Saturation sliders until you like what you see.

5 Again, in the Layers palette, set the adjustment layer's blending mode to Dissolve (Alt/Opt-Shift-I). Initially, you shouldn't see any change.

6 Reduce the Dissolve adjustment layer's opacity to about 50%; this produces Dissolve's typical grainy effect. The resulting picture contains pixels randomly selected from the underlying image and from the image after the application of the Hue/Saturation layer.

7 If, in some cases, you find the effect looks a little harsh, you can add some blur to the Hard Mix layer. 10 or 20% should do the trick.

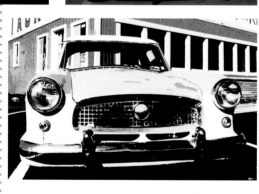

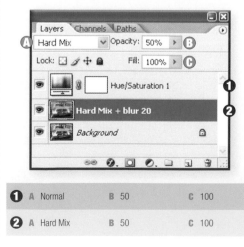

Because the big wheel's spokes and fine details are obscured by blurring the Hard Mix layer, the blur step was skipped for this image.

❶	A	Normal	B	50	C	100
❷	A	Hard Mix	B	50	C	100

❶	A	Normal	B	50	C	100
❷	A	Hard Mix	B	50	C	70

Detailed images

These soldiers were photographed on a wet, October day in southern England. This recipe works best where the picture contains a lot of detail.

Original image.

Saturated color

Using an adjustment layer, and not changing its settings, has the same effect as a self-blend and lets you make Hue/Saturation adjustments, too. Here, I matched this midday scene to the car shot, far left.

Original image.

Still life

This recipe also works well with still-life shots.

Original image.

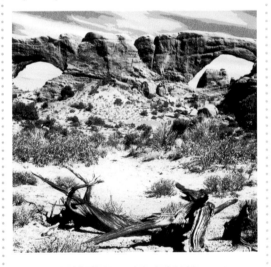

77

	A	B	C
❶	A Normal	B 50	C 100
❷	A Hard Mix	B 50	C 100

	A	B	C
❶	A Normal	B 50	C 100
❷	A Hard Mix	B 50	C 100

	A	B	C
❶	A Normal	B 50	C 100
❷	A Hard Mix	B 50	C 100

Fire and Ice

This recipe darkens and adds contrast to any image—not surprising, since its main ingredient is a pair of inverted layers that use the Hard Light and Hard Mix blending modes. The technique is best suited to low-contrast pictures that don't require a natural-looking result.

1 In the Layers palette, duplicate the original image layer by dragging the background layer onto the "Create a new layer" icon, or use Ctrl/Cmd-J.

2 Using the pull-down blending mode menu in the Layers palette, change the new layer's blending mode to Hard Light (alternatively, use the shortcut Alt/Opt-Shift-H) and name it "Hard Light."

3 Invert the Hard Light layer using Ctrl/Cmd-I.

4 Use Ctrl/Cmd-J to make a duplicate of the Hard Light layer. Set the new layer's blending mode to Hard Mix either via the pull-down menu or using the shortcut Alt/Opt-Shift-L. Name the layer "Hard Mix."

5 Reduce the Hard Mix fill opacity to 50%.

6 Make a duplicate of the Hard Mix layer using Ctrl/Cmd-J and set the new layer's blending mode to Color Burn (Alt/Opt-Shift-B). Name the new layer "Color Burn."

7 Invert the Color Burn layer using Ctrl/Cmd-I.

8 Set the Color Burn's opacity to a value of between 50% and 100%.

9 Blur the Hard Light layer with **Filter > Blur > Gaussian Blur**. A radius of between 5 and 20 is enough.

78

Towering inferno

The original was shot at midday in Tokyo and the light had a strong blue color cast. The two inverted layers make the picture fiercely hot.

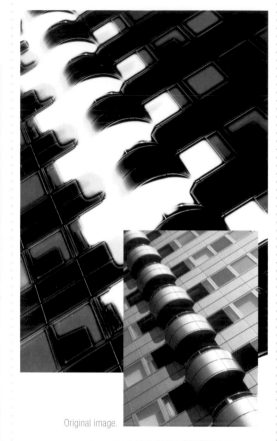

Original image.

	A		B		C	
1	Color Burn		100		100	
2	Hard Mix		100		50	
3	Hard Light		100		100	

Positive effect

With this image of a young girl, the result using the original recipe looked overcooked. I got an acceptable result, however, when I left the Hard Mix layer as a positive.

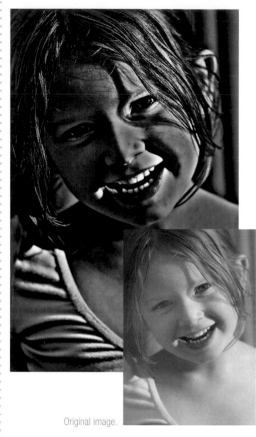

Original image.

	A		B		C	
1	Color Burn		100		60	
2	Hard Mix		100		50	
3	Hard Light		100		100	

Visible sign

To ensure that "Route 66" remained visible, I had to mask it. Also see how blurring the Hard Light layer caused a red rim around the "One Way" sign.

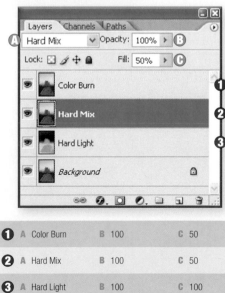

Original image.

Monumental color

For this shot of Monument Valley, I preferred the result I got by making the Hard Mix layer positive.

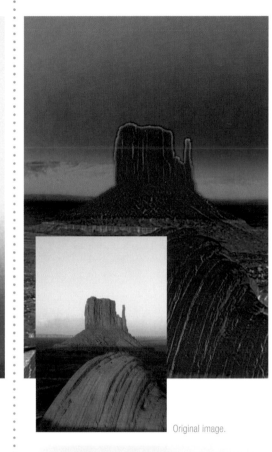

Original image.

Shining armor

In this particular example, I preferred to set the top layer to Lighten mode—Color Burn was too dark.

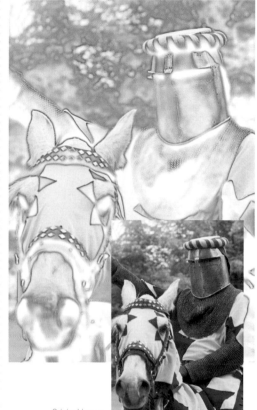
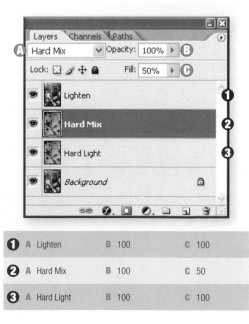

Original image.

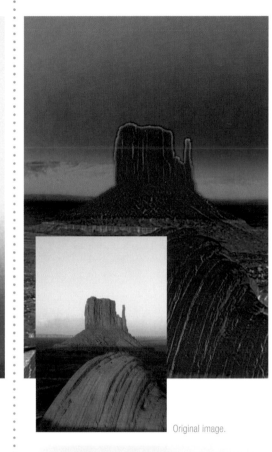

A Color Burn — Opacity: 100% — B
Lock: — Fill: 100% — C
1 Color Burn
2 Hard Mix
3 Hard Light
Background

A Hard Mix — Opacity: 100% — B
Lock: — Fill: 50% — C
1 Color Burn
2 Hard Mix
3 Hard Light
Background

A Hard Mix — Opacity: 100% — B
Lock: — Fill: 50% — C
1 Lighten
2 Hard Mix
3 Hard Light
Background

	A	B	C
1	Color Burn	100	100
2	Hard Mix	100	50
3	Hard Light	100	100

	A	B	C
1	Color Burn	100	50
2	Hard Mix	100	50
3	Hard Light	100	100

	A	B	C
1	Lighten	100	100
2	Hard Mix	100	50
3	Hard Light	100	100

Softening Contrast

In this recipe, we're going to apply lots of blur—more than you'd ever use if you wanted a simple soft-focus effect. There's a sandwich of two such layers, one with the Darken mode and the other using the Screen blending mode. This combination increases the image contrast, and, if we want, we can then reintroduce a bit more realism with a semitransparent layer containing the original.

1 In the Layers palette, duplicate the original image by dragging the background layer onto the "Create a new layer" icon. Alternatively, just use the keyboard shortcut Ctrl/Cmd-J. Name this layer "Darken."

2 With the Darken layer selected, go to **Filter > Blur > Gaussian Blur** and set the radius to about 45.

3 Still on the Darken layer, select Darken from the blending mode pull-down menu.

4 Return to the original layer. Make another copy of the background image and call it "Normal."

5 Drag the Normal layer to the top of the Layers palette and experiment with reducing the fill opacity until you've arrived at a subtle line-drawing effect.

Original image.

Soft touch

With this subject, a less high-key approach seemed more suitable, so I wanted to reduce the Screen layer's opacity to increase the opacity of the top layer. With a picture like this, the Screen layer might be said to control the "dreaminess" factor.

❶	A Normal	B 100	C 30
❷	A Screen	B 40	C 100
❸	A Darken	B 100	C 100

Blown away

The technique can also be applied to even lower key images but this image illustrates something to watch out for. The contrast range was already very high and the Screen layer resulted in unacceptably blown highlights on the preacher's nose and cheeks. Once the opacity of the Screen layer was reduced, the Darken layer gave the low-contrast, brooding tone I wanted to express.

Original image.

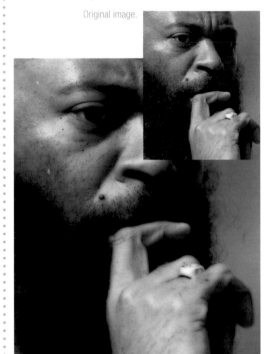

❶	A Normal	B 100	C 30
❷	A Screen	B 40	C 100
❸	A Darken	B 100	C 100

Blurred edges

Now let's try applying the same technique to a very different subject. What's most noticeable here is how the blurred Darken layer bleeds into the surrounding sky. Here, it's strong, and leaving off the top layer has produced an almost posterized effect. The bleeding "shadows" hint at an early morning mist, and we can obviously reduce the layer's opacity if that seems to suit the image.

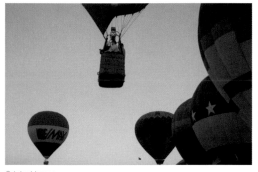

Original image.

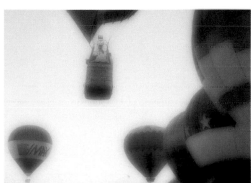

Soft glow

Here the sandwich is very simple. The darken and screen layers were blurred using a Gaussian amount of 45, and were then placed below a 50% opaque copy of the original image.

Original image.

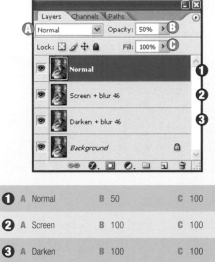

Radiant glow

The same method can be the basis for a more high-key treatment when you duplicate the Darken layer and change the new layer's blending mode to Screen. With the more high-key effect, you may have to increase the opacity of the top layer so that more detail remains in the image.

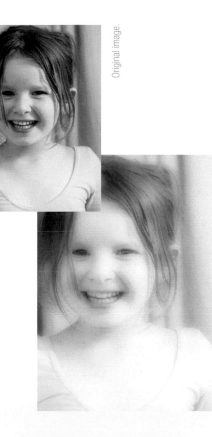

Original image.

Blurred edges layers panel

❶	A Screen	B 100	C 100
❷	A Darken	B 100	C 100

Soft glow layers panel

❶	A Normal	B 50	C 100
❷	A Screen	B 100	C 100
❸	A Darken	B 100	C 100

Radiant glow layers panel

❶	A Normal	B 100	C 25
❷	A Darken	B 100	C 70

Overlapped Lighten Layers

Applying the Lighten blending mode to a layer means that the final image shows only those pixels from the blend that are lighter than those of the underlying image. You can use this behavior to overlay copies of an image and produce effects that range from viewing the image through patterned glass to simulating movement.

1 In the Layers palette, duplicate the original image layer by dragging the background layer onto the "Create a new layer" icon, or use Ctrl/Cmd-J.

2 Use the pull-down blending mode menu in the Layers palette to change the duplicate layer's blending mode to Lighten (alternatively, use the shortcut Alt/Opt-Shift-G) and rename it "Lighten."

3 Select the Move tool (M) and reposition the Lighten layer over the background image.

Creating a Mask

Click the "Add layer mask" icon in the Layers palette and select the Brush tool (B). Check to be sure that the mask is active—you should see the mask icon to the left of the thumbnail. If not, click the white mask to the right of the thumbnail. Also ensure that the foreground color is set to black. Now, paint on the mask, and notice how the white thumbnail shows some black areas that correlate with now-transparent areas on the image layer.

Patterns of light

In this particular example, I used five Lighten blend layers; each layer was moved 60 pixels left, and 60 pixels up.

Original image.

	A		B		C	
1	A	Lighten	B	100	C	100
2	A	Lighten	B	100	C	100
3	A	Lighten	B	100	C	100
4	A	Lighten	B	100	C	100
5	A	Lighten	B	100	C	100

Mirror image

This profile shot allowed me to produce a symmetrical composite with a single Lighten blend layer that was flipped horizontally.

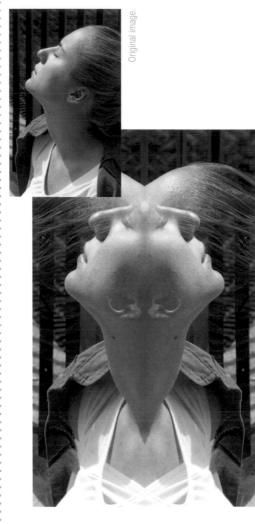

Original image.

	A		B		C	
1	A	Lighten	B	100	C	100

Multiples

Not quite Mount Rushmore, but copying the original layer, then flipping and moving the duplicates, has created an interesting effect. Notice too the use of masks to tidy up the composite. (See Tip box "Creating a Mask," opposite.)

Original image.

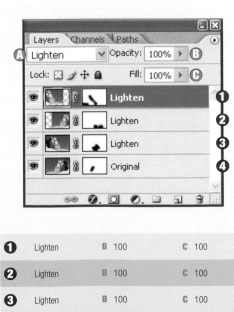

❶	Lighten	B	100	C	100
❷	Lighten	B	100	C	100
❸	Lighten	B	100	C	100
❹	Lighten	B	100	C	100

Seeing double

Here, I used **Edit > Transform** to resize the duplicate layer. I also reduced the Lighten layer's opacity to 20% so that the giant wheel's whites were brighter than the duplicate's color and would therefore show through.

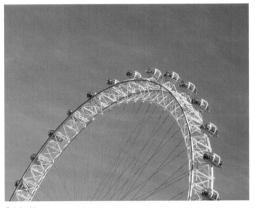

Original image.

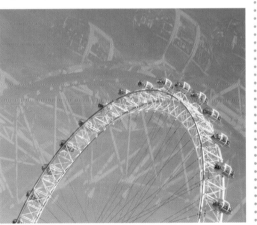

❶	Lighten	B	20	C	100

Creating movement

A large amount of Motion Blur can be combined with masking to give the impression of moving past an object.

Original image.

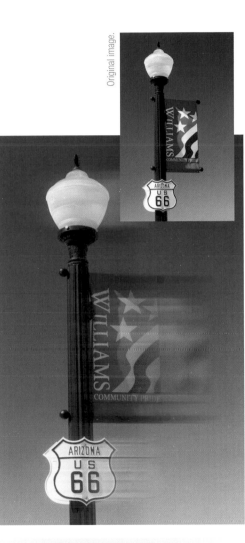

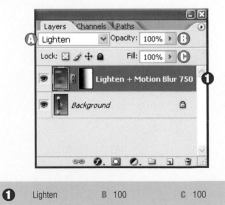

❶	Lighten	B	100	C	100

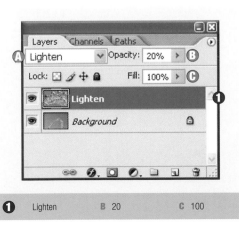

83

Gentle Skin

I noticed this skin-softening technique in Scott Kelby's *Photoshop CS Book for Digital Photographers*. It's fundamentally the same, but here I've added a twist. Duplicate the original image twice, blur both layers, set one's blending mode to Lighten and the other's to Darken, and then use masks to show or hide the softening effect. Sounds easy? Let's dive straight in.

1 In the Layers palette, make two duplicates of the original image. Drag the background layer onto the "Create a new layer" icon, or just use the keyboard shortcut Ctrl/Cmd and J.

2 Double-click the middle layer, rename it Darken, and set its blend mode to Darken too. The shortcut is Alt/Opt Shift K.

3 Be sure that the Darken layer is still active and apply some Gaussian Blur with **Filters > Blur > Gaussian Blur**. Use quite a high amount—40 or 50.

4 Reduce the Darken layer's opacity to 30–50%.

5 Double-click the top layer, rename it Lighten, and set its blend mode to Lighten. The shortcut is Alt/Opt-Shift-G.

6 Select the Lighten layer and apply some Gaussian blur. Use a higher amount than was used for the Darken layer—60 to 80 is fine.

7 In the Layers palette, click the "Create a new group" icon. This is going to contain our Lighten and Darken layers. At this point Scott Kelby merges the two layers instead of placing them in a group—

although it makes little difference, I prefer the layer group's flexibility and trade it off against increased file sizes.

8 Select the Darken layer and drag it on to the layer group, then do the same with the Lighten layer, making sure the Lighten layer is on top.

9 Reduce the layer group's opacity to around 40–50%. Because the set's blending mode is Pass Through, this adjusts the combined opacity of the Darken and Lighten layers.

10 While the softening effect is now completed, there is another important step that is often needed. Usually, you only want to soften parts of the image—dry skin or wrinkles beneath the eyes, for instance—but leave the eyes and other details sharp. So, now add a mask to the layer group. The quickest way is to make sure that the group is selected and then click the "Add layer mask" icon at the bottom of the layer palette.

11 Now paint the layer group mask with black to make the important details show through, and with white to apply the softening effect.

Light hands

The layer group saves the effort of masking both the Darken and Lighten layers. If you are using an older version of Photoshop that doesn't have the Layer Group or earlier Layer Set feature, or if you want to produce a smaller file, hide the background layer, create a new transparent layer, and select Merge Visible from the Layers palette to merge the Darken and Lighten layers. Then mask it as shown with the group.

The hands and the coat are very different in tone, so I used **Select > Color Range** because it was faster to select the hands than using tools like the Magic Wand or Magic Lasso. I then filled the selection with white, so that the skin is softened while the button, belt, and coat fabric are unaffected.

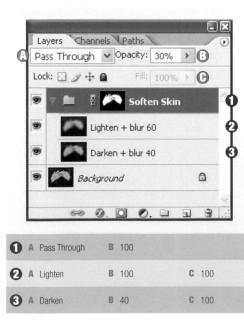

The final image shows detail in the coat and softens the skin. I also painted black onto the mask. To that the softening didn't affect the wedding ring.

❶	A Pass Through	B 100	
❷	A Lighten	B 100	C 100
❸	A Darken	B 40	C 100

Blonde highlights

I liked the sharp appearance of this image, but tried skin-softening everything except the eyes. The overall result was a little like the Shadow/Highlights adjustment, lifting the shadows and maintaining the highlights.

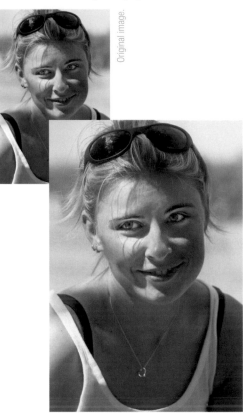

Original image.

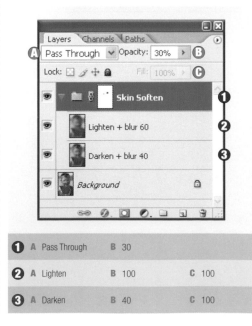

❶	A Pass Through	B 30	
❷	A Lighten	B 100	C 100
❸	A Darken	B 40	C 100

Soft skin

Even with a young child, skin softening can add to the image. Here, I only left the eyes sharp.

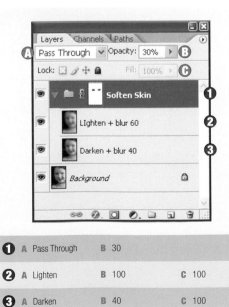

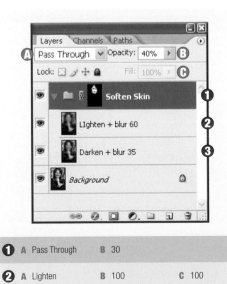

Original image.

Sharp look

Harsh, midday sun makes this woman close her eyes. I softened the entire image and then painted with a soft, black brush around the eyes and lips.

Original image.

I wanted to subtly soften under the eyes but leave the eyes sharp, so I zoomed in close and selected only those areas I wanted to change.

Before

After

Selective softening

Often it's easier to paint the entire mask black, and then switch to white to reveal softening. This image's background was deliberately out of focus and I only wanted to soften a few parts of the man's face.

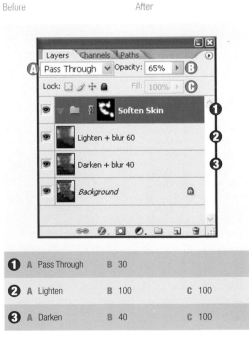

Original image.

It's not just skin that you can soften. I felt the man's nostrils were too obvious and softened them by painting white onto that part of the mask.

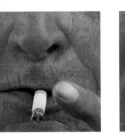

Before

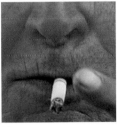

After

85

Column 1 (Soft skin):

Layers / Channels / Paths

A Pass Through — Opacity: 30% B

Lock: / Fill: 100% C

- 1 Soften Skin
- 2 Lighten + blur 60
- 3 Darken + blur 40
- Background

	A	B	C
❶	Pass Through	30	
❷	Lighten	100	100
❸	Darken	40	100

Column 2 (Sharp look):

Layers / Channels / Paths

A Pass Through — Opacity: 40% B

Lock: / Fill: 100% C

- 1 Soften Skin
- 2 Lighten + blur 60
- 3 Darken + blur 35
- Background

	A	B	C
❶	Pass Through	30	
❷	Lighten	100	100
❸	Darken	40	100

Column 3 (Selective softening):

Layers / Channels / Paths

A Pass Through — Opacity: 65% B

Lock: / Fill: 100% C

- 1 Soften Skin
- 2 Lighten + blur 60
- 3 Darken + blur 40
- Background

	A	B	C
❶	Pass Through	30	
❷	Lighten	100	100
❸	Darken	40	100

Soft Hard Mix

Each of the Exclusion, Pin Light, and Hard Mix blending modes can be used on its own to distort or degrade an image. Here, they're used together in a perhaps unlikely combination. Exclusion and Pin Light distort the image contrast and cause color shifts, then Hard Mix is used to moderate the effect and to restore at least a semblance of a natural appearance.

1 In the Layers palette, duplicate the original image layer by dragging the background layer onto the "Create a new layer" icon, or use Ctrl/Cmd-J.

2 Using either the pull-down blending mode menu in the Layers palette or the shortcut Alt/Opt-Shift-X, change the duplicate layer's blending mode to Exclusion and rename it "Exclusion."

3 Using the shortcut Ctrl/Cmd-J, duplicate the original image layer again, and drag the new layer to the top of the layer stack.

4 Change the new layer's blending mode to Pin Light using either the pull-down menu again or the shortcut Alt/Opt-Shift-Z and rename it "Pin Light."

5 With the Pin Light layer selected, apply some blur using Filters **Blur > Gaussian Blur**—a small radius, 10–20, is enough to form a slight halo around the details.

6 Using the shortcut Ctrl/Cmd-J, duplicate the original image layer again, and drag the new layer to the top of the layer stack.

7 Change the new layer's blending mode to Hard Mix using Alt/Opt-Shift-L and rename it "Hard Mix."

8 Reduce the Hard Mix layer's opacity. If you reduce the layer opacity, the image will become darker and lose contrast. Generally, it's better to choose the fill opacity if you want to retain Hard Mix's high-contrast output. The exact percentage can vary widely depending on the image.

Exclusion often creates a lower-contrast negative effect with some posterization. Notice the rim around the edge of the shadows.

The blurred Pin Light makes the image positive again and enhances the halo or rim around the darker details.

Balancing contrast

The final Hard Mix layer can be used to balance image contrast.

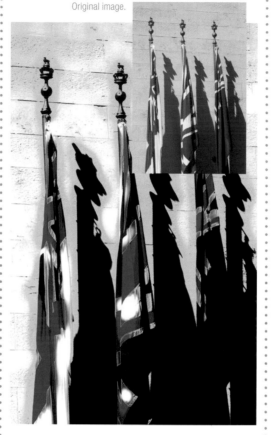

Original image.

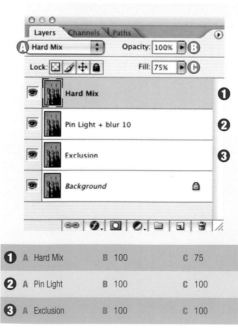

	A		B		C	
1	A	Hard Mix	B	100	C	75
2	A	Pin Light	B	100	C	100
3	A	Exclusion	B	100	C	100

Working with midtones

If the Hard Mix layer's opacity is too high, it dominates the result. But this image also had a lot of drab midtones that appeared posterized if the Hard Mix layer was too transparent—90% opacity worked best here.

Original image.

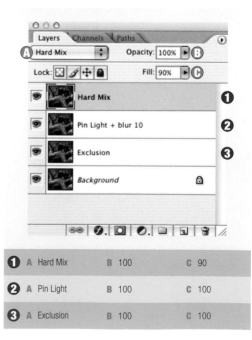

	A		B		C	
1	A	Hard Mix	B	100	C	90
2	A	Pin Light	B	100	C	100
3	A	Exclusion	B	100	C	100

Light shade

This photograph was taken in bright mid-morning light, and the Hard Mix layer's opacity had to be set to under 50% before any detail became apparent in the walls.

Overcast

This building detail was shot on an overcast morning. This recipe helps to bring out the cold light.

Customizing contrast

In this example, the Hard Mix layer's fill opacity worked best at around 50%. At 100% it bleached the image.

Original image

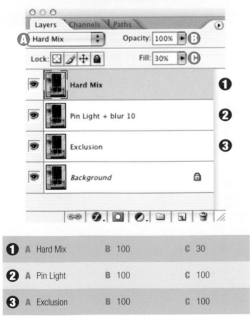

Original image

Original image.

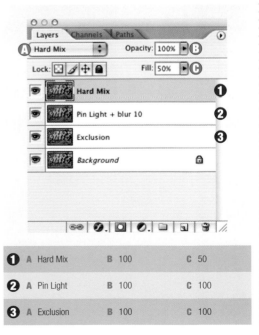

❶	A	Hard Mix	B	100	C	30
❷	A	Pin Light	B	100	C	100
❸	A	Exclusion	B	100	C	100

❶	A	Hard Mix	B	100	C	75
❷	A	Pin Light	B	100	C	100
❸	A	Exclusion	B	100	C	100

❶	A	Hard Mix	B	100	C	50
❷	A	Pin Light	B	100	C	100
❸	A	Exclusion	B	100	C	100

Reducing Digital Noise

There are many ways to reduce digital noise or color aliasing—the red, green, and blue pixels that often show up in low-light photographs. If the digital picture is in a Raw file format, you can use Adobe Camera Raw or your Raw converter to minimize the noise. Alternatively, you can try one of the many Photoshop plug-ins or image-editing techniques, often involving use of the Lab image mode, to help. Here, however, is a quick method that utilizes blending modes.

1 In the Layers palette, duplicate the original image layer by dragging the background layer onto the "Create a new layer" icon, or use Ctrl/Cmd-J.

2 Using either the pull-down blending mode menu in the Layers palette or the shortcut Alt/Opt-Shift-L, change the duplicate layer's blending mode to Color and rename it "Color."

3 Zoom in to 100% using **View > Actual Pixels** or Ctrl/Cmd-Alt/Option-Zero and move around the screen to an area where the digital noise is clearly visible.

4 Apply some Gaussian Blur using **Filter > Blur > Gaussian Blur**. Use a very small amount—just enough for the noise to disappear.

Images shot in low light

The camera was hand-held in exceptionally low light to get this shot in a nineteenth-century fortress; I had to push the ISO sensitivity up to 6400 to avoid camera shake.

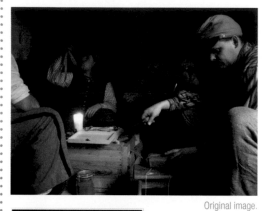

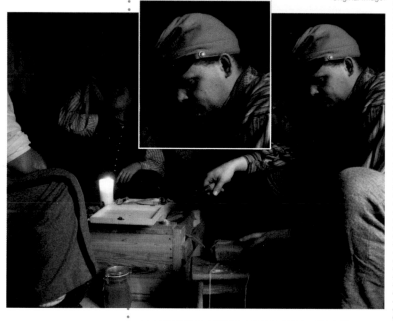

Original image.

Noisy surface textures

The digital noise was most obvious in this man's coat, but was made much less obvious with a Color blend layer featuring a Gaussian Blur radius of 10.

Original image.

1 A Color B 100 C 100

1 A Color B 100 C 100

Selective noise reduction

The recipe helped to reduce the noise in the paved areas of this photo.

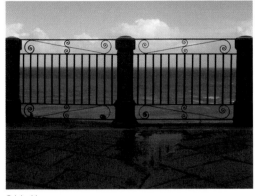

Original image.

An alternate approach

Here is an alternative approach. Don't copy the layer. Apply Gaussian Blur until the noise disappears, then immediately select **Edit > Fade Gaussian Blur** and select Color from the mode drop-down box. The blur vanishes, but the noise reduction remains.

Original image.

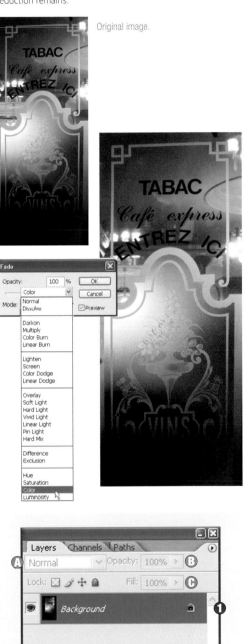

Selective reduction with masks

When parts of the image don't contain significant noise, consider masking the Color layer and limiting its effect on the composite image.

Original image.

❶ A Color B 100 C 100

❶ A Color B 100 C 100

❶ A Color B 100 C 100

Soft Posterization

Although Photoshop has a posterization adjustment, its dialog offers little control and the results can be harsh and hard-edged. Here's a technique that lets you create posterization that's much softer and easier to control.

1 In the Layers palette, duplicate the original image layer by dragging the background layer onto the "Create a new layer" icon, or use Ctrl/Cmd-J.

2 Change the new layer's blending mode to Difference with Alt/Opt-Shift-E and rename the layer "Difference."

3 Invert the Difference layer using Ctrl/Cmd-I.

4 Using the shortcut Ctrl/Cmd-J, duplicate the Difference layer.

5 Return to the background layer and duplicate it by dragging it onto the "Create a new layer" icon, or use Ctrl/Cmd-J.

6 Drag this new layer to the top of the layer stack, change its blending mode to Exclusion using either the pull-down blending mode menu or the shortcut Alt/Opt-Shift-X, and rename it "Exclusion."

7 Duplicate the Exclusion layer using Ctrl/Cmd-J. The image now includes two negative Difference layers and two positive Exclusion layers.

8 Create another copy of the background layer, move the new layer to the top of the layer stack, change its blending mode to Screen using Alt/Opt-Shift-S, and rename it "Screen."

9 If the effect is too muted, try increasing the layer's opacity or changing it to one of the contrast-increasing modes—Overlay is a good start.

90

Soft focus

Here, I applied a Gaussian Blur to the Difference layers. A blur radius of 30 exaggerated the posterization effect.

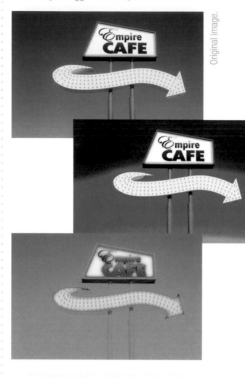

Original image.

	A		B		C	
1	A Screen	B	20	C	100	
2	A Exclusion	B	100	C	100	
3	A Exclusion	B	100	C	100	
4	A Difference	B	100	C	100	
5	A Difference	B	100	C	100	

Pastel colors

Images with plenty of detail are good for showing this recipe's posterization effect.

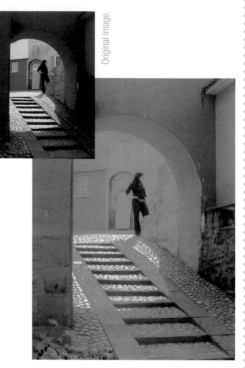

Original image.

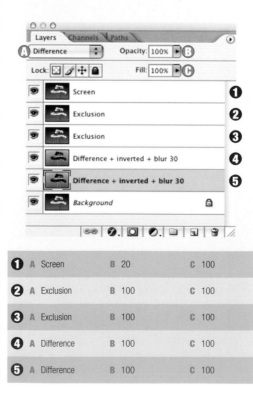

	A		B		C	
1	A Screen	B	20	C	100	
2	A Exclusion	B	100	C	100	
3	A Exclusion	B	100	C	100	
4	A Difference	B	100	C	100	
5	A Difference	B	100	C	100	

Colored plastic

Images with plenty of bright colors work well with this recipe.

Original image.

Working with drab originals

The original scene was so drab that I eliminated one of the Exclusion layers and reduced the Screen layer's opacity.

Original image.

Soft noise

Look out for noise—it can either detract from an image or make it a success.

Original image.

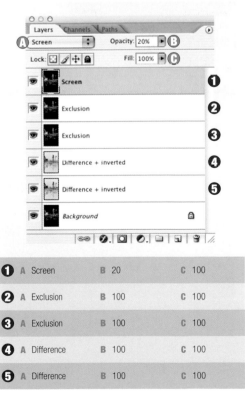

Colored plastic (Layers)

	A		B		C	
❶	A	Screen	B	20	C	100
❷	A	Exclusion	B	100	C	100
❸	A	Exclusion	B	100	C	100
❹	A	Difference	B	100	C	100
❺	A	Difference	B	100	C	100

Working with drab originals (Layers)

	A		B		C	
❶	A	Screen	B	10	C	100
❷	A	Exclusion	B	100	C	100
❸	A	Exclusion	B	100	C	100
❹	A	Difference	B	100	C	100
❺	A	Difference	B	100	C	100

Soft noise (Layers)

	A		B		C	
❶	A	Screen	B	20	C	100
❷	A	Exclusion	B	100	C	100
❸	A	Exclusion	B	100	C	100
❹	A	Difference	B	100	C	100
❺	A	Difference	B	100	C	100

Posterization reduces an image to a limited number of tonal values. Photoshop has the command Image > Adjustments > Posterize, which changes the image pixels themselves, or you can use a Posterize adjustment layer instead. In either case, the Posterize dialog box lets you choose the number of levels that should remain in the image. But an adjustment layer lets you change your mind later and experiment with combining posterization with blending modes.

1 In the Layers palette, click the "Create a new fill or adjustment layer" and select Posterize. Name this layer "Posterize."

2 The Posterize dialog sets how many tonal values should remain in the final posterized image. For a strongly posterized result, select a low number.

3 Change the Posterize adjustment layer's blending mode to Linear Burn using either the pull-down blending mode menu or the shortcut Alt/Opt-Shift-A. It'll be clearer later on if you now rename this layer "Posterize + Linear Burn."

4 In the Layers palette, duplicate the original image layer by dragging the background layer onto the "Create a new layer" icon, or use Ctrl/Cmd-J.

5 Move the duplicate layer to the top of the layer stack and change its blending mode to either Difference or Exclusion. Toggle between these modes using either the pull-down blending menu or the keyboard shortcuts Alt/Opt-Shift-E or Alt/Opt-Shift-X. Name the layer either "Difference" or "Exclusion."

6 Apply some Gaussian Blur to the Difference/Exclusion layer. The amount can vary widely, so you must experiment. For this motel sign, I used a radius of 30.

Halo Halo

I applied a Gaussian Blur with a radius of 30 to the top layer. This created the halos around the arrow and other bright details.

For variation, I added a yellow-filled layer, setting its blending mode to Dissolve and its opacity to 1 or 2%. This produced a yellow graininess over the image. I then used Select > Color Range to mask out the sign and restrict the effect to the sky. Would you believe this shot was taken at midday in Arizona?

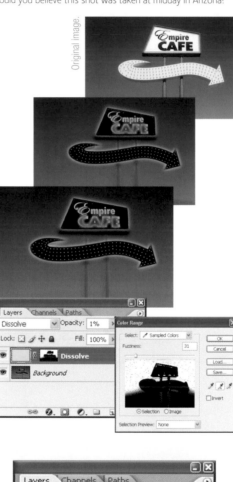

Original image.

① A Difference B 100 C 100

② A Linear Burn B 100 C 100

Mondrian

Details disappeared if I used a blur radius greater than 10.

Original image.

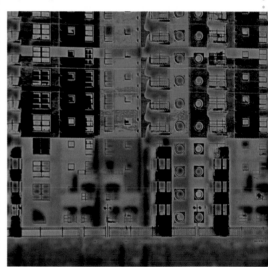

① A Difference B 100 C 100

② A Linear Burn B 100 C 100

Difference mode

The reversal effect of the Difference blending mode is particularly prominent in this image.

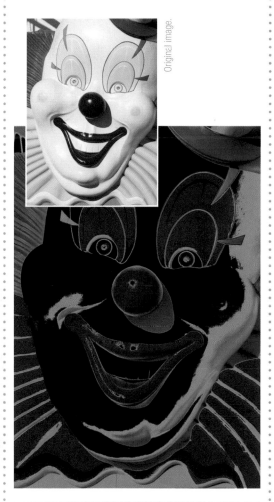

Original image.

Colored solarization

Exclusion can work better than the Difference blending mode. I also desaturated the top layer to remove the ugly gray-purple color from the halo around this replica of Liberty.

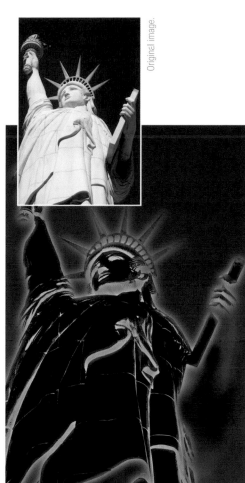

Original image.

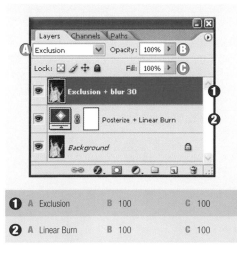

Opposite effects

To keep the fine detail in the shutters, only a small blur radius was used on the top layer.

Difference produces a more direct reversal effect, while Exclusion is weaker and maintains some of the original colors.

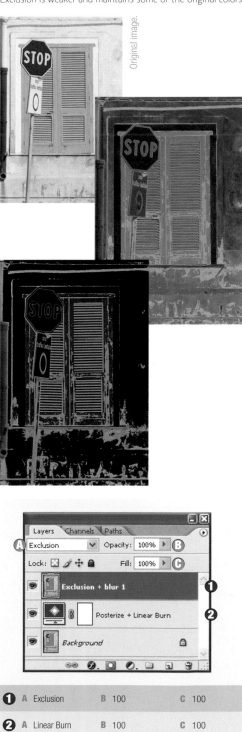

Original image.

93

Layers Channels Paths

A Difference ▾ Opacity: 100% ▶ B

Lock: ☒ ✎ ✛ 🔒 Fill: 100% ▶ C

👁 Difference + blur 30 ❶
👁 Posterize + Linear Burn ❷
👁 Background 🔒

❶ A Difference B 100 C 100
❷ A Linear Burn B 100 C 100

Layers Channels Paths

A Exclusion ▾ Opacity: 100% ▶ B

Lock: ☒ ✎ ✛ 🔒 Fill: 100% ▶ C

👁 Exclusion + blur 30 ❶
👁 Posterize + Linear Burn ❷
👁 Background 🔒

❶ A Exclusion B 100 C 100
❷ A Linear Burn B 100 C 100

Layers Channels Paths

A Exclusion ▾ Opacity: 100% ▶ B

Lock: ☒ ✎ ✛ 🔒 Fill: 100% ▶ C

👁 Exclusion + blur 1 ❶
👁 Posterize + Linear Burn ❷
👁 Background 🔒

❶ A Exclusion B 100 C 100
❷ A Linear Burn B 100 C 100

Most effective with pictures containing lots of detail, this recipe takes advantage of some Photoshop filters that produce an image that is mostly white. Find Edges is probably the most commonly used of this group, but another is Trace Contours. This filter outputs a basic contour map by joining together all pixels matching the brightness value that you choose in the Trace Contours dialog box.

You can create an effect like a hiking map's contours by adding many such layers and setting their blending mode to Multiply or another member of the "Darken" group. Because white is the neutral color of these modes, it is stripped out of the filtered layer, and you are left with just colored contour lines. Overlay a few such contour maps and you can produce some really interesting results.

1 In the Layers palette, duplicate the original image layer by dragging the background layer onto the "Create a new layer" icon, or use Ctrl/Cmd-J.

2 Using either the pull-down blending mode menu in the Layers palette or the shortcut Alt/Opt-Shift-M, change the new layer's blending mode to Multiply and name it "Multiply."

3 Set the Multiply layer's opacity to between 50 and 70%.

4 Apply some blur using **Filter > Blur > Gaussian Blur**—a radius value of 10 is enough.

5 Make a number of copies of the Multiply layer. It's easiest to use Ctrl/Cmd-J to do this.

6 Hide the Background layer by clicking on the eye icon.

7 On each Multiply layer, run **Filter > Stylize > Trace Contour** and enter a different value each time. Start with a value of around 200 and work downward, maybe reducing the value by the same amount each time—so, 200, then 180, then 160. After the first time you apply it, remember to use Ctrl/Cmd-Alt/Opt-F to quickly display the Trace Contour dialog again.

To save time when you add the layers, record an action like this and set the Trace Contour step so that its dialog box is displayed.

Soft contours

With this dark picture, I only added three contours and felt it looked better with some of the original showing through.

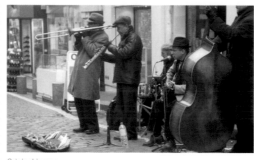

Original image.

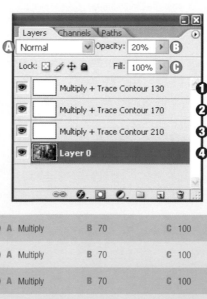

	A	B	C
1	Multiply	70	100
2	Multiply	70	100
3	Multiply	70	100
4	Original pic	20	100

Multiple contours

This colorful image can take a lot of contours. Also, the more contours, the less the need to restore the original.

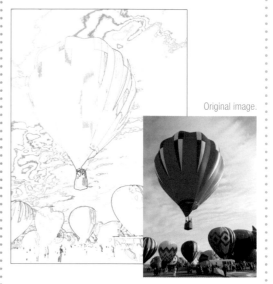

Original image.

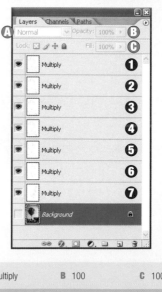

	A	B	C
1	Multiply	100	100
2	Multiply	100	100
3	Multiply	100	100
4	Multiply	100	100
5	Multiply	100	100
6	Multiply	100	100
7	Multiply	100	100

94

A few contours

This old pump contains lots of detail and needed few contours. As usual, I leave the original hidden, just in case I want to add more layers.

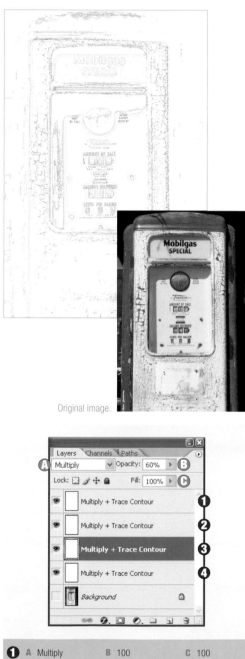

Original image.

❶	A	Multiply	B	100	C	100
❷	A	Multiply	B	100	C	100
❸	A	Multiply	B	100	C	100
❹	A	Multiply	B	100	C	100

Portrait contours

Try using this recipe on faces. Here, I needed to trace contours at brightness intervals of 30.

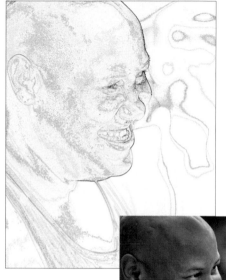

Original image.

❶	A	Multiply	B	100	C	100
❷	A	Multiply	B	100	C	100
❸	A	Multiply	B	100	C	100
❹	A	Multiply	B	100	C	100
❺	A	Multiply	B	100	C	100
❻	A	Desaturated	B	80	C	100

Beyond the pale

Here, I combined Trace Contour with Find Edges, another filter that outputs a largely white image.

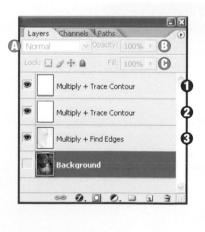

Original image.

95

❶	A	Multiply	B	100	C	100
❷	A	Multiply	B	100	C	100
❸	A	Multiply	B	100	C	100

General Sharpening

Almost every digital image needs to be sharpened at some point, and the Unsharp Mask filter is a favorite tool. However, because it's a destructive process, Unsharp Mask is often applied as the final step before printing. There is a surprising non-destructive alternative that involves the Hard Mix blending mode used in conjunction with a low-radius Gaussian Blur. When I first encountered Hard Mix, its obvious use seemed to be to drastically transform an image. It reduces an image to just eight colors and this brutal behavior is still apparent even after reducing the opacity. However, if you apply a small amount of Gaussian Blur to the Hard Mix layer, then there is a noticeable sharpening effect. You can adjust the strength of the sharpening effect by experimenting with the Fill Opacity slider.

1 In the Layers palette, duplicate the original image by dragging the background layer onto the "Create a new layer" icon. Alternatively, just use the keyboard shortcut Ctrl/Cmd-J. Name this layer "Hard Mix."

2 With the Hard Mix layer selected, choose Hard Mix from the blending mode pull-down menu.

3 Apply a small amount of Gaussian Blur to the Hard Mix layer. Somewhere between 3 and 4 seems to work best.

4 Experiment with the Fill Opacity slider until you achieve a satisfactory sharpening effect.

Basic technique

Make a duplicate of the image layer. Then if you want to see the effect of applying blur in real time, make the blend layer Hard Mix and reduce its opacity to 10%. Next, apply a small amount of Gaussian Blur—I usually settle on something between 3 and 4. If you haven't already switched the layer to Hard Mix, do so now. In either case, you will probably want to adjust the opacity again.

Straight out of the camera, many digital images appear slightly soft.

At 8% fill opacity there is a distinct improvement in contrast and sharpness.

The dialog shows the blurred Hard Mix blend layer, but look at the image itself to see the sharpening effect resulting from small changes in blur amount.

Original image.

1 A Hard Mix + blur 3 B 100 C 8

Blur with care

While you can always adjust the fill opacity afterward, you can't do so with Gaussian Blur—you would have to repeat the step. So don't overdo the blur amount, otherwise the Hard Mix is no longer working its rough magic on pixels around the edges and the sharpening effect isn't going to work.

To have a sharpening effect yet retain a natural appearance, 5 is more than enough for Gaussian Blur.

Ultra-sharp high contrast

Sometimes Hard Mix can be just too aggressive, other times it can be what you want. Here, by pushing its opacity up over 50%, the image has bleached out and has grossly saturated colors. It reminds me of my experiments with color printing from slides—20 minutes' carefully controlled development and you find you gave the exposure too much time. This is the result here—an ultra-sharp, high-contrast image with strong blues and bleached highlights.

This reminds me of a badly overexposed Cibachrome.

Saturated sharpening

Pushing up the Hard Mix layer's fill opacity can retain a natural appearance, while also pushing up the saturation. Here, the Gaussian Blur radius was set to 4, but the fill opacity was kept to 15%. Any more fill opacity and the photograph would have begun to posterize.

Higher levels of Fill Opacity will add to the saturation and sharpening effect. 15% is toward the top end of Fill Opacity if you want to retain a natural-looking image.

1 A Hard Mix + blur 2 B 100 C 5

1 A Hard Mix B 100 C 50

1 A Hard Mix + blur 4 B 100 C 14

Sharpening without Color Noise

Many photographers switch off in-camera sharpening because they prefer the control that they get from sharpening in Photoshop. The Unsharp Mask is a very popular sharpening tool, but a downside is that it can introduce visible color noise and halos. Here's a quick sharpening recipe that uses the Luminosity and Color blending modes to eliminate these problems.

Basic technique

After sharpening the image with this technique, flatten the image (**Layer > Flatten Image**) if you want to save disk space.

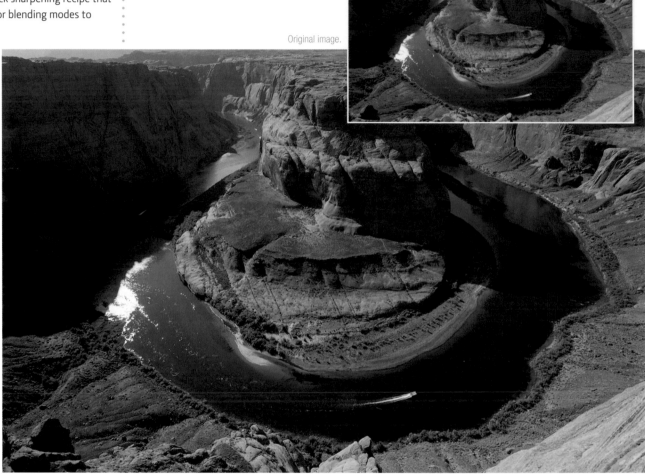

Original image.

1 In the Layers palette, duplicate the original image layer by dragging the background layer onto the "Create a new layer" icon, or use Ctrl/Cmd-J.

2 Using the pull-down blending mode menu in the Layers palette or the shortcut Alt/Opt-Shift-Y, change the duplicate layer's blending mode to Luminosity and rename it "Luminosity."

3 Apply some Gaussian Blur to the Luminosity layer. Set an amount of 200—250% with a radius of 1 and threshold of 0.

4 In the Layers palette, use Ctrl/Cmd-J to make another duplicate of the original image layer and drag the new layer to the top of the layer stack.

5 Change the duplicate layer's blending mode to Color using the pull-down menu or shortcut Alt/Opt-Shift-C and rename it "Color."

6 Blur the Color layer using **Filter > Blur > Gaussian Blur**. Set a small amount—3 or 4 should be enough to take out the halos and color noise around the details.

	A	B	C
1	Color	100	100
2	Luminosity	100	100

Magnified to 200%, the original image's lack of sharpness is very obvious.

Applying the Unsharp Mask sharpens the picture, but notice how it introduces color noise—green is especially obvious in the boat's wake.

The blurred Color layer eliminates the color shift, but retains the sharpening.

Working with layer groups

I like to put the pair of sharpening layers into a layer group. This way you can toggle both layers' visibility with a single click and it's easier to check your work. One way to create a layer group is to choose **Layer > New > Layer Group** to bring up the New Layer Group dialog box. Give the set a suitable name, and when you return to the Layers palette, you'll see a new folder icon with your chosen name. You can then drag any existing or newly created layers in or out of the folder.

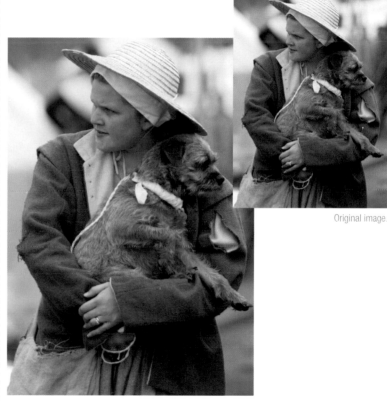

Original image.

	A		B		C	
1	Color		100		100	
2	Luminosity		100		100	

Ultrawide Sharpening

Photoshop is full of surprises. Here's an effect that started off with a blurred, inverted Color Dodge layer. Usually, this is a good base for a line drawing—the degree of blur controls the lines' strength. But instead of using blur, I wanted to see the effect of applying the Unsharp Mask filter over a wide area—that is, pushing up its radius slider. It took no time to repeat the process with Ctrl/Cmd-F and discover that evenly toned areas could be bleached and the details could be fringed with the original image colors. It's such an easy recipe and can be applied to all sorts of pictures.

Fringed edges

With this image, the appearance of fringing emphasizes the already wintry feel of this image.

Original image.

Burned out

I just applied the Unsharp Mask once to this high-contrast portrait of a girl in the sun.

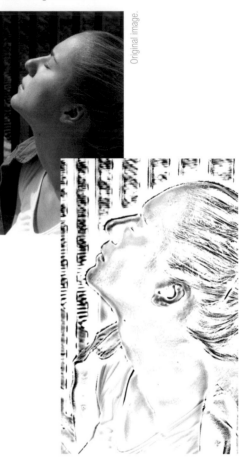

Original image.

1 In the Layers palette, duplicate the original image layer by dragging the background layer onto the "Create a new layer" icon, or use Ctrl/Cmd-J.

2 Using the pull-down blending mode menu in the Layers palette or the shortcut Alt/Opt-Shift-D, change the new layer's blending mode to Color Dodge, and name it "Color Dodge."

3 Invert the Color Dodge layer with Ctrl/Cmd-I. The image should now appear completely white.

4 In the Layers palette, use Ctrl/Cmd-J to make two copies of the original image layer, and drag them to the top of the layer stack. Name one "Color" and one "Color Burn," and set their blending modes accordingly. Drag the "Color Burn" layer to the top of the stack.

5 Activate the inverted Color Dodge layer and sharpen it. Use **Filter > Sharpen > Unsharp Mask**. Set the amount at 200 or more and push up the radius to at least 50. Leave the threshold value low, such as below 5. Click OK. Repeat the filter for a more intense effect.

6 For other interesting results, experiment with changing the opacity of the various blend layers.

In this example, although the tree is bleached out, the branches are surrounded by blues from the original image.

	A		B	C
1	A Color Burn		B 100	C 100
2	A Color		B 100	C 100
3	A Color Dodge		B 100	C 100

	A		B	C
1	A Color Burn		B 100	C 100
2	A Color		B 100	C 100
3	A Color Dodge		B 100	C 100

False reticulation

In some cases, where a source image contains a lot of detail, you have to be judicious with applying Unsharp Mask to retain it.

Original image..

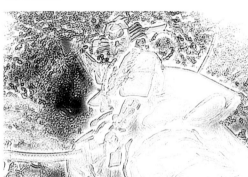

This picture contains lots of detail in the trees. This disappeared unless the Unsharp Mask radius was set to a relatively low value.

❶ A Color Burn	B 100	C 100
❷ A Color	B 100	C 100
❸ A Color Dodge	B 100	C 100

Color line drawing

Using an Unsharp Mask with a radius of 100 was enough to spice up this picture but retained the seagull and other important details in the bridge.

Original image.

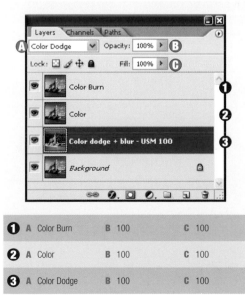

❶ A Color Burn	B 100	C 100
❷ A Color	B 100	C 100
❸ A Color Dodge	B 100	C 100

Graphic patterns

By the time I had applied the Unsharp Mask filter three times to this image of Brighton Pavilion, England, fascinating patterns were appearing in the plain blue sky of this image.

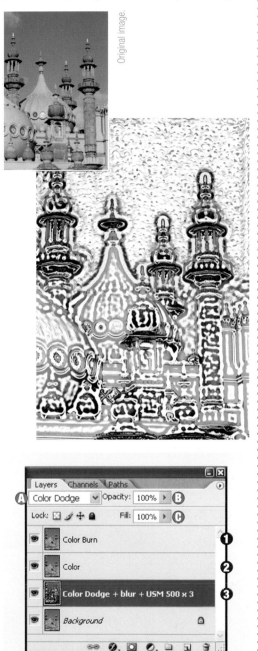

Original image.

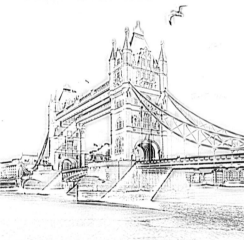

❶ A Color Burn	B 100	C 100
❷ A Color	B 100	C 100
❸ A Color Dodge	B 100	C 100

Ultra Sharpening

ard Mix is a fascinating blending mode that crudely reduces a picture to one of just eight colors. Apply it to a blend layer, then add some Gaussian Blur and set a low layer opacity. Halos appear around the details, resulting in a sharpening effect. This recipe builds on that idea, applying more blur and producing extreme Hard Mix sharpening. It works on its own, or as the basis for other treatments.

1 In the Layers palette, duplicate the original image. Drag the background layer onto the "Create a new layer" icon, or use Ctrl/Cmd-J.

2 Invert the new layer with Ctrl/Cmd-I.

3 Using the pull-down blending mode menu in the Layers palette or the shortcut Alt/Opt-Shift-L, change the new layer's blending mode to Hard Mix, and name the layer "Hard Mix."

4 Because Hard Mix has such a powerful effect, it's important to see what we're doing. You might not get an accurate view of the end result if you are not zoomed in to 100%—certainly, my screen was very misleading. So, zoom in to the image to 100% and you should have a threshold-like image with very little detail, and extremely harsh colors.

5 With the Hard Mix layer active, use **Filters > Blur > Gaussian Blur** to add some Gaussian Blur—and don't be sparing. Any radius from 20 to 100 can produce interesting effects.

6 At this point the recipe is completed, but consider reducing the Hard Mix layer's opacity if you want to limit its effect.

102

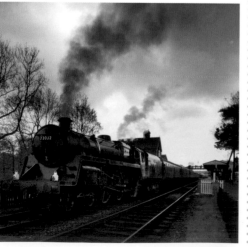

Original image

Basic technique

This is the sort of image that best suits this recipe. Both the subject and the sky contain lots of fine detail.

The amount of blur can produce wildly different results. Here, the image was bleached by a much higher Gaussian Blur radius.

Although excellent in its own right, this recipe can also be the basis for many exciting variations.

Enhancing edges

Again, in this example the subject has plenty of detail, and this recipe acts like a powerful Find Edges filter or Threshold.

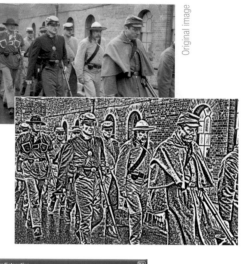

Original image

To finish this picture, I added a Hue/Saturation adjustment layer with the color set to a suitably military tone.

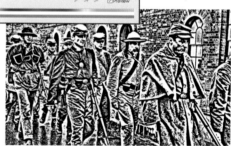

	A Hard Mix	B 100	C 100

	A Hard Mix	B 100	C 100

Creating visual texture

The layer's opacity and the fill opacity have a big effect on the results of the Hard Mix. Reduce the layer opacity if you want to moderate the effect. But reducing the fill opacity, even a little, quickly removes the overwhelming contours and the Hard Mix layer produces a more conventional sharpening effect.

Original image

Patterned halos

This recipe makes halos around blurred details. While this can be attractive, it's less appealing when the image has large, evenly toned areas, such as the sky around Big Ben.

Original image

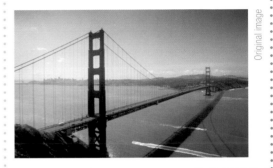

Psychedelic color effects

With a blur radius of just 5, you still get enough of the effect, but in this example, Hard Mix is too brutal on the sky.

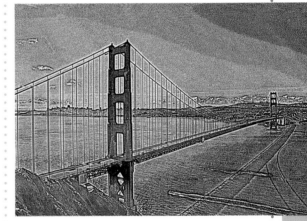

Original image

Layers panel — Hard Mix + inverted + blur 20; Background

	A		B		C
1	Hard Mix		100		100
2	Hard Mix + inverted		50		100

Layers panel — Hard Mix + inverted + blur 40; Background

	A		B		C
1	Hard Mix + inverted		100		100

Layers panel — Hard Mix + inverted + blur 5; Background

	A		B		C
1	Hard Mix + inverted		100		100

Emboss Sharpening

Every digital image needs some level of sharpening before it's printed, saved to the Web, or output to its ultimate use. Many sharpening techniques exist, from Photoshop's Unsharp Mask (USM), "edge-sharpening" variations where the USM filter is applied in Lab mode, plug-ins, and countless actions. As for which is best, there's probably no right answer and it's better to add the tools to your armory, try them out, and decide with your own eyes.

So, here are two more techniques to try. They are very similar and both rely on two Photoshop filters and on blending modes whose neutral color is gray. The two filters, Emboss and High Pass, make the image gray, but with distinct edges. The gray is then eliminated by setting the layer's blending mode to Hard Light, leaving just a sharpening effect whose strength can be easily fine-tuned.

1 In the Layers palette, duplicate the original image layer by dragging the background layer onto the "Create a new layer" icon, or use Ctrl/Cmd-J.

2 Use **View > Actual Pixels** or the shortcut Alt/Opt-0 Zoom to view the image at 100%. Move around the image until you can see an important area—the subject's eyes, for instance.

3 Using the pull-down blending mode menu in the Layers palette or the shortcut Alt/Opt-Shift-H, change the duplicate layer's blending mode to Hard Light and rename it "Sharpening." You can do this step later, but doing it now means that you can see the final result in step 4.

4 Now select either:
a) **Filter > Stylize > Emboss**. The most important setting is Height—this should be between 1 and 5.
b) **Filter > Other > High Pass**. Any radius between 2 and 10 can work well.

5 To check the effect, toggle the layer's visibility. If it is too strong, adjust the Sharpening layer's opacity. Other finishing touches might include adding a mask to the Sharpening layer and painting it black where you don't want any sharpening effect.

Using High Pass

A radius value of 10 is enough for the High Pass filter.

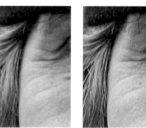

Original image.

| A Hard Light | B 100 | C 100 |

Using Emboss

A Height value of 2 is enough for the Emboss filter to create a sharpening effect.

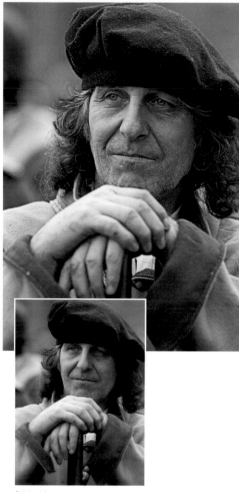

Always examine sharpening results at 100%.

| A Hard Light | B 100 | C 100 |

Style icon

Use enough sharpening to sharpen the image, but not so much that it appears unnatural. A radius of 5 in the High Pass filter was enough for this detail.

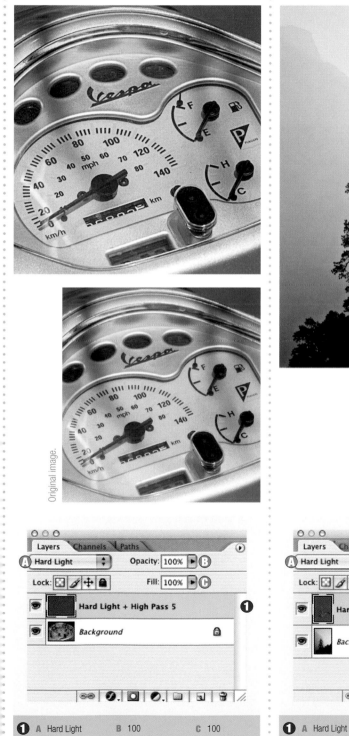

Original image.

Subtle High Pass

Here, I experimented with a high radius of 30 in the High Pass filter. The effect was so unnatural that I had to reduce the layer's opacity.

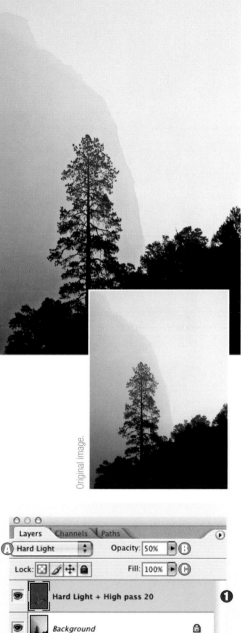

Original image.

Light Emboss

In this example, the Emboss filter was used with the height set to 2; it has sharpened the image, while keeping it looking realistic.

Original image.

Layers Channels Paths

A Hard Light Opacity: 100% B

Lock: 🔲 ✏ ✛ 🔒 Fill: 100% C

Hard Light + High Pass 5 ❶

Background 🔒

❶ A Hard Light B 100 C 100

Layers Channels Paths

A Hard Light Opacity: 50% B

Lock: 🔲 ✏ ✛ 🔒 Fill: 100% C

Hard Light + High pass 20 ❶

Background 🔒

❶ A Hard Light B 50 C 100

Layers Channels Paths

A Hard Light Opacity: 100% B

Lock: 🔲 ✏ ✛ 🔒 Fill: 100% C

Hard Light + Emboss 2 ❶

Background 🔒

❶ A Hard Light B 100 C 100

Woodworm

I've called this recipe "Woodworm" because that's what I was reminded of after I applied it to the image of the knight. The main ingredients are the Hard Mix and Pin Light blending modes and a couple of shots of Gaussian Blur. How much of each is up to you, but the two work closely together in this effect. On its own, Hard Mix reduces all pixels to one of eight colors, making a blocky image. But blurring the image creates larger areas of similarly colored pixels, which Hard Mix brutally shapes into lumps of pure color, like a gradient map or woodworm. The higher the blur radius value, the more obvious this effect becomes, although with really high values you'll lose all semblance of the original picture.

1 In the Layers palette, duplicate the original image by dragging the background layer onto the "Create a new layer" icon. Alternatively, just use the keyboard shortcut Ctrl/Cmd-J. Name this layer "Hard Mix."

2 With the Hard Mix layer selected, choose Hard Mix from the blending mode pull-down menu.

3 Invert the Hard Mix layer by selecting **Image > Adjustments > Invert** (Ctrl/Cmd-I).

4 Still with the Hard Mix layer selected, apply **Filter > Blur > Gaussian Blur**, and set the radius value to 5.

5 Return to the Original layer, duplicate the background image again, and call it "Pin Light."

6 Drag the Pin Light layer to the top of the Layers palette and select Pin Light from the blending mode pull-down menu.

7 Invert the Pin Light layer (Ctrl/Cmd-I), then go to **Filter > Blur > Gaussian Blur** and apply a radius value of 5.

8 With the Pin Light layer selected, experiment by reducing the fill opacity until you get the desired result.

Burnishing effect

Only a small amount of Gaussian Blur is needed for the woodworm effect to show—in this example, the Gaussian Blur radius was set to just 5 in the Hard Mix layer. Areas of detail, such as the chain mail, contain lots of contrast and so remain less distorted. But the out-of-focus trees gain a strong woodworm pattern.

Original image.

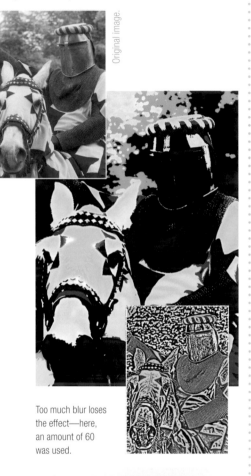

Too much blur loses the effect—here, an amount of 60 was used.

Monochrome contrasts

The reflections of a neighboring building in the panes of this building make high-contrast monochrome shapes, while the windows that don't reflect the neighboring building are more evenly toned. This time I added a Gaussian Blur radius of 10, forcing the reflections into even stronger contrast.

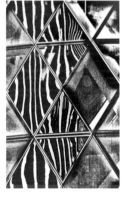

Original image.

Blurring the Hard Mix layer with a Gaussian Blur radius of 60 retains enough shape in this picture.

Burnishing effect layers palette

Layers / Channels / Paths
(A) Pin Light — Opacity: 100% (B)
Lock: 🗆 ✏ ✛ 🔒 Fill: 30% (C)

- Pin Light + inverted + blur **①**
- Hard Mix + inverted + blur **②**
- Background

①	A	Pin Light + blurred+ inverted	B	100	C	30
②	A	Hard Mix + blurred+ inverted	B	100	C	100

Monochrome contrasts layers palette

Layers / Channels / Paths
(A) Hard Mix — Opacity: 100% (B)
Lock: 🗆 ✏ ✛ 🔒 Fill: 100% (C)

- Pin Light + inverted + blur **①**
- Hard Mix + inverted + blur **②**
- Background

①	A	Pin Light + blurred+ inverted	B	100	C	30
②	A	Hard Mix + blurred+ inverted	B	100	C	100

Textured color

In this picture I used a low Gaussian Blur value, which is why the windows' shapes are clearly visible, but the more subtly toned reflections are colorized by the Hard Mix blending layer.

Notice too how the blue sky is dotted with odd pixels of color. This happens in areas of even tone where individual pixels differ slightly from their neighbors and where the Hard Mix algorithm forces them to assume a completely different color.

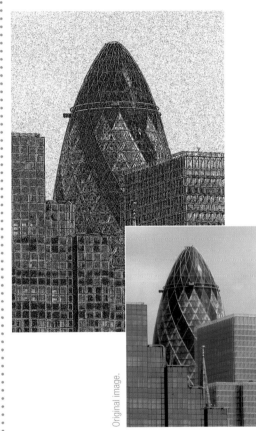

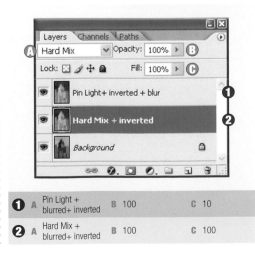

Original image.

Unnatural light

Try varying a Hard Mix layer's opacity, because even small percentage changes have a big effect. Here, you can see that the edges of the glass windows are white and so stand out strongly. It's almost a sharpening effect, though the result is still deliberately unnatural. But at a very low opacity, as low as 5–10%, Hard Mix can be used to deliberately sharpen a picture.

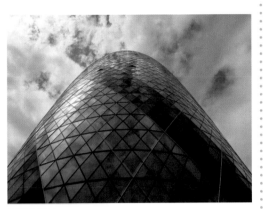

Original image.

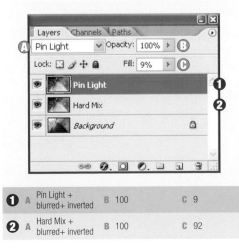

Hard Mix sharpening

With an image that contains lots of detail, such as the one shown here, this recipe won't produce the same dramatic woodworm effect that is obvious in the picture of the knight. Instead, it will sharpen the image. The picture remains natural-looking if the Hard Mix layer's opacity is set to a low percentage. Here, percentages above 50% sharpen the image. Notice the halos around the stones—you can also see this in some of the pictures of the buildings.

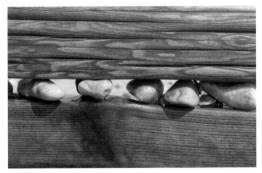

Original image.

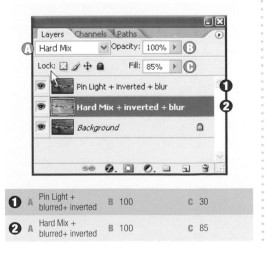

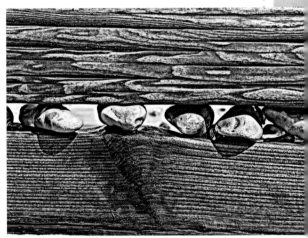

	A		B	C
❶	A	Pin Light + blurred+ inverted	B 100	C 10
❷	A	Hard Mix + blurred+ inverted	B 100	C 100

	A		B	C
❶	A	Pin Light + blurred+ inverted	B 100	C 9
❷	A	Hard Mix + blurred+ inverted	B 100	C 92

	A		B	C
❶	A	Pin Light + blurred+ inverted	B 100	C 30
❷	A	Hard Mix + blurred+ inverted	B 100	C 85

Hard Shadows

Here's another recipe that uses the Layer Styles dialog's Blend If sliders. In this case, the Blend If sliders are a finishing touch and control how much of the original color is restored to an image that has been desaturated and subjected to a Hard Mix layer. It's a recipe that works well on images with lots of detail, but can produce fascinating results when pictures have apparently evenly toned areas with slight variations of tone.

1 In the Layers palette, duplicate the original image layer by dragging the background layer onto the "Create a new layer" icon, or use Ctrl/Cmd-J.

2 Select **Image > Adjustments > Desaturate** to desaturate the new layer, or use Ctrl/Cmd-Shift-U. Name the layer "Desturated."

3 In the Layers palette, duplicate the Desaturated layer using Ctrl/Cmd-J.

4 Using the pull-down blending mode menu in the Layers palette or the shortcut Alt/Opt-Shift-L, change the new layer's blending mode to Hard Mix, invert it using Ctrl/Cmd-I, and name it "Hard Mix."

5 Using **Filter > Blur > Gaussian Blur**, add only a little blur to the Hard Mix layer—about 10.

6 In the Layers palette, duplicate the background layer using Ctrl/Cmd-J and drag the new layer to the top of the layer stack.

7 Change the new layer's blending mode to Multiply using the pull-down blending mode menu or with the shortcut Alt/Opt-Shift-M and rename it "Multiply."

8 Using **Filter > Blur > Gaussian Blur**, add a little blur to the Multiply layer—about 10.

9 Double-click the Multiply layer's thumbnail and open the Layer Styles dialog box. Find the Blend If section and drag the black triangle on the This Layer slider so that shadow areas start to reveal the underlying Hard Mix layer.

10 To make the transition smoother, hold Alt/Option and drag one side of the black triangle so that the triangle splits. Then adjust the two halves independently, and click OK when you're happy with the transition.

Casting shadows

Large expanses of evenly toned areas can often become separated. Notice how the dark halos around the balloons resemble drop shadows.

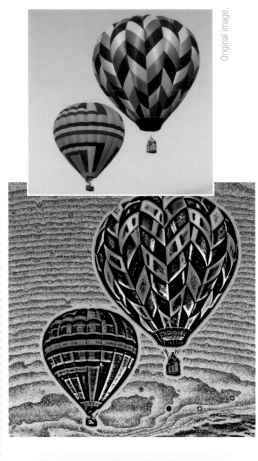

Original image.

Faux stained glass

This image contains lots of evenly lit detail, even in the wallpaper. The end result is reminiscent of stained glass.

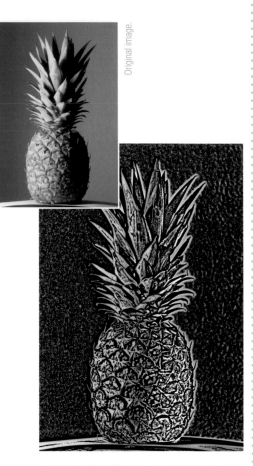

Original image.

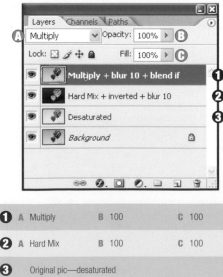

❶	A Multiply	B 100	C 100
❷	A Hard Mix	B 100	C 100
❸	Original pic—desaturated		

Hand-drawn knight

This recipe works particularly well with historical images because it lends the subject a hand-drawn quality.

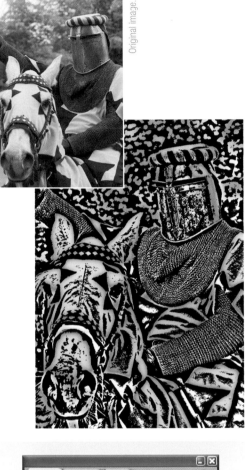

Original image.

Tone separationa

If you drag Blend If's black triangles but keep them close together, the transition will be abrupt. Here, I dragged them until the sky was separated from the tree.

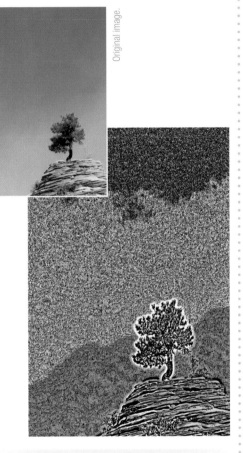

Original image.

Retaining shadows

For another variation, try adjusting the Blend If slider on both the Multiply and the Hard Mix layers. Here, I used Blend If to exclude the Hard Mix layer's highlights and midtones so that shadows from the original photo showed in the final image.

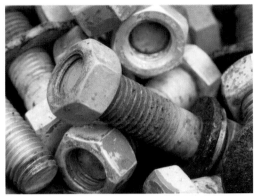

Original image.

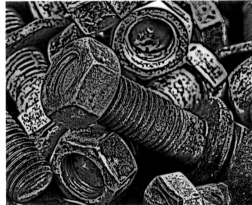

109

Hand-drawn knight layers

Layers | Channels | Paths

A Multiply · Opacity: 100% B · Lock · Fill: 100% C

1. Multiply + blur 10 + blend if
2. Hard Mix + inverted + blur 10
3. Desaturated
 Background

❶	A Multiply	B 100	C 100
❷	A Hard Mix	B 100	C 100
❸	Original pic—desaturated		

Tone separationa layers

Layers | Channels | Paths

A Multiply · Opacity: 100% B · Lock · Fill: 100% C

1. Multiply + blur 10 + blend if
2. Hard Mix + inverted + blur 10
3. Desaturated
 Background

❶	A Multiply	B 100	C 100
❷	A Hard Mix	B 100	C 100
❸	Original pic—desaturated		

Retaining shadows layers

Layers | Channels | Paths

A Multiply · Opacity: 100% B · Lock · Fill: 100% C

1. Multiply + blur 10 + blend if
2. Hard Mix + inverted + blur 10
3. Desaturated
 Background

❶	A Multiply	B 100	C 100
❷	A Hard Mix	B 100	C 100
❸	Original pic—desaturated		

Hard Mix Highlights

Hidden away in Photoshop's Layer Styles are a pair of Blend If sliders. These control how much of the image comes from the current layer and how much from below. Simply by dragging the slider, you can exclude some tones from the composite image. Here's a recipe that has a blurred Hard Mix layer to transform the picture, and then takes advantage of Blend If to restore the original image's shadow tones.

1 In the Layers palette, duplicate the original image layer by dragging the background layer onto the "Create a new layer" icon, or use Ctrl/Cmd-J.

2 Choose **Image** > **Adjustments** > **Desaturate** (or Ctrl/Cmd-Shift-U) to desaturate the new layer and name it "Desaturated."

3 In the Layers palette, use Ctrl/Cmd-J to duplicate the Desaturated layer.

4 Using the pull-down blending mode menu in the Layers palette or the shortcut Alt/Opt-Shift-L, change the new layer's blending mode to Hard Mix and rename it "Hard Mix."

5 Invert the Hard Mix layer using Ctrl/Cmd-I.

6 Add a lot of blur to the Hard Mix layer using **Filter** > **Blur** > **Gaussian Blur**. The objective is to sharpen the image so much that halos flow round the details, rather like wood grain or a viscous liquid. A radius of 30 is a good starting point.

7 In the Layers palette, double-click the Hard Mix layer's thumbnail and bring up the Layer Styles dialog box.

8 Find the Blend If section and drag the white triangle on the This Layer slider. Bright tones in the Hard Mix layer will be hidden if they lie to the right of the white triangle, so you should quickly see the darker areas of the original picture begin to appear through the Hard Mix layer.

9 To make the transition smoother, hold Alt/Option and drag one side of the white triangle so that the triangle splits. Then adjust the two halves independently, and click OK.

10 In the Layers palette, use Ctrl/Cmd-J to make a duplicate of the original image layer. Drag the new layer to the top of the layer stack.

11 Using the pull-down blending mode menu in the Layers palette or the shortcut Alt/Opt-Shift-M, change the new layer's blending mode to Multiply and rename it "Multiply." Reduce its opacity to below 50% or whatever value is needed to colorize the picture.

110

Emphasizing shapes

Notice how the Hard Mix layer's halo emphasizes the shape of the bridge.

Original image.

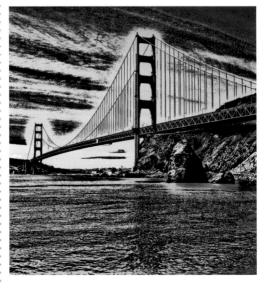

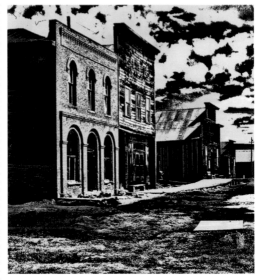

	A		B		C	
1	Multiply		50		100	
2	Hard Mix		100		100	
3	Original pic—desaturated					

Cloudy skies

Uneven skies look great when halos form around the clouds.

Original image.

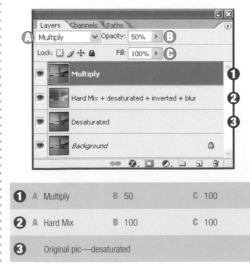

	A		B		C	
1	Multiply		50		100	
2	Hard Mix		100		100	
3	Original pic—desaturated					

Selective blending

By using the Blend If slider, the man's vest and the background show through from the original image, while his face appears from the Hard Mix layer.

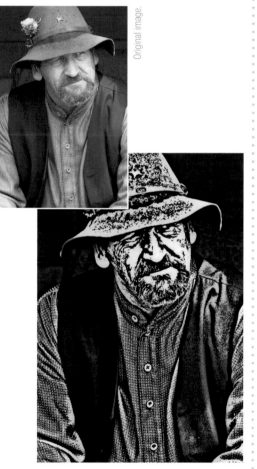

Original image.

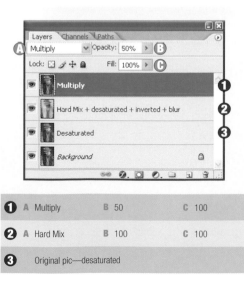

Channel blending

The Blend If slider can control the visibility of individual channels. Here, I wanted the red tiles of the original image to show through, while the other channels come from the Hard Mix layer.

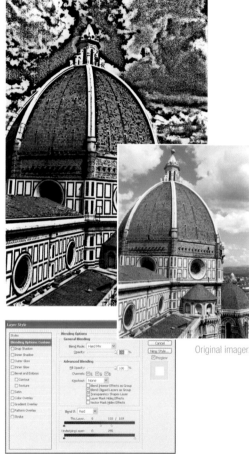

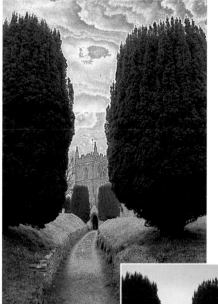

Original imager.

Adding Linear Dodge

In this example, the original image was underexposed and the top layer was set to Linear Dodge to show some color.

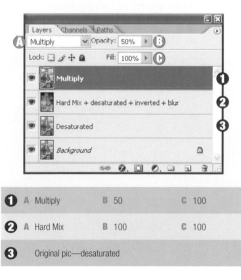

Original image.

111

Layers	Channels	Paths	
A Multiply	Opacity: 50% B		
Lock: Fill: 100% C			
Multiply			1
Hard Mix + desaturated + inverted + blur			2
Desaturated			3
Background			

	A	Multiply	B	50	C	100
1						
2	A	Hard Mix	B	100	C	100
3		Original pic—desaturated				

Layers	Channels	Paths	
A Multiply	Opacity: 50% B		
Lock: Fill: 100% C			
Multiply			1
Hard Mix + desaturated + inverted + blur			2
Desaturated			3
Background			

	A	Multiply	B	50	C	100
1						
2	A	Hard Mix	B	100	C	100
3		Original pic—desaturated				

Layers	Channels	Paths	
A Linear Dodge	Opacity: 100% B		
Lock: Fill: 56% C			
Linear Dodge			1
Hard Mix + desaturated + inverted + blur			2
Desaturated			3
Background			

	A	Linear Dodge	B	100	C	56
1						
2	A	Hard Mix	B	100	C	100
3		Original pic—desaturated				

Metallic Shadows

Most of this book's recipes involve self-blends (where an image is blended with copies of itself), but here's one that blends the tones separately. Use Select > Color Range to copy shadows and midtones into new layers, before applying blending modes. Here, the result is to reverse shadows and midtones, but you can use the same method to select and transform the color channels. I feel it works best with images where the focal point is in the highlights, which you don't reverse, but you can try it on any type of picture.

1 In the Layers palette, duplicate the original image layer by dragging the background layer onto the "Create a new layer" icon, or use Ctrl/Cmd-J.

2 Using the pull-down blending mode menu in the Layers palette or the shortcut Alt/Opt-Shift-D, change the new layer's blending mode to Color Dodge and name it "Color Dodge."

3 Invert the Color Dodge layer with Ctrl/Cmd-I. The image should now appear completely white.

4 Add blur to the Color Dodge layer using **Filter > Blur > Gaussian Blur**. A radius of 5 should be enough to make an edge drawing appear.

5 Hide the Color Dodge layer by clicking the eye in the Layers palette.

6 Activate the background layer and use the menu **Select > Color Range**. Choose Shadows from the drop-down box and click OK.

7 Using Ctrl/Cmd-J, copy the selection into a new layer and rename the new layer "Shadows."

8 Move the Shadows layer to the top of the layer stack.

9 Invert the Shadows layer using Ctrl/Cmd-I.

10 Using the pull-down blending mode menu in the Layers palette or the shortcut Alt/Opt-Shift-I, change the Shadows layer's blending mode to Dissolve.

11 Hide the Shadows layer by clicking the eye in the Layers palette.

12 Activate the background layer and Repeat steps 6 to 9, but choose Midtones in the Color Range dialog, and name the new layer "Midtones." Leave its blending mode set to Normal.

13 Move the Midtones layer to the top of the layer stack.

14 Show the Color Dodge and Shadows layers by clicking the eye in the Layers palette.

Sunny highlights

This recipe preserves the highlights, ensuring that the sunlight on the girl's face remains the central subject of this picture.

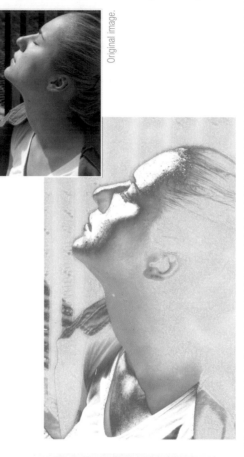

Original image.

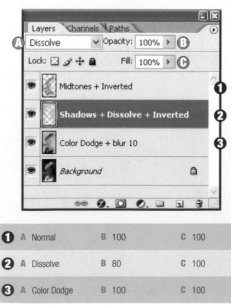

①	A Normal	B 100	C 100
②	A Dissolve	B 80	C 100
③	A Color Dodge	B 100	C 100

False infrared

This scene contained plenty of cool midtones and drab shadows that are warmed and partly reversed by the recipe.

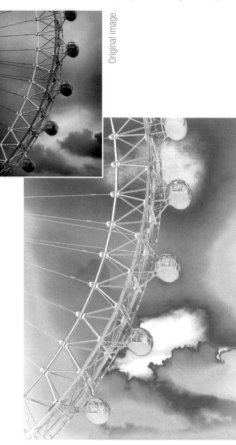

Original image.

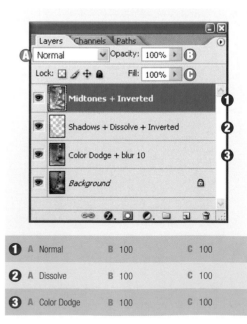

①	A Normal	B 100	C 100
②	A Dissolve	B 100	C 100
③	A Color Dodge	B 100	C 100

Color reversal

This midday shot consisted almost entirely of green midtones and few shadows, so the color reversal is especially obvious.

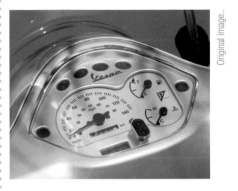

Original image..

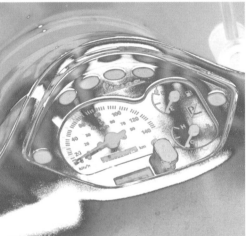

Reflective surfaces

This recipe works well with subjects containing metals and other reflective material. Here, the reversed midtones layer produced an unnatural orange sky; desaturating the layer, however, produced an effective result.

Original image..

Non-reflective surfaces

You can still apply this recipe to subjects that contain very little metal.

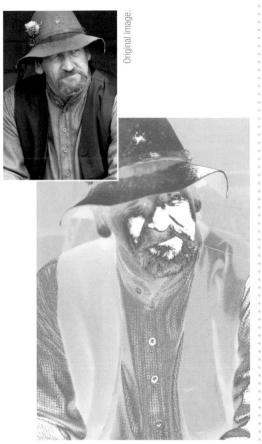

Original image.

113

Color reversal — layers

	A	B	C
❶	Normal	100	100
❷	Dissolve	100	100
❸	Color Dodge	100	100

Layers · Channels · Paths
Normal Opacity: 100%
Lock: Fill: 100%
❶ Midtones + Inverted
❷ Shadows + Dissolve + Inverted
❸ Color Dodge + blur 10
Background

Reflective surfaces — layers

	A	B	C
❶	Normal	100	100
❷	Dissolve	100	100
❸	Color Dodge	100	100

Layers · Channels · Paths
Normal Opacity: 100%
Lock: Fill: 100%
❶ Midtones + Inverted
❷ Shadows + Dissolve + Inverted
❸ Color Dodge + blur 10
Background

Non-reflective surfaces — layers

	A	B	C
❶	Normal	100	100
❷	Dissolve	100	100
❸	Color Dodge	100	100

Layers · Channels · Paths
Normal Opacity: 100%
Lock: Fill: 100%
❶ Midtones + Inverted
❷ Shadows + Dissolve + Inverted
❸ Color Dodge + blur 10
Background

Tarnished Silver

Interesting things happen when you apply the Difference blending mode to an inverted copy of the base layer. Because Inversion turns white into black—Difference's neutral color—it leaves highlights and midtones unaffected, but reverses the shadows. This recipe takes advantage of these strange reversals.

1 In the Layers palette, duplicate the original image layer by dragging the background layer onto the "Create a new layer" icon, or use Ctrl/Cmd-J.

2 Using the pull-down blending mode menu in the Layers palette or the shortcut Alt/Opt-Shift-E, change the duplicate layer's blending mode to Difference and rename it "Difference."

3 Invert the Difference layer using Ctrl/Cmd-I.

4 Using **Filter > Blur > Gaussian Blur**, add some blur to the Difference layer. Any radius can be used—start with a low value such as 5 and add more later if necessary.

5 Duplicate the Difference layer using Ctrl/Cmd-J.

6 In the Layers palette, use Ctrl/Cmd-J to duplicate the original image layer, move this new layer to the top of the layer stack, and change its blending mode to Pin Light using the shortcut Alt/Opt-Shift-Z. Name the layer "Pin Light." Invert the Pin Light layer using Ctrl/Cmd-I.

7 In the Layers palette, make another copy of the original image layer, drag it to the top of the layer stack, and change its blending mode to Exclusion using the shortcut Alt/Opt-Shift-X.

The picture's shadows should be partially reversed and have dark rims as a result of the blur.

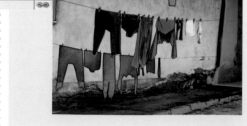

Washed out

The photo of this washing line was taken in a Mediterranean backstreet and is a good example of how this recipe causes partial reversal of the image.

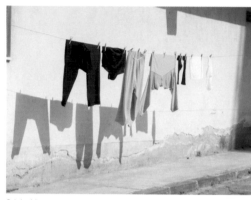

Original image.

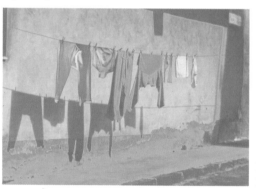

	A		B		C	
1	A	Exclusion	B	100	C	100
2	A	Pin Light	B	100	C	100
3	A	Difference	B	100	C	100
4	A	Difference	B	100	C	100

High-key sky

This example of another high-key image shows strange color shifts.

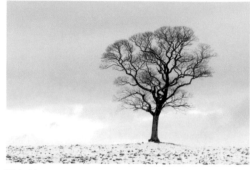

Original image.

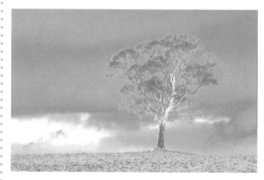

	A		B		C	
1	A	Exclusion	B	100	C	100
2	A	Pin Light	B	100	C	100
3	A	Difference	B	100	C	100
4	A	Difference	B	100	C	100

Rusted metal

Here, many more color reversals are produced because this slightly overexposed shot contains more midtones.

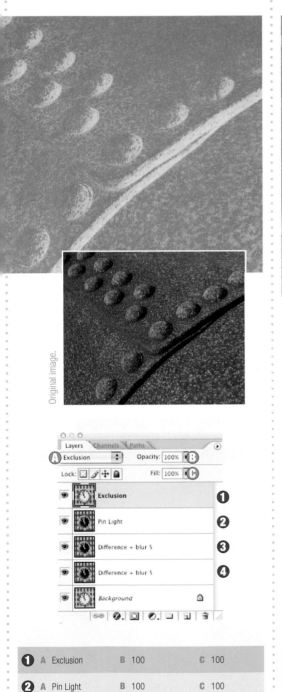

Original image.

Antique effect

In this example, the shadows are reversed, but the effect remains realistic.

Original image.

Reflective surfaces

Metallic subjects work well with this recipe. The shadows are reversed, producing an interesting effect in the clock's hand and in the office windows.

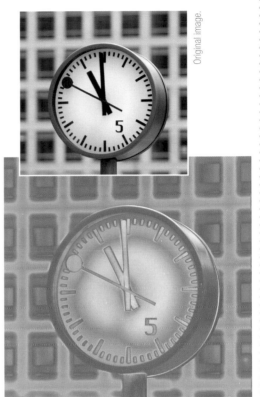

Original image.

	A	B	C
❶	Exclusion	100	100
❷	Pin Light	100	100
❸	Difference	100	100
❹	Difference	100	100

	A	B	C
❶	Exclusion	100	100
❷	Pin Light	100	100
❸	Difference	100	100
❹	Difference	100	100

	A	B	C
❶	Exclusion	100	100
❷	Pin Light	100	100
❸	Difference	100	100
❹	Difference	100	100

115

Color Halftone

This recipe produces an image that is similar to the original and with its highlights more saturated, but reverses and reduces contrast in the shadows and midtones. It usually results in a darkening of the image, but this can be fine-tuned by adjusting the Difference layer.

Dark skies

With this night shot, notice how the brightly lit church is almost as the original, but reversal occurs in the shadows. To fix this, I reduced the opacity of the Difference layer.

Natural reversal

In this example, a much lower opacity was set for the Difference layer, which produced a combination of natural and reversed tones.

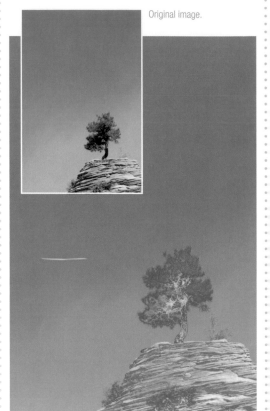

Original image.

Original image.

1 In the Layers palette, duplicate the original image layer by dragging the background layer onto the "Create a new layer" icon, or use Ctrl/Cmd-J.

2 Using the pull-down blending mode menu in the Layers palette or the shortcut Alt/Opt-Shift-S, change the new layer's blending mode to Screen and name it "Screen."

3 In the Layers palette, use Ctrl/Cmd-J to make another copy of the background layer and drag the new layer to the top of the layer stack.

4 Change the new layer's blending mode to Exclusion using the pull-down menu or the shortcut Alt/Opt-Shift-X and name it "Exclusion."

5 Invert the Exclusion layer using Ctrl/Cmd-I.

6 Use Ctrl/Cmd-J to duplicate the Exclusion layer, then change the new layer's blending mode to Difference using the pull-down menu or the shortcut Alt/Opt-Shift-E. Name the layer "Difference."

7 Set the Difference layer's fill opacity to 50%—this is a starting point and can be fine-tuned afterward.

8 In the Layers palette, use Ctrl/Cmd-J to make another copy of the background layer and drag it to the top of the layer stack.

9 Change the new layer's blending mode to Hue using Alt/Opt-Shift-U and name it "Hue."

	A	B	C
1	Hue	100	100
2	Difference	100	30
3	Exclusion	100	100
4	Screen	100	100

	A	B	C
1	Hue	100	100
2	Difference	100	15
3	Exclusion	100	100
4	Screen	100	100

Positive reversal

Here, the white of the clown's face remains a positive image, but tonal reversals occur all over the rest of this colorful image.

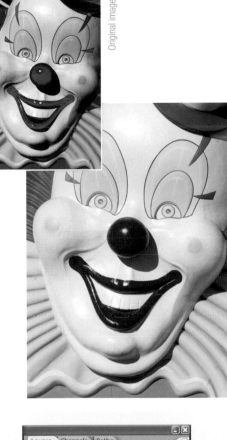

Original image.

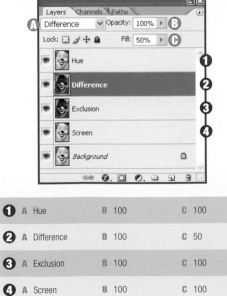

Ghostly effect

Again, for this image to work, I had to reduce the opacity of the Difference layer.

Original image.

Saturated color

Here, the result is highly saturated. I also added a little blur to the Hue layer, which resulted in colored edges.

Original image.

117

Positive reversal panel

Layers / Channels / Paths
A Difference Opacity: 100% B
Lock: ☒ 🖉 ✛ 🔒 Fill: 50% C

- Hue ①
- **Difference** ②
- Exclusion ③
- Screen ④
- Background 🔒

①	A Hue	B 100	C 100
②	A Difference	B 100	C 50
③	A Exclusion	B 100	C 100
④	A Screen	B 100	C 100

Ghostly effect panel

Layers / Channels / Paths
A Difference Opacity: 100% B
Lock: ☒ 🖉 ✛ 🔒 Fill: 30% C

- Hue ①
- **Difference** ②
- Exclusion ③
- Screen ④
- Background 🔒

①	A Hue	B 100	C 100
②	A Difference	B 100	C 30
③	A Exclusion	B 100	C 100
④	A Screen	B 100	C 100

Saturated color panel

Layers / Channels / Paths
A Difference Opacity: 100% B
Lock: ☒ 🖉 ✛ 🔒 Fill: 30% C

- Hue + blur 25 ①
- **Difference** ②
- Exclusion ③
- Screen ④
- Background 🔒

①	A Hue	B 100	C 100
②	A Difference	B 100	C 30
③	A Exclusion	B 100	C 100
④	A Screen	B 100	C 100

Sometimes we want an image that is imperfect. I like to imitate the black spots that you can find on old black-and-white prints. These occur where there are "dropouts"—silver grains that have dislodged from the negative—which allow enlarger light to shine through.

While we can apply a filter and add noise or grain, it's not easy to adjust it afterward. Varying the layer's opacity may vary the noise, but it isn't that "all or nothing" effect that you get from a damaged negative.

Photoshop provides many ways to another option. To emulate dropouts, blend with Dissolve. This mode outputs pixels from either the blend or the underlying layers. The blend layer's opacity controls the proportion of the blend layer's pixels that will be present in the final image. While we could blend copies of the original, it's as easy to fill the blend layer with a color. Later we can drag the opacity slider to fine-tune the dropout degradation.

1 In the Layers palette, duplicate the original image. Drag the background layer onto the "Create a new layer" icon, or use Ctrl/Cmd-J.

2 Invert the new layer using Ctrl/Cmd-I.

3 Using the pull-down blending mode menu in the Layers palette or the shortcut Alt/Opt-Shift-U, change the new layer's blending mode to Hue and name it "Hue."

4 Reduce the Hue layer's opacity to about 50%.

5 Duplicate the Hue layer, and using either the pull-down blending mode menu or the shortcut Alt/Opt-Shift-Z, change the new duplicate layer's blending mode to Pin Light and name it "Pin Light."

6 Set the Pin Light layer's opacity to 30% and add a little blur—10 will be enough. Try changing the fill opacity instead of the main layer opacity.

7 Either go to **Layer > New > Layer** (Ctrl/Cmd-Shift-N) or click on the "Create a new layer" icon in the Layers palette to add a new layer at the top of the layer stack.

8 Using the pull-down blending mode menu in the Layers palette or the shortcut Alt/Opt-Shift-I, set the new layer's blending mode to Dissolve, fill it with a dark color using the Paint Bucket tool (G), and call it "Dissolve."

9 Reduce the Dissolve layer's opacity until you like the balance between the image and the noise. I find a low percentage, around 10%, works best.

10 If you want to change the image's tone, use Ctrl/Cmd-Shift-N to add a new transparent layer and change the layer's blending mode to Color. Fill the layer with a color. I like to use a cold sepia tone, but vivid shades of blue can work well too.

Faded color effect I

The underlying image disappears if the Dissolve layer is set at more than 10%. Also consider eliminating the Pin Light layer's color shifts by desaturating the image.

Original image.

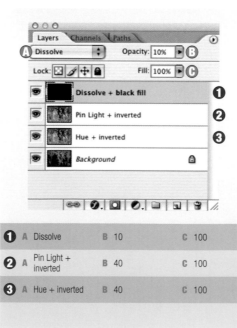

	A		B		C	
1	Dissolve		10		100	
2	Pin Light + inverted		40		100	
3	Hue + inverted		40		100	

Faded color effect II

This image also needed a low opacity for the Dissolve layer. Pin Light at 100% created too much "blooming," so I reduced the Pin Light layer's opacity.

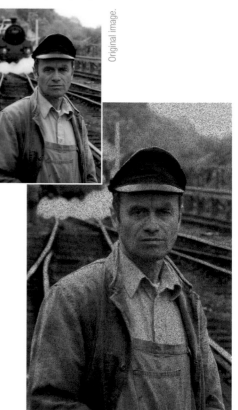

Original image.

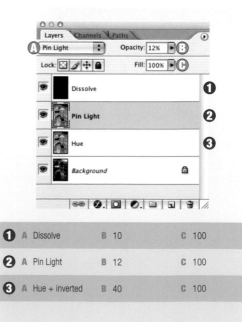

	A		B		C	
1	Dissolve		10		100	
2	Pin Light		12		100	
3	Hue + inverted		40		100	

Faded hand-colored effect

A Color blending mode was filled with a dark gray and used to replace the Pin Light layer. Setting it to a lower opacity allowed some of the stronger colors to show through.

Original image.

Soft tint effect

Try adding a Color blending mode layer as well the Pin Light layer.

Original image.

Inverted color effect

In this example, the blue sky became sandy-colored when it was inverted.

Original image.

	A		B		C	
1	Dissolve		10		100	
2	Color		60		100	
3	Hue		40		100	

	A		B		C	
1	Dissolve		10		100	
2	Color		90		100	
3	Pin Light		40		100	
4	Hue		40		100	

	A		B		C	
1	Dissolve		12		100	
2	Pin Light		100		20	
3	Hue		30		100	

Water Droplets

It's easy to add the effect of water droplets. You don't need to sandwich your original with a stock photograph of droplets. Instead, make some water droplets of your own, and add steam or mist to simulate looking through a window or into a mirror.

1 In the Layers palette, duplicate the original layer by dragging the background layer onto the "Create a new layer" icon, or use Ctrl/Cmd-J.

2 Add a new layer using either the "Create a new layer" icon or the shortcut Ctrl/Cmd-Shift-N and name "Droplets."

3 Hit the D key to reset the foreground and background colors, press the X key to switch the foreground and background colors, then hit Alt/Option-Backspace to fill the new layer with white.

4 Set the Droplets layer's blending mode to Hard Light using the pull-down blending mode menu in the Layers palette or the shortcut Alt/Opt-Shift-H.

5 Using **Filter > Noise > Add Noise**, add noise to the Droplets layer. Use Gaussian Noise with a value of 200, and check monochromatic check box.

6 With the Droplets layer active, apply blur using **Filter Blur > Gaussian Blur**. The Radius value needn't be greater than 5.

7 Select **Image > Adjustments > Threshold** and drag the slider to the right—the dots grow larger.

8 Repeat steps 4 and 5. Keep the droplets below 50% of the total image.

9 Check the foreground color is still white, then choose **Select > Color Range**; with the default settings, the white pixels should automatically be selected. Click OK.

10 Hit Delete (Backspace), and the layer should only consist of water droplets.

11 Invert the selection using Ctrl/Cmd-Shift-I.

12 Set the foreground color to a light gray and use Alt/Opt-Backspace to fill the droplets with it.

13 In the Layers palette, click the "Add a layer style" icon and select Bevel and Emboss.

14 Also in the Layer Styles dialog box, double-click Stroke and add a darker gray stroke, with its size set to 1 pixel and the Opacity at around 50%. Click OK.

15 In the Layers palette, duplicate the background layer using Ctrl/Cmd-J. Change this new layer's blending mode to Screen and name this layer "Screen" or "Steam."

16 With the Screen layer active, use **Filter > Blur > Gaussian Blur**, and set a radius of 150.

17 Adjust the Screen layer's opacity and consider masking or blurring it.

Textured glass effect

Here, I used a mask on the Steam layer so the mistiness was higher toward the top. (See page 82 for creating masks.)

Original image.

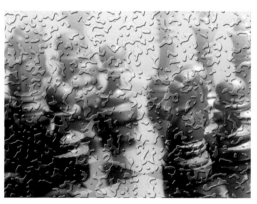

	A		B		C	
❶	Hard Light		100		100	
❷	Screen		80		100	

Altered landscape

A clipping mask is used so that the top Hue/Saturation adjustment layer only colors the raindrops. The mask is created when you hold down Alt/Opt and click the line between the two layers—you'll notice that the cursor briefly changes shape.

Original image.

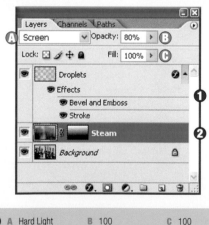

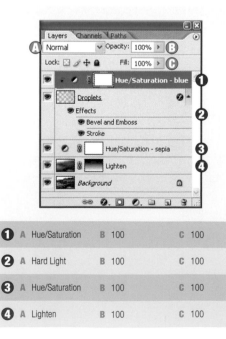

	A		B		C	
❶	Hue/Saturation		100		100	
❷	Hard Light		100		100	
❸	Hue/Saturation		100		100	
❹	Lighten		100		100	

Blurred steam effect

To keep the girl's face sharp, I added a mask to the blurred steam layer, and the droplets were deleted manually around her mouth and eyes.

Textured vignette effect

Again, a mask is used on the center of this picture. There is also a little vignetting because of the use of a Screen blending mode, which lightened the edges of the image.

High-contrast images

This recipe isn't just suitable only for low-contrast, muted images. Here, I also used a mask to reduce the blurring of the balloons.

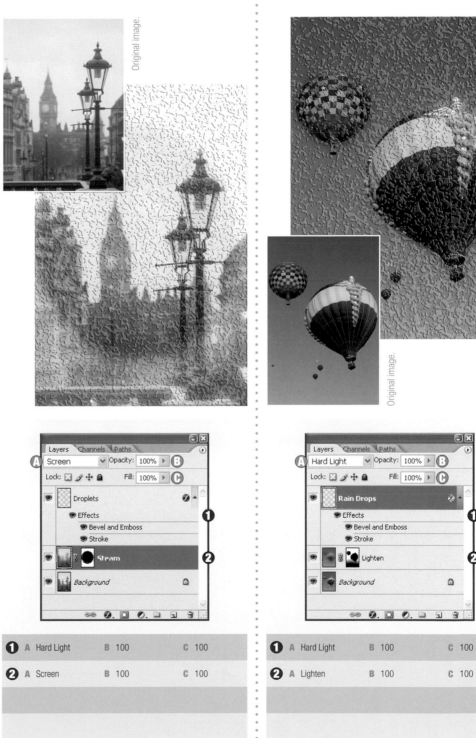

Original image.

121

❶	A Hard Light	B 100	C 100
❷	A Lighten	B 80	C 100

❶	A Hard Light	B 100	C 100
❷	A Screen	B 100	C 100

❶	A Hard Light	B 100	C 100
❷	A Lighten	B 100	C 100

Lens Flare

Lens flare is usually something you try to avoid, but it can create atmosphere in a photo. It's easy to add flare in Photoshop, but there are good and bad ways to do it. The lazy way is to apply the Lens Flare filter to the image—at worst, you might even overwrite the original image. Alternatively, add flare to a copy of the original layer, but this is less convenient if you want to edit the image or apply adjustments—your changes will affect both the image and the lens flare. The solution is to create the lens flare on its own layer and use blending modes to fine-tune the result.

It's always worth checking what authentic lens flare looks like. I shot this with a 14mm lens.

1 In the Layers palette, double-click the background layer and name the layer "Original."

2 Go to **Image > Canvas Size**. Make the canvas at least double the original image size. This step is included to allow you to reposition the flare layer afterward, so you don't need to be too precise.

3 Go to either **Layer > New > Layer** (Ctrl/Cmd-Shift-N) or else click on the "Create a new layer" icon in the Layers palette to create a new layer. Name the layer "Flare."

4 Using the pull-down blending mode menu in the Layers palette or the shortcut Alt/Opt-Shift-H, set the Flare layer's blending mode to Hard Light.

5 Go to **Edit > Fill**, and, in the Fill dialog box, select 50% Gray in the Contents drop-down menu and Overlay in the Blending

pull-down menu. Then click OK.

6 With the Flare layer active, select **Filter > Render > Lens Flare** and add the flare.

7 If the flare is in the wrong place, select the Move tool (M) and move the Flare layer. This is where steps 1 and 2 become useful—without them, moving the Flare layer would show the layer's edges.

8 You can also use **Edit > Transform** to resize the Flare—just remember to hold down the Shift key as you drag the layer's corners to retain the correct proportions.

9 Finally, if necessary, crop the new image back to the borders of the original image. In the Layers palette, Ctrl/Cmd-Click the Original layer and then use **Image > Crop**.

122

Adding sun

Original image.

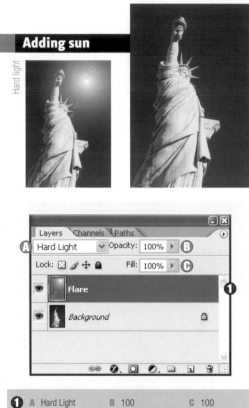

Hard light

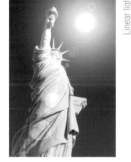

A Hard Light **B** 100 **C** 100

A Hard Light blending mode produces the most natural effect. Using Linear Light as the blending mode resulted in an image that looked as if it included the sun.

Linear light

A Linear Light **B** 100 **C** 100

Adding a highlight

After adding the flare, I repositioned the brightest spot directly over a highlight on the nearest balloon.

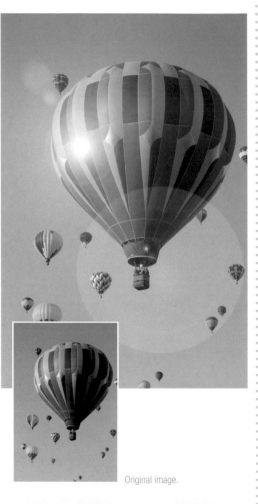

Original image.

A Hard Light **B** 100 **C** 100

Adding lens flare

The Screen blending mode is often best at replicating how flare can produce washed-out, low-contrast results.

Original image.

Adding atmosphere

This contre-jour image (whereby the photographer shoots into the light) already contained lens flare. I duplicated the Photoshop Flare layer to intensify the atmosphere it lent the image.

Original image.

Emphasizing lens flare

This is another contre-jour image that was already slightly spoiled by true lens flare. I needed to duplicate the Photoshop Flare layer to strengthen its effect.

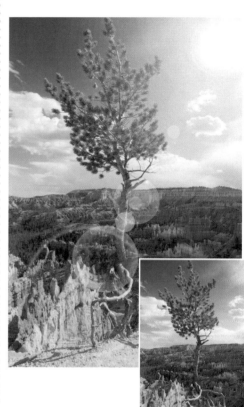

Original image.

	A		B		C	
①	A Hard Light		B 100		C 100	
②	A Hard Light		B 100		C 100	
③	A Hard Light		B 100		C 100	

① A Screen		B 100	C 100

① A Screen		B 100	C 100

Brushed Aluminum

The main ingredients for this brushed aluminum effect are the Hue and Vivid Light blending modes, with generous helpings of Noise, Motion, and Gaussian Blur filters, and, for variation, a dash of Unsharp Mask to roughen up the final result. It's another fun, quick technique, and you can work in your own variations by desaturating and inverting one or more layers—you can even experiment by changing the order of the layers.

You may want to crop the edges where the Motion Blur filter tails off.

1 In the Layers palette, duplicate the original image by dragging the background layer onto the "Create a new layer" icon. Alternatively, just use the keyboard shortcut Ctrl/Cmd-J. Name this layer "Hue."

2 With the Hue layer active, select Hue from the blending mode pull-down menu.

3 Invert the Hue layer by selecting **Image > Adjustments > Invert** (Ctrl/Cmd-I).

4 Make another copy of the original image (Ctrl/Cmd-J), rename it "Vivid Light," and drag it to the top of the layer stack.

5 With the Vivid Light layer active, select Vivid Light from the blending mode pull-down menu.

6 Add some noise with **Filter > Noise > Add Noise**. I used a value of around 100 and checked the Gaussian and Monochromatic check boxes.

7 With the Vivid Light layer still active, go to **Filter > Blur > Motion Blur**. Use the wheel to determine the direction of the blur and the Distance setting to adjust the length of the brushing effect.

8 Consider desaturating the Vivid Light layer (Ctrl/Cmd-U) and adjusting its opacity. Try inverting the image—use Ctrl/Cmd-I to toggle between positive and negative versions.

The Noise filter adds random grain. Here, I chose a high value and created a coarse output.

Textured still life

Here, the Hue layer's opacity is set to 50%, desaturating the image, and the Vivid Light layer's high opacity of 80% helps to restore the original colors.

Original image.

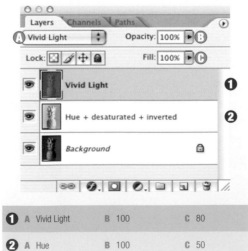

Unsharp Mask

Amount: 201 %

Radius: 0.5 pixels

Threshold: 4 levels

| ❶ | A | Vivid Light | B | 100 | C | 80 |
| ❷ | A | Hue | B | 100 | C | 50 |

❶ Vivid Light
❷ Hue + desaturated + inverted
Background

In this variation, the Vivid Light layer was sharpened using the Unsharp Mask. Applying Unsharp Mask makes the brushed effect much stronger and rougher.

Tintype

As the Hue layer's fill opacity approaches 50%, the image is increasingly like a black-and-white picture toned with the negative's color. At 50% it is black and white, while lower percentages gradually restore the original colors. Here, the Hue layer's opacity was set to 49%—just enough to restore some of the image's strongest colors.

Original image.

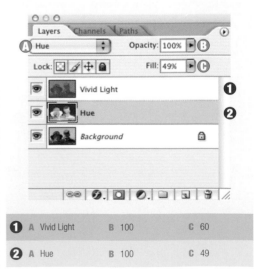

❶ Vivid Light
❷ Hue
Background

| ❶ | A | Vivid Light | B | 100 | C | 60 |
| ❷ | A | Hue | B | 100 | C | 49 |

False infrared

This method works well in this image of the London Eye, where there are large, evenly toned areas.

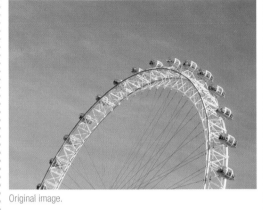

Original image.

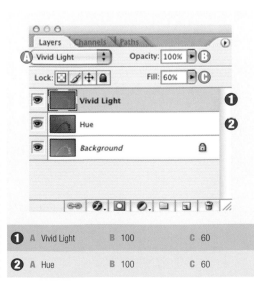

Textured landscape

This technique can also be used to advantage with soft, backlit subjects.

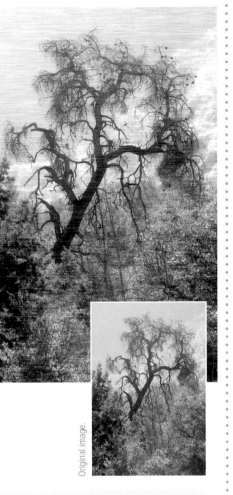

Original image.

Textured reversal

For a variation, I left the inverted original in Normal blending mode and left the blend layers at full opacity.

Original image.

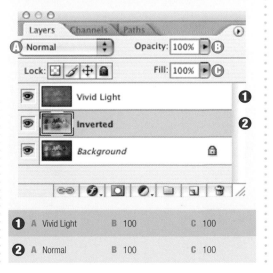

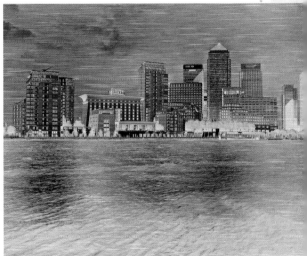

	A		B		C
❶	Vivid Light		100		60
❷	Hue		100		60

	A		B		C
❶	Vivid Light		100		52
❷	Hue		100		60

	A		B		C
❶	Vivid Light		100		100
❷	Normal		100		100

Vibrant Mix

This recipe works best on low-contrast, slightly drab images and uses the Hard Mix blending mode to inject color. Hard Mix is so powerful that it's often necessary to balance it with another blending mode or reduce its effect using the layer's fill opacity. A small percentage change can make a very big difference to the result, so I find it's more precise to put the cursor in the Fill Opacity box in the Layers palette and use the keyboard's Up and Down arrows. You can very quickly go from primary colors to something that is almost natural—best of all, you can always fine-tune the results.

1 In the Layers palette, duplicate the original image layer by dragging the background layer onto the "Create a new layer" icon, or use Ctrl/Cmd-J.

2 Using the pull-down blending mode menu in the Layers palette or the shortcut Alt/Opt-Shift-L, change the duplicate layer's blending mode to Hard and rename it "Hard Mix."

3 Go to **Image > Adjustments > Desaturate** or use Ctrl/Cmd-Shift-U to desaturate the Hard Mix layer.

4 Invert the Hard Mix layer using Ctrl/Cmd-I.

5 Use Ctrl/Cmd-J to duplicate the original image layer again, and drag the new layer to the top of the layer stack.

6 Use the pull-down blending mode menu or the shortcut Alt/Opt-Shift-Z to change the new layer's blending mode to Pin Light and call it "Pin Light." The main purpose of the layer is to add some blur, and any of the other contrast-increasing blending modes will be fine.

7 Blur the Pin Light layer using **Filters > Blur > Gaussian Blur**. Set a radius of around 10–20.

8 In the Layers palette, activate the Hard Mix layer again and blur it with a very small amount of blur. Do check what would happen with a higher value, but 1 or 2 is enough for now.

9 Adjust the Hard Mix layer's fill opacity to taste.

126

Basic technique

Reducing the Hard Mix layer's opacity by just 7% was enough to replace the primary colors with near-realistic tones.

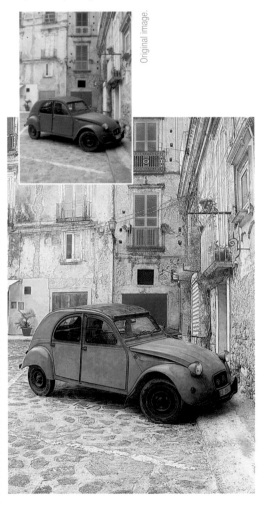

Original image.

| ❶ | A | Pin Light | B | 100 | C | 100 |
| ❷ | A | Hard Mix | B | 100 | C | 93 |

Choosing settings

You can see big differences with small percentage changes in the Hard Mix layer's opacity. 93% looked right to me here.

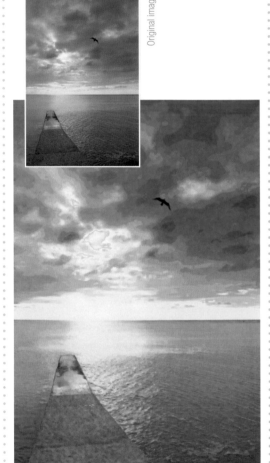

Original image.

| ❶ | A | Pin Light | B | 100 | C | 100 |
| ❷ | A | Hard Mix | B | 100 | C | 93 |

Graphic effect

In this example, I preferred the Hard Mix primary colors and left the Hard Mix layer's opacity at 100%.

Original image.

Vibrant portraits

Skin tones are uncontrollable with this recipe—even with 65% fill opacity, the Hard Mix layer is dominant.

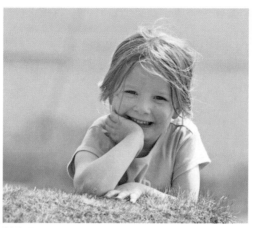

Original image.

Moderating saturation

The painted acorn had such saturated yellows and blues that the Hard Mix layer needed to be set at 80% fill opacity to reduce its effect.

Original image.

127

	A	Pin Light	B	100	C	100
1	A	Pin Light	B	100	C	100
2	A	Hard Mix	B	100	C	100

	A	Pin Light	B	100	C	100
1	A	Pin Light	B	100	C	100
2	A	Hard Mix	B	100	C	65

	A	Pin Light	B	100	C	100
1	A	Pin Light	B	100	C	100
2	A	Hard Mix	B	100	C	80

Ultra Color

A really quick way to add color to an image is with the Hard Mix blending mode, which turns an image into just eight colors. Combine Hard Mix with some blur, and the results can be spectacular.

1 In the Layers palette, duplicate the original image layer by dragging the background layer onto the "Create a new layer" icon, or use Ctrl/Cmd-J.

2 Using the pull-down blending mode menu in the Layers palette or the shortcut Alt/Opt-Shift-L, change the duplicate layer's blending mode to Hard Mix and rename it "Hard Mix."

3 Invert the Hard Mix layer using Ctrl/Cmd-I.

A typical Hard Mix self-blend.

Desaturating the Hard Mix layer results in an explosion of colors.

4 Go to **Image > Adjustments > Desaturate** or use Ctrl/Cmd-Shift-U to desaturate the Hard Mix layer.

5 Blur the Hard Mix layer by using **Filters > Blur > Gaussian Blur**. It's best to zoom in to 100% or go to **View > Actual Pixels** (Ctrl/Cmd-Alt/Opt-0) so that the preview matches the final result.

Adding a halo

This picture needed a blur radius of 15 for the halo effect.

Original image.

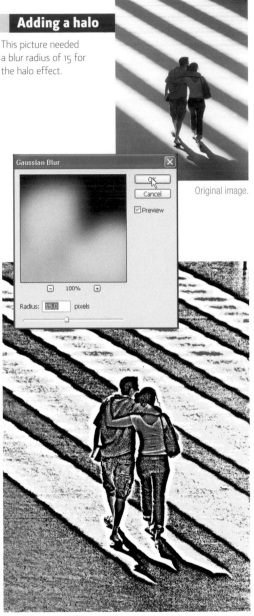

1	A Hard Mix	B 100	C 100

Emphasizing details

Here, the blur radius was only 4, which helped to emphasize the detail in this building's windows.

Original image.

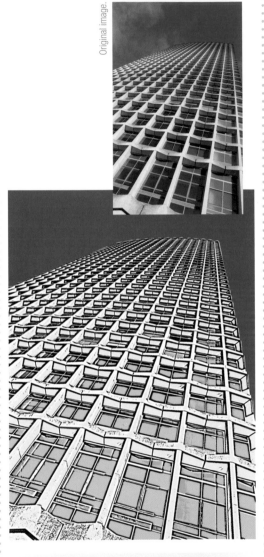

1	A Hard Mix	B 100	C 100

Adding visual interest

Any subject can be transformed by this recipe.

Original image.

Controlling the mix

In this example, the slightly lower fill opacity moderated the effect of the Hard Mix layer.

Original image.

Adjusting settings for best results

Hard Mix is very powerful and even a small reduction in fill opacity can have a big effect.

Original image.

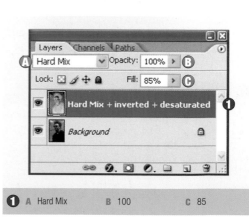

129

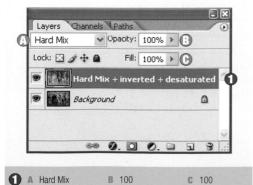

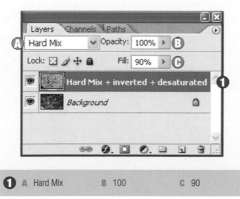

	A	Hard Mix	B	100	C	100

	A	Hard Mix	B	100	C	90

	A	Hard Mix	B	100	C	85

Rimmed Color

As you've already seen, the Hard Mix blending mode simplifies pictures by boiling them down to just eight colors. Although it can often be very crude, a Hard Mix blend layer can also be a great base upon which to build other effects. This recipe utilizes a Color blending layer to restore some natural color to the image. Here, the Hard Mix layer is blurred and forms nice halos around edges, so this recipe is most effective on images with plenty of detail—but feel free to experiment with any image.

1 In the Layers palette, duplicate the original image layer by dragging the background layer onto the "Create a new layer" icon, or use Ctrl/Cmd-J.

2 Using the pull-down blending mode menu in the Layers palette or the shortcut Alt/Opt-Shift-L, change the duplicate layer's blending mode to Hard Mix and rename it "Hard Mix."

3 Invert the Hard Mix layer using Ctrl/Cmd-I.

4 Go to **Image > Adjustments > Desaturate** or use Ctrl/Cmd-Shift-U to desaturate the Hard Mix layer.

5 In the Layers palette, use Ctrl/Cmd-J to duplicate the original image layer, and drag the new layer to the top of the layer stack.

6 Using the pull-down blending mode menu in the Layers palette or the shortcut Alt/Opt-Shift-C, change the duplicate layer's blending mode to Color and rename it "Color."

7 In the Layers palette, activate the Hard Mix layer and apply some blur using **Filters > Blur > Gaussian Blur**. The aim is to produce a bright halo around the image's main details. A radius of 20 is usually enough.

Drag a duplicate of the original image to the top of the layer stack and set its blending mode to Color. If you do this before blurring the Hard Mix layer, you can see the final result as you adjust the blur radius.

Halo haze

Experiment with the amount of blur. A low blur radius may be enough, while too high a radius may create a halo that overwhelms the picture.

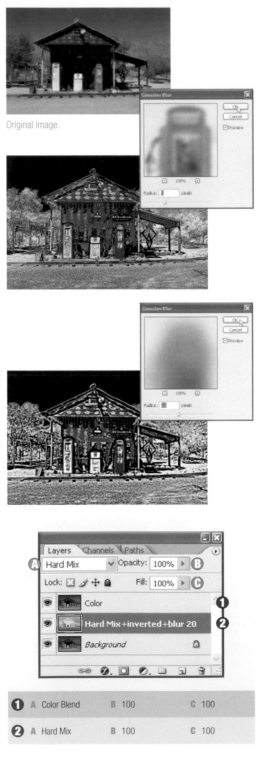

Original image.

| 1 | A Color Blend | B 100 | C 100 |
| 2 | A Hard Mix | B 100 | C 100 |

Unnatural pallor

Consider inverting the Color layer (Ctrl/Cmd-I) for an unnatural effect. Control the skin color by dragging the Color layer's opacity slider—at 100% it will be an odd turquoise green.

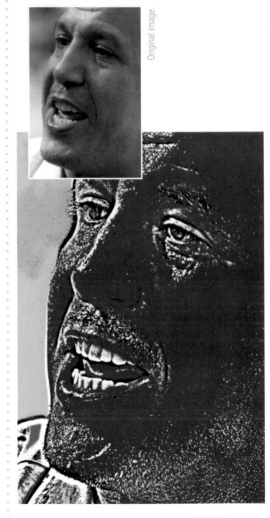

Original image.

| 1 | A Color | B 50 | C 100 |
| 2 | A Hard Mix | B 100 | C 100 |

130

A Gaussian blur radius of 50 produced a deliberately artificial result.

Original image.

The halo effect can emphasize details such as these soldiers' rifles.

Original image.

The final result is usually a positive image with exaggerated colors.

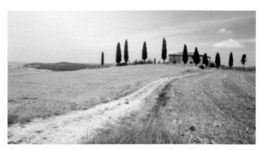

Original image.

	A	B	C
1	Color Blend	100	100
2	Hard Mix	100	100

	A	B	C
1	Color Blend	100	100
2	Hard Mix	100	100

	A	B	C
1	Color Blend	100	100
2	Hard M ix	100	100

Grainy Hard Mix

Instead of using a Color blending mode layer to balance the result of a Hard Mix layer as I did in the previous recipe, this recipe uses a second layer with its blending mode set to Dissolve. This mode adds a grittiness to the image which can be varied in intensity by adjusting the opacity and inverting the color. This is another quick and flexible recipe that works well on most images.

1 In the Layers palette, duplicate the original image layer by dragging the background layer onto the "Create a new layer" icon, or use Ctrl/Cmd-J.

2 Using the pull-down blending mode menu in the Layers palette or the shortcut Alt/Opt-Shift-L, change the duplicate layer's blending mode to Hard Mix and rename it "Hard Mix."

3 Invert the Hard Mix layer using Ctrl/Cmd-I.

4 Go to **Image > Adjustments > Desaturate** or use Ctrl/Cmd-Shift-U to desaturate the Hard Mix layer.

5 Apply some blur using **Filters > Blur > Gaussian Blur**. The Hard Mix layer will not dominate this recipe so, apply a radius of 10.

6 In the Layers palette, duplicate the original image layer again using Ctrl/Cmd-J, and drag the new layer to the top of the layer stack.

7 Using the pull-down blending mode menu in the Layers palette or the shortcut Alt/Opt-Shift-C, change the duplicate layer's blending mode to Color and rename it "Color."

8 Reduce the opacity of the Color layer—it doesn't matter if it's the layer or the fill opacity.

9 In the Layers palette, use Ctrl/Cmd-J to duplicate the Color layer, then use Alt/Opt-Shift-I to change the new layer's blending mode to Dissolve; rename it "Dissolve."

10 Adjust the Dissolve layer's opacity. At 100%, the composite image appears like the original picture. Anything between 10 and 50% adds an attractive graininess to the final result.

The inverted Hard Mix layer produces a vividly colored result.

Subdued color

The Color and Dissolve layers can be combined to produce subdued results.

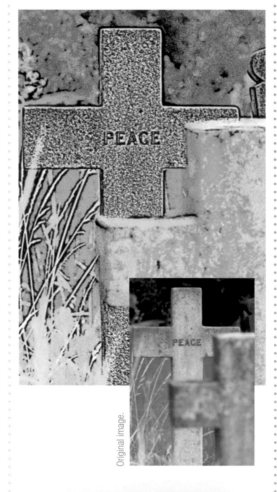

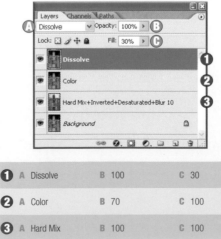

Original image.

	A		B		C	
1	Dissolve		100		30	
2	Color		70		100	
3	Hard Mix		100		100	

Rich color

The recipe is also well-suited to originals with bright colors and strong shapes.

Original image.

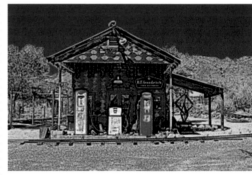

	A		B		C	
1	Dissolve		100		30	
2	Color		70		100	
3	Hard Mix		100		100	

Extra grain

Setting Dissolve's layer opacity to 50% produces lots more grain.

Original image.

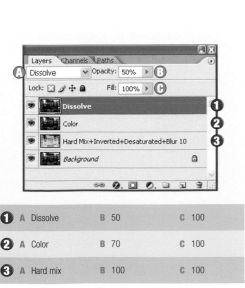

❶	A Dissolve	B 50	C 100
❷	A Color	B 70	C 100
❸	A Hard mix	B 100	C 100

Evening tones

There's always a possibility that Hard Mix will separate evenly toned areas, such as the late afternoon sky. Try reducing the Hard Mix layer's fill opacity—it can sometimes fix the problem.

Original image.

❶	A Dissolve	B 100	C 30
❷	A Color	B 70	C 100
❸	A Hard mix	B 100	C 100

Engraving

Try this recipe with black-and-white shots too—there may not be any color, but the result can sometimes resemble an engraving.

Original image.

I reduced the Hard Mix layer's fill opacity to 90%, enough to unify the sky without losing this blend mode's powerful effect.

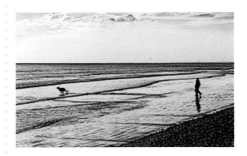

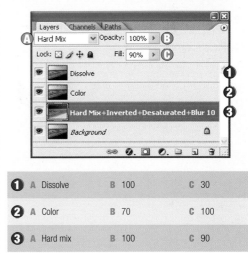

❶	A Dissolve	B 100	C 30
❷	A Color	B 70	C 100
❸	A Hard mix	B 100	C 90

133

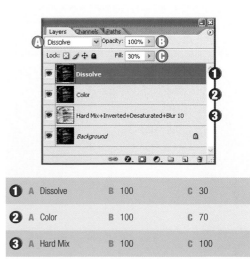

❶	A Dissolve	B 100	C 30
❷	A Color	B 100	C 70
❸	A Hard Mix	B 100	C 100

Color Gel

This recipe was described to me as being like shooting with a secondary light source using a colored gel. Deeply saturated colors are added to deeper shadows. Other colors are relatively untouched.

1 In the Layers palette, duplicate the original image layer by dragging the background layer onto the "Create a new layer" icon, or use Ctrl/Cmd-J.

2 Using the pull-down blending mode menu in the Layers palette or the shortcut Alt/Opt-Shift-G, change the new layer's blending mode to Lighten and name it "Lighten."

3 With the Lighten layer active, select **Filter > Blur > Gaussian Blur** and set a small radius. Try 10 as a starting point.

4 In the Layers palette, use Ctrl/Cmd-J to make another duplicate of the original image layer. Move it to the top of the layers, and using the shortcut Alt/Opt-Shift-X, change its blending mode to Exclusion; name it "Exclusion."

5 Use Ctrl/Cmd-I to invert the Exclusion layer. At this stage, the image should appear partially reversed, but low contrast.

6 Make another duplicate of the original image layer, place it at the top of the layer stack, and set its blending mode to Hard Mix using the shortcut Alt/Opt-Shift-L; name it "Hard Mix."

7 Reduce the Hard Mix layer's fill opacity to retain the high contrast and the lighter colors.

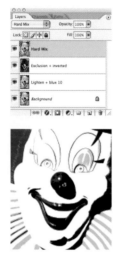

The finishing touch is to moderate Hard Mix's crude eight-color result—simply reduce the fill opacity.

Don't reduce the Hard Mix layer's opacity—the result is too low-contrast.

Spotlight effect

The best result for this picture was when the Hard Mix layer's fill opacity was set to 80%.

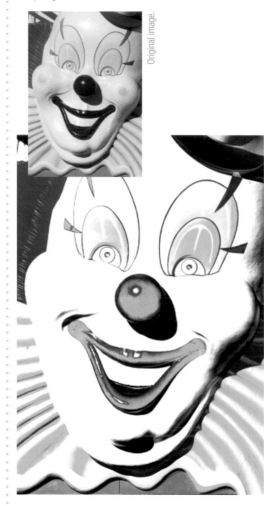

Original image.

	A		B		C	
1	A Hard Mix		B 100		C 80	
2	A Exclusion		B 100		C 100	
3	A Lighten		B 100		C 100	

Pastel effect

For the best result, this picture's Hard Mix layer's fill opacity could be anything above 50%.

Original image.

	A		B		C	
1	A Hard Mix		B 100		C 50	
2	A Exclusion		B 100		C 100	
3	A Lighten		B 100		C 100	

Modulating the effect

Too high a fill opacity can cause Hard Mix to separate smoothly toned areas.

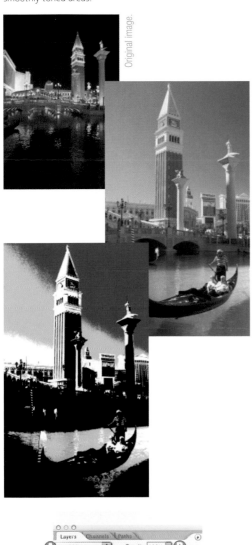

Original image.

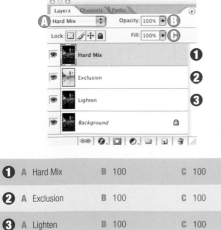

Unreal color

Nighttime shots can be transformed. Here, the fill opacity needed to be between 80 and 100%.

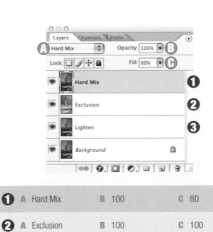

Color gel portraits

Outdoor shots of people can be given an almost psychedelic effect.

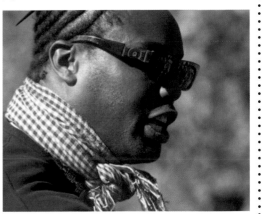

Original image.

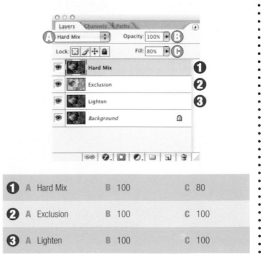

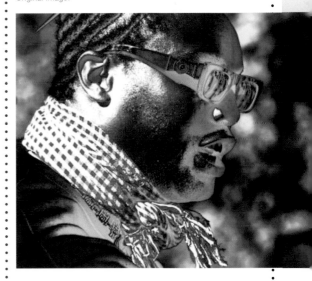

	A		B		C
❶	Hard Mix		100		100
❷	Exclusion		100		100
❸	Lighten		100		100

	A		B		C
❶	Hard Mix		100		80
❷	Exclusion		100		100
❸	Lighten		100		100

	A		B		C
❶	Hard Mix		100		80
❷	Exclusion		100		100
❸	Lighten		100		100

Powder Pastels

This recipe replaces the colors of the original image with powdery pastels. Apart from being great on its own, this recipe can be a great shortcut for hand-coloring an image.

1 In the Layers palette, duplicate the original image layer by dragging the background layer onto the "Create a new" layer icon, or use Ctrl/Cmd-J.

2 Using the pull-down blending mode menu in the Layers palette or the shortcut Alt/Opt-Shift-U, change the new layer's blending mode to Hue, and rename it "Hue."

3 Invert the Hue layer using Ctrl/Cmd-I.

4 Change the Hue layer's opacity to 50%. At this stage the image is almost grayscale.

5 Duplicate the Hue layer and change the new layer's blending mode to Color Dodge using the shortcut Alt/Opt-Shift-D. Name the new layer "Color Dodge."

6 Increase the Color Dodge layer's opacity to 100%.

7 Apply a small amount of blur to the Color Dodge layer with **Filter > Blur > Gaussian Blur**. Use a small radius— 5 should be enough to emphasize edges within the picture.

8 Use Ctrl/Cmd-J to duplicate the Color Dodge layer and set the new layer's blending mode to Pin Light using the shortcut Alt/Opt-Shift-Z; name it "Pin Light."

9 Invert the new Pin Light layer using Ctrl/Cmd-I.

10 Go to **Image > Adjustments > Desaturate** or use Ctrl/Cmd-Shift-U to desaturate the Pin Light layer.

136

Subtle color

Shadows and midtones turn grayscale, pure blues become yellows, reds come out cyan, and greens go lilac.

Original image.

	A		**B**		**C**	
1	A	Pin Light	B	100	C	80
2	A	Color Dodge	B	100	C	100
3	A	Hue	B	50	C	100

Soft color

As expected with this recipe, the dark wood behind these ceramics has become grayscale.

Original image.

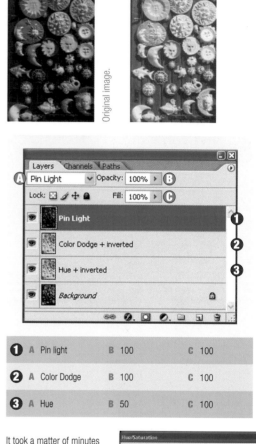

	A		**B**		**C**	
1	A	Pin light	B	100	C	100
2	A	Color Dodge	B	100	C	100
3	A	Hue	B	50	C	100

It took a matter of minutes to create this hand-colored effect. One Hue/Saturation layer saturated the colors, and another used the Color Range selection to create a mask, over which I added the sepia tone.

Using the recipe as a starting point, I used **Select > Color Range** to select the grayscale parts of this image.

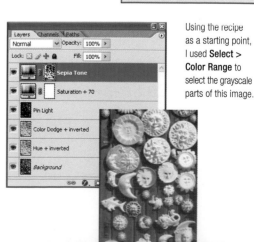

Reversed color

Where colored areas are very dark, they will become grayscale. A polarizing filter was used for this photo, and the dark sky has separated into pastel and grayscale areas.

Original image.

Color midtones

Reduce the Pin Light layer's fill opacity to restore some pastel colors in the midtones.

Original image.

Modulating the effect

Again, it was helpful to reduce the Pin Light layer's opacity —until this was done, the only colors were a yellow in the blue sky and some dashes of pale blue in the foreground.

Original image.

	A		B		C	
1	A	Pin Light	B	100	C	100
2	A	Color Dodge	B	100	C	100
3	A	Hue	B	50	C	100

	A		B		C	
1	A	Pin Light	B	100	C	70
2	A	Color Dodge	B	100	C	100
3	A	Hue	B	50	C	100

	A		B		C	
1	A	Pin Light	B	50	C	100
2	A	Color Dodge	B	100	C	100
3	A	Hue	B	50	C	100

Hard Light on Fine Edges

This recipe can create an effect rather like a watercolor, but with harsher lines. On top of an edge drawing, a blurred Hard Light layer gently restores some original color. Sandwiched between them is an inverted Hard Mix layer that lets you control the harshness of the lines. The result is generally soft.

1 In the Layers palette, duplicate the original image layer by dragging the background layer onto the "Create a new layer" icon, or use Ctrl/Cmd-J.

2 Run the Find Edges filter using **Filters > Stylize > Find Edges**.

3 Create another copy of the background layer and make it the top layer.

4 Using the pull-down blending mode menu in the Layers palette or the shortcut Alt/Opt-Shift-L, change the new layer's blending mode to Hard Mix and name it "Hard Mix."

5 Using Ctrl/Cmd-I, invert the Hard Mix layer and then press Ctrl /Cmd Shift U to desaturate.

6 Set the Hard Mix layer's fill opacity to between 10 and 30%.

7 Use Ctrl/Cmd-J to create another copy of the background layer and drag it to the top of the layer stack.

8 Change the new layer's blending mode to Hard Light using the shortcut Alt/Opt-Shift-H and name it "Hard Light."

9 Blur the Hard Light layer using **Filter > Blur > Gaussian Blur**— it doesn't need much.

138

Colored pencil

This photograph of an eroded landscape looks like a colored drawing.

Original image.

Bleached effect

Setting the Hard Mix layer's opacity to 100% has bleached this picture.

Original image.

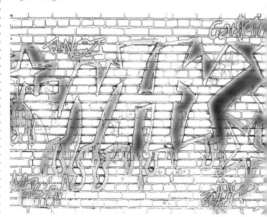

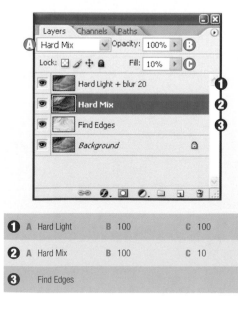

	A		B		C	
1	Hard Light		100		100	
2	Hard Mix		100		10	
3	Find Edges					

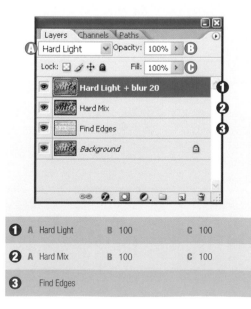

	A		B		C	
1	Hard Light		100		100	
2	Hard Mix		100		100	
3	Find Edges					

Bleached colored pencil

It's not the inverted Hard Mix layer that makes the water look as if it is a negative image—the fine droplets were backlit and produced lots of dark edges in the Find Edges layer.

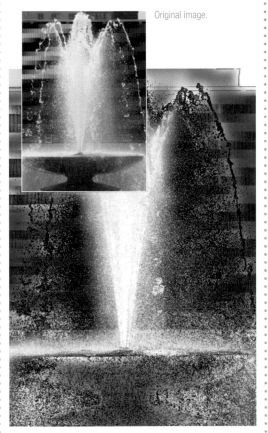

Original image.

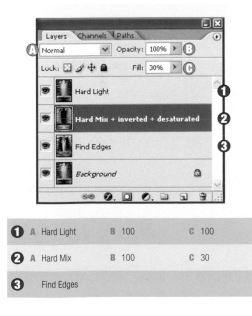

Soft cartoon effect

A little more blur made the image more like a cartoon.

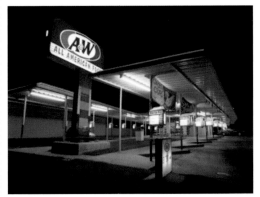

Original image.

Soft glow

This picture worked better with more blur and a Hard Mix fill opacity of 50%.

Original image.

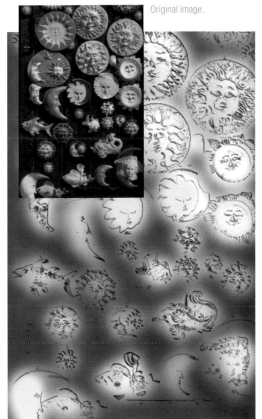

139

❶	A Hard Light	B 100	C 100
❷	A Hard Mix	B 100	C 30
❸	Find Edges		

❶	A Hard Light	B 100	C 100
❷	A Hard Mix	B 100	C 100
❸	Find Edges		

❶	A Hard Light	B 100	C 100
❷	A Hard Mix	B 100	C 50
❸	Find Edges		

Vivid Pastels

This recipe's key ingredient is a layer that has been inverted and whose blending mode has been set to Exclusion. The result is a partial inversion of the image with shadows and midtones reversing, but highlights remaining largely unaffected. The resulting colors are soft but vivid—with the right image, a very pleasing result is achieved.

1 In the Layers palette, duplicate the original image layer by dragging the background layer onto the "Create a new layer" icon, or use Ctrl/Cmd-J.

2 Using the pull-down blending mode menu in the Layers palette or the shortcut Alt/Opt-Shift-G, change the new layer's blending mode to Lighten and name the layer "Lighten."

3 Blur the Lighten layer with **Filter > Blur > Gaussian Blur**. Use a small radius for now—you can always blur this layer again later.

4 Use Ctrl/Cmd-J to duplicate the original image layer again; move the new layer to the top of the layer stack and change its blending mode to Exclusion using the shortcut Alt/Opt-Shift-X.

5 Invert the Exclusion layer using the shortcut Ctrl/Cmd-I so that the image becomes a partial negative.

6 Make another copy of the original image layer, drag it to the top of the layer stack, and set its blending mode to Overlay using the shortcut Alt/Opt-Shift-O.

Shadow glow

The original image's highlights remain, but color reversal occurs in shadow areas.

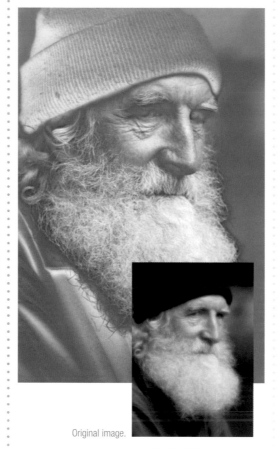

Original image.

Dark halo

The angle of light means that the transformation is concentrated on the shadow side of the rose.

Original image.

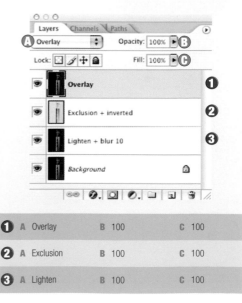

	A Overlay	B 100	C 100
1	A Overlay	B 100	C 100
2	A Exclusion	B 100	C 100
3	A Lighten	B 100	C 100

	A Overlay	B 100	C 100
1	A Overlay	B 100	C 100
2	A Exclusion	B 100	C 100
3	A Lighten	B 100	C 100

Dark shadows

Only the stone acorn and the arch have been reversed. Notice too how the blur causes a halo around the sculpture.

Original image.

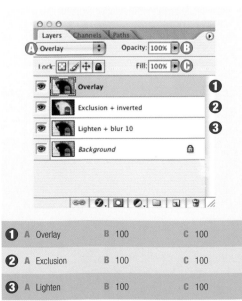

Backlit images

A backlit image also contains a suitable mixture of shadows, which reverse, and highlights, which retain the original coloration.

Original image.

The natural look

The tonal balance in this example resulted in reversal of the balloons, but a natural-looking sky.

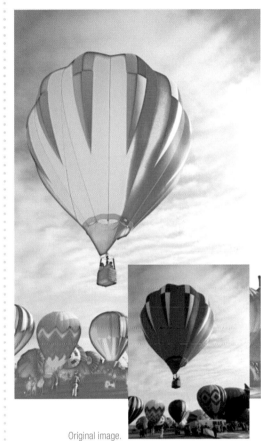

Original image.

Layers / Channels / Paths

A Overlay Opacity: 100% B

Lock: Fill: 100% C

Overlay	❶
Exclusion + inverted	❷
Lighten + blur 10	❸
Background	

❶ A Overlay B 100 C 100

❷ A Exclusion B 100 C 100

❸ A Lighten B 100 C 100

Layers / Channels / Paths

A Overlay Opacity: 100% B

Lock: Fill: 100% C

Overlay	❶
Exclusion + inverted	❷
Lighten + blur 10	❸
Background	

❶ A Overlay B 100 C 100

❷ A Exclusion B 100 C 100

❸ A Lighten B 100 C 100

Layers / Channels / Paths

A Overlay Opacity: 100% B

Lock: Fill: 100% C

Overlay	❶
Exclusion + inverted	❷
Lighten + blur 10	❸
Background	

❶ A Overlay B 100 C 100

❷ A Exclusion B 100 C 100

❸ A Lighten B 100 C 100

Super Pastels

H ere's a simple recipe that you can use to transform an image into a bright pastel piece. The first (and key) step is to bleach the image by blending it with a desaturated negative with its blending mode set to Color Dodge.

1 In the Layers palette, duplicate the original image layer by dragging the background layer onto the "Create a new layer" icon, or use Ctrl/Cmd-J.

2 Invert the new layer with Ctrl/Cmd-I.

3 Go to **Image > Adjustments > Desaturate** or use Ctrl/Cmd-Shift-U to desaturate the new layer.

4 Using the pull-down blending mode menu in the Layers palette or Alt/Opt-Shift-D, change the new layer's blending mode to Color Dodge and call it "Color Dodge." At this point, the image should appear bleached.

5 If you want to add an edge around the details, apply a little Gaussian Blur to the Color Dodge layer. A small radius is enough.

6 In the Layers palette, use Ctrl/Cmd-J to make another duplicate of the original image layer, move it to the top of the layers, and change its blending mode to Color Burn using the shortcut Alt/Opt-Shift-B; call it "Color Burn."

7 In the Layers palette, use Ctrl/Cmd-J to make a further duplicate of the original image layer, move it to the top of the layers, and change its blending mode to Screen using the shortcut Alt/Opt-Shift-S; call it "Screen."

8 Desaturate the new Screen layer using the shortcut Ctrl/Cmd-Shift-U and adjust its opacity until you're happy with the result.

High-key neon effect

This image already had quite a high-key effect and doesn't really need the Screen layer to brighten it further.

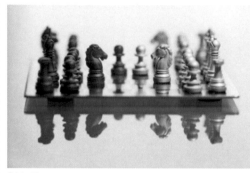

Original image.

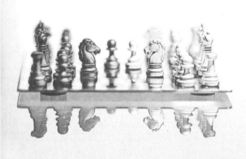

	A		B		C	
1	Screen		10		100	
2	Color Burn		100		100	
3	Color Dodge		100		100	

Soft neon effect

This image works better without the Screen layer.

Original image.

	A		B		C	
1	Color Burn		100		100	
2	Color Dodge		100		100	

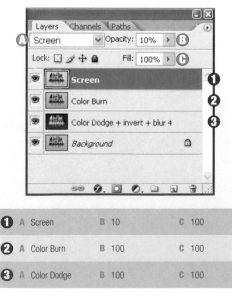

Illustration effects

I also applied more Gaussian blur, a radius of 35, to add more interest to the blended image. Notice the tell-tale halos around the jacket and in the lettering.

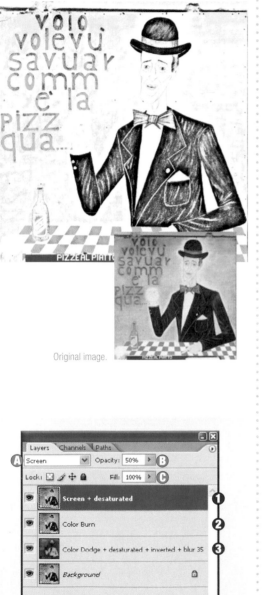

Original image.

Bleached neon effect

This car's colors were so soft that I strengthened the lines and colors by adding four Color Burn layers. The pastel colors were maintained by desaturating the upper layers.

Original image.

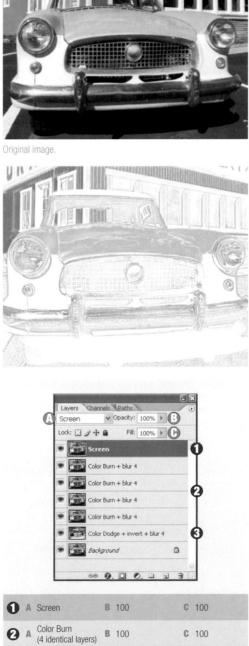

Lighter palette

In this example, the original image was much darker, so I set the Screen layer to a higher percentage opacity to brighten it. Because the photo was taken in late afternoon light, the colors were very saturated, so I used a lower opacity for the Color Burn layer.

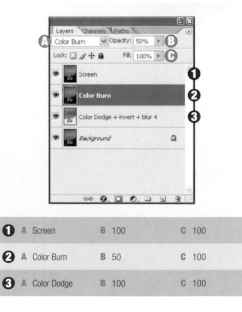

Original image.

Layers / Channels / Paths
A: Screen — B: Opacity: 50%
Lock: — C: Fill: 100%

- ❶ Screen + desaturated
- ❷ Color Burn
- ❸ Color Dodge + desaturated + inverted + blur 35
- Background

	A	B	C
❶	Screen	50	100
❷	Color Burn	100	100
❸	Color Dodge	100	100

Layers / Channels / Paths
A: Screen — B: Opacity: 100%
Lock: — C: Fill: 100%

- ❶ Screen
- Color Burn + blur 4
- Color Burn + blur 4
- ❷ Color Burn + blur 4
- Color Burn + blur 4
- ❸ Color Dodge + invert + blur 4
- Background

	A	B	C
❶	Screen	100	100
❷	Color Burn (4 identical layers)	100	100
❸	Color Dodge	100	100

Layers / Channels / Paths
A: Color Burn — B: Opacity: 50%
Lock: — C: Fill: 100%

- ❶ Screen
- ❷ Color Burn
- ❸ Color Dodge + invert + blur 4
- Background

	A	B	C
❶	Screen	100	100
❷	Color Burn	50	100
❸	Color Dodge	100	100

Colored Sketches

Maybe I'm compensating for my inability to draw or paint, but I often convert photographs to line drawings and then restore some colors. This recipe began just that way. On top of a line drawing, I restored some color with a Color Burn self-blend, added some grittiness with a Dissolve layer, and finished it off with some contrast and color from one of the contrast group of blending modes. The result is often a mix of a charcoal and a crayon sketch.

1 In the Layers palette, duplicate the original image layer by dragging the background layer onto the "Create a new layer" icon, or use Ctrl/Cmd-J.

2 Using **Filters > Styles > Find Edges**, make this new layer into a line drawing. Leave its blending mode set to Normal and name the layer "Find Edges."

3 In the Layers palette, duplicate the original image layer using the shortcut Ctrl/Cmd-J. Drag this new layer to the top of the layer stack and, using the pull-down blending mode menu in the Layers palette or the shortcut Alt/Opt-Shift-B, change its blending mode to Color Burn. Name the layer "Color Burn."

4 Using **Filter > Blur > Gaussian Blur**, apply a small amount of blur to the Color Burn layer—a radius of 5 should be enough.

5 Use Ctrl/Cmd-J to duplicate the original image layer again, move the new layer to the top of the layer stack, and set the new layer's blending mode to Dissolve using the shortcut Alt/Opt-Shift-I; name this layer "Dissolve."

6 Reduce the opacity of the Dissolve layer to a low percentage. This value can vary widely—from 5 to 50%.

7 Make another copy of the original image layer, make it the top layer, and set its blending mode to one of the contrast group of blending modes. Try Pin Light or Hard Light first.

8 Apply a small amount of blur to this top layer—a Gaussian blur radius of 5 should be enough.

Enhancing detail

Here, the Pin Light layer restored some body to this photograph of a preaching cowboy.

Original image.

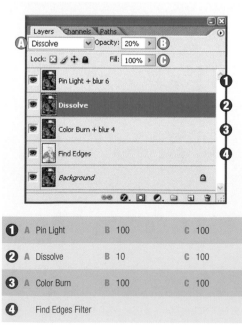

	A		B		C	
1	Pin Light		100		100	
2	Dissolve		10		100	
3	Color Burn		100		100	
4	Find Edges Filter					

Adding texture

The Dissolve layer's blending mode was set to 50% to give this urban landscape a gritty appearance.

Original image.

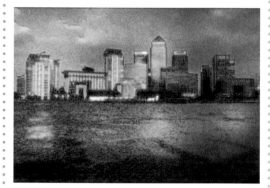

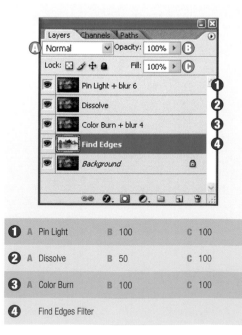

	A		B		C	
1	Pin Light		100		100	
2	Dissolve		50		100	
3	Color Burn		100		100	
4	Find Edges Filter					

Bleaching

This recipe tends to bleach a moderately high-key original.

Original image.

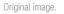

1	A Pin Light	B 100	C 100	
2	A Dissolve	B 10	C 100	
3	A Color Burn	B 100	C 100	
4	Find Edges Filter			

Antique effect

Part of the fun of playing with blending modes is that you never know quite how things will turn out with some recipes. I had recorded this recipe as an action, and just applied it to an old scan of a 35mm slide.

Original image.

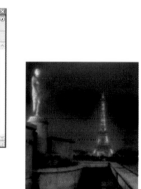

Just to see what happened, I added an inverted self blend set to Overlay, then changed the mode of this top layer to Color.

1	A Pin Light	B 100	C 100	
2	A Dissolve	B 10	C 100	
3	A Color Burn	B 100	C 100	
4	Find Edges Filter			

Charcoal effect

With this recipe, the image has a charcoal-drawing effect.

Original image.

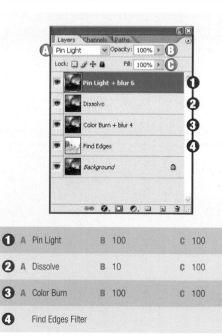

145

1	A Pin Light	B 100	C 100	
2	A Dissolve	B 10	C 100	
3	A Color Burn	B 100	C 100	
4	Find Edges Filter			

Faded Fresco

It's easy to spot the main ingredient in this recipe—it's the Dissolve blend mode. The clue lies in the stippled effect: the result of Dissolve's random use of pixel colors from either the blend or the base layer. With the Dissolve layer's opacity set at a high value, the image is severely degraded, but at low opacity much more of the underlying image is visible. The use of Screen blending layers restores some of the original image.

Damaged fresco

Although I began this recipe by shifting the picture's color with an inverted Hue layer, the main effect here is the Dissolve layer. At a high fill opacity, there's no obvious effect. Reduce the opacity below 50% and it really starts to show. Here, I pushed the fill opacity right down to 5%. At this point I was reminded of damaged frescoes, of the original, I applied a pair of Screen layers. In addition to varying the Dissolve layer's fill opacity, try changing its position or swapping it between inverted and non-inverted display.

The Dissolve blending mode layer set to a low fill opacity causes "dropouts" that resemble a chipped and damaged fresco.

Stippling shadows and highlights

In this alternative, I desaturated the Dissolve layer. You can use Image > Adjustments > Desaturate (Ctrl/Cmd-Shift-U), but I'm a black-and-white enthusiast and like to control desaturation more precisely. To let me preview the likely result, I first reduced the fill opacity to 30%. Then I chose Image > Adjustments > Channel Mixer and checked the Monochrome check box. The default conversion was just right for this picture. With this method you can adjust the Channel Mixer dialog box's RGB sliders to fine-tune the conversion process.

Try desaturating the Dissolve layer.

Here, I used the Channel Mixer's Blue channel rather than the default Red—notice how the black stippling is now in the sky, and the sign has a light pattern.

Original image.

1 In the Layers palette, duplicate the original image by dragging the background layer onto the "Create a new layer" icon. Alternatively, just use the keyboard shortcut Ctrl/Cmd-J. Name this layer "Hue."

2 With the Hue layer active, select Hue from the blending mode pull-down menu. Invert this layer by selecting Image > Adjustments > Invert (Ctrl/Cmd-I).

3 Return to the original image and make another copy (Ctrl/Cmd-J); call it "Dissolve."

4 Drag the Dissolve layer above the Hue layer and select Dissolve from the blending mode pull-down menu. Invert this layer (Ctrl/Cmd-I) and set the fill opacity to 5%.

5 Return to the original image and make another copy (Ctrl/Cmd-J); call it "Screen."

6 Drag the Screen layer to the top of the Layers palette and select Screen from the blending mode pull-down menu.

7 Duplicate the Screen layer.

	A		B		C	
1	A	Screen	B	100	C	100
2	A	Screen	B	100	C	100
3	A	Dissolve + invert	B	100	C	5
4	A	Hue + invert	B	100	C	100

	A		B		C	
1	A	Screen	B	100	C	100
2	A	Dissolve + desaturated	B	100	C	31

Modulating color

I shot this street sign close to midday at Williams, Arizona, and wanted to capture the clean, saturated colors. It becomes a very different sort of image with this recipe. Try varying either the Dissolve layer's opacity or fill opacity—it makes no difference.

Strong, clear colors can be given a gritty texture with Dissolve.

Soft effect

You don't always want the dropout effect to be accompanied by the color shifts that result from using an inverted layer. But self-blending with Dissolve has no effect, as it shows pixels from either the base or blend layer. The solution is to blur the blend layer and then reduce the opacity. Experiment with the position of the Dissolve and Screen layers—if Dissolve is on top, there's usually a darker grittiness, while having Screen on top softens the final result.

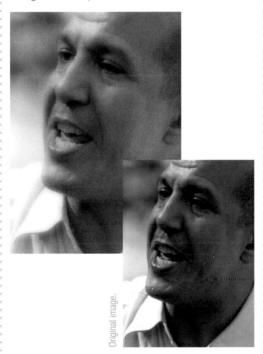

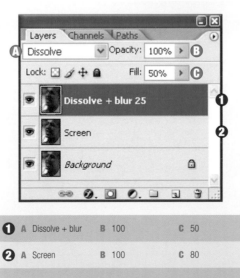

Pointillist effect

Again, in this example, the Dissolve layer has been set at a low opacity, and I also made sure that I had the opacity turned down before applying the Channel Mixer to desaturate the image. As I adjusted the red slider, this more Pointillist effect became increasingly apparent. As always, it's a question of experimenting until a recipe tastes just right.

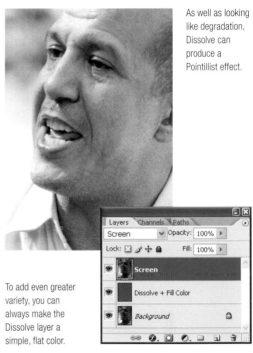

As well as looking like degradation, Dissolve can produce a Pointillist effect.

To add even greater variety, you can always make the Dissolve layer a simple, flat color.

147

	A		B		C	
❶	A Screen		B 100		C 100	
❷	A Dissolve + invert		B 100		C 31	

❶	A Dissolve + blur	B 100		C 50
❷	A Screen	B 100		C 80

❶	A Screen	B 100		C 100
❷	A Dissolve + channel mixer	B 100		C 15

Fauve Colors

This recipe transforms any picture using a pair of negatives. The first negative is desaturated and set to the Color Dodge blending mode, and dramatically brightens the original image's shadows. The top negative layer is set to the Color Burn mode and restores some original color. I prefer the Fauve colors that result from inverting this Color Burn layer, but also try leaving it as a positive image—in either case, the result is bright and artificial with no pure blacks.

1 In the Layers palette, duplicate the original image layer by dragging the background layer onto the "Create a new layer" icon, or use Ctrl/Cmd-J.

2 Using the pull-down blending mode menu in the Layers palette or the shortcut Alt/Opt-Shift-D, change the new layer's blending mode to Color Dodge. Rename it "Color Dodge."

3 Go to **Image > Adjustments > Desaturate** or use Ctrl/Cmd-Shift-U to desaturate the Color Dodge layer.

4 Invert the Color Dodge layer using the shortcut Ctrl/Cmd-I. The image should now be very bright and positive.

5 Blur the Color Dodge layer using **Filter > Blur > Gaussian Blur**. Use a small radius, such as 5—you can always blur this layer again later. This step restores some edge detail.

6 Duplicate the original image layer again by dragging the background layer onto the "Create a new layer icon," or use Ctrl/Cmd-J and drag this new layer to the top of the layer stack.

7 Change the new layer's blending mode to Color Burn with Alt/Opt-Shift-B.

8 Invert the new Color Burn layer with Ctrl/Cmd-I.

Before blur. / After blur.

Fauvorite place

The colorful midtones of this mock-Italian small town made it an ideal subject for this recipe.

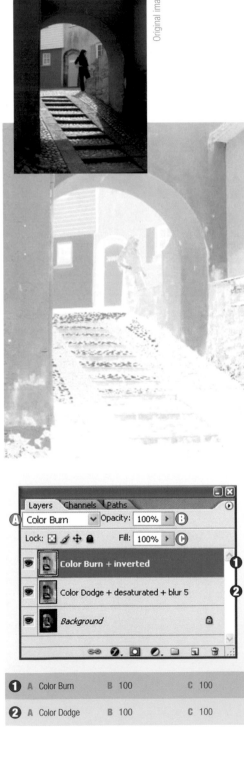

Original image.

| ❶ A Color Burn | B 100 | C 100 |
| ❷ A Color Dodge | B 100 | C 100 |

Textured shadows

With this recipe, all colors are brightened—in this example, the color noise in the shadows beneath this classic car is particularly exaggerated.

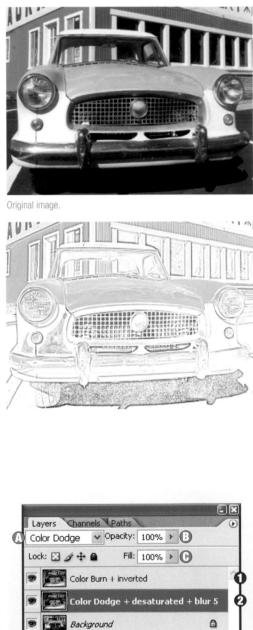

Original image.

| ❶ A Color Burn | B 100 | C 100 |
| ❷ A Color Dodge | B 100 | C 100 |

Working with midtones

The color-reversal effect is less obvious when the image contains lots of midtones.

Original image.

Flattening shadows

This clown sign contained only bright colors. It now looks more like a sketch than a photograph.

Original image.

Landscapes

Even landscapes can be cooked in this spicy sauce.

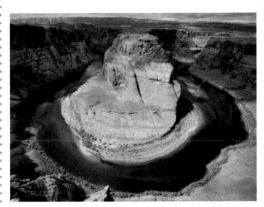

Original image.

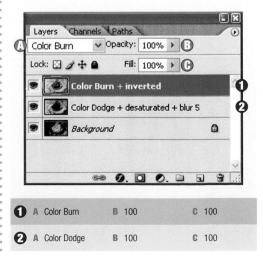

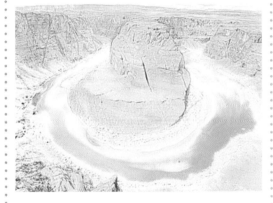

149

	A	B	C
1	Color Burn	100	100
2	Color Dodge	100	100

	A	B	C
1	Color Burn	100	100
2	Color Dodge	100	100

	A	B	C
1	Color Burn	100	100
2	Color Dodge	100	100

This recipe uses the Pin Light blending mode with two copies of the original image, one of which is inverted. They are placed over a plain background—I've used white, but it can be any color you want.

Pin Light belongs to the "gray group" of blend modes, so tones are lightened or darkened depending on whether they are lighter or darker than mid-gray. The inverted image is like a film negative, and former shadow areas have become highlights, which Pin Light washes out. Meanwhile, tone is added in the original image's highlights. As this is on a channel-by-channel basis, the inverted Pin Light layer creates partial reversals and color shifts. A second Pin Light layer then restores some of the original mid- and darker tones.

1 Open the image file and go to **Layer > New > Layer** (Ctrl/Cmd-Shift-N). In the New Layer dialog box, call the new layer "Normal+White," then click OK.

2 Click the white box in the Color Picker icon at the bottom of the Toolbar and then select the Paint Bucket tool Ctrl/Cmd-G).

3 Ensuring you're still on the Normal+White layer, fill the new layer with white.

4 In the Layers palette, duplicate the original image by dragging the background layer onto the "Create a new layer" icon (Ctrl/Cmd-J). Name this layer "Pin Light+Inverted."

5 Drag the Pin Light +Inverted layer above the Normal+White layer. Invert the Pin Light+Inverted layer by selecting **Image > Adjustments > Invert** (Ctrl/Cmd-I).

6 With the Pin Light +Inverted layer still active, select Pin Light from the blending mode pull-down menu.

7 Return to the original image, duplicate it again, and call it "Pin Light."

8 Drag the Pin Light layer to the top of the Layers palette, and again, select Pin Light blending mode.

Pale facade

Eliminating the inverted layer results in a higher-contrast image.

I shot this Italian church at sunset, hence the beautiful, warm colors of the building, but long, dark shadows in the olive groves. Using this recipe, the shadow areas remain natural-looking, while the blue sky has gained a little yellow, blue's opposite color (created by the inverted layer); and the warm-toned church facade is lit with cyan, which is the opposite of red.

Original image.

A strongly saturated image becomes candy-colored with this effect.

	A		B		C	
1	Pin Light		100		100	
2	Pin Light + inverted		100		100	
3	Normal + white		100		100	

Amazing grays

Believe it or not, this is a color photograph. It was taken in London one December morning and contains mainly midtones. The Candy Color recipe doesn't add much color, but it lifts the image and gives it a slightly "unreal" edge, almost like the darkroom technique known as solarization. When faced with this sort of image, it can be an interesting exercise to experiment with the plain layer, filling it with another color or even leaving it out completely.

Original image.

A drab image can be revived.

Leaving out the white layer has made the most of the cold grays.

	A		B		C	
1	Pin Light		100		100	
2	Pin Light + inverted		100		100	
3	Normal + white		100		100	

Evening tones

When these hot-air balloons rose into the sky, the sun was just rising and the warm colors were highly saturated. Notice how the apparently even tones in the sky have been separated and colors shifted in opposite directions. Reducing the opacity of the inverted Pin Light layer can help, though below 50% you soon start losing the partial reversal effects.

Blurry midtones

This recipe can produce all sorts of strange tonal reversals in the mid- and lighter tones when it's combined with a little Gaussian blur. If you apply blur to the inverted Pin Light layer, the final result retains sharper detail in the shadows, such as the lettering, and some dark haloes such as around the left of the hand. Blurring the top Pin Light layer reduces the darker details while adding color shifts in the lighter areas.

Diffused light

Taking this picture of a burned tree in Zion Canyon, I shot into the sun on a misty September morning. The light was very diffused and the image contained few strong tones, so the recipe produced a color shift in all parts of the image. Experiment with the amount of Gaussian blur that you apply to the inverted layer. Here, an amount of 80 has produced noticeable halos around the tree.

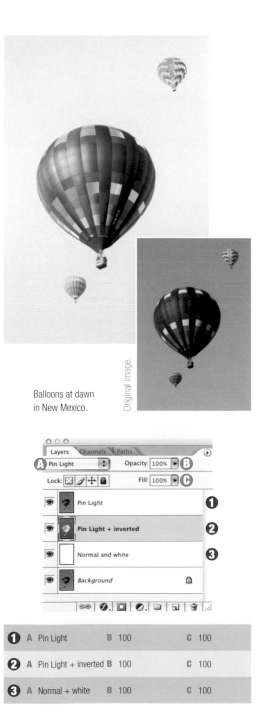

Balloons at dawn in New Mexico.

Original image.

Inverted blur layer

Top blur layer

Original image.

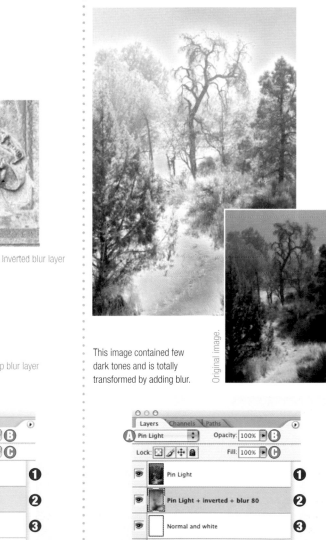

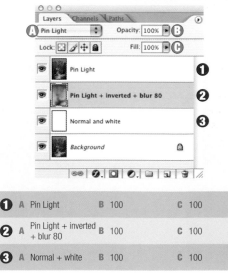

This image contained few dark tones and is totally transformed by adding blur.

Original image.

151

Evening tones

Layers / Channels / Paths

A Pin Light — Opacity: 100% B
Lock: Fill: 100% C

- 👁 Pin Light — **1**
- 👁 Pin Light + inverted — **2**
- 👁 Normal and white — **3**
- 👁 Background 🔒

	A		B	C
1	Pin Light		100	100
2	Pin Light + inverted		100	100
3	Normal + white		100	100

Column 2 (Blurry midtones)

Layers / Channels / Paths

A Pin Light — Opacity: 100% B
Lock: Fill: 100% C

- 👁 Pin Light — **1**
- 👁 **Pin Light + inverted + blur 80** — **2**
- 👁 Normal + white — **3**
- 👁 Background 🔒

	A		B	C
1	Pin Light		100	100
2	Pin Light + inverted + blur 80		100	100
3	Normal + white		100	100

Column 3 (Diffused light)

Layers / Channels / Paths

A Pin Light — Opacity: 100% B
Lock: Fill: 100% C

- 👁 Pin Light — **1**
- 👁 **Pin Light + inverted + blur 80** — **2**
- 👁 Normal and white — **3**
- 👁 Background 🔒

	A		B	C
1	Pin Light		100	100
2	Pin Light + inverted + blur 80		100	100
3	Normal + white		100	100

Line Drawing with Find Edges

A quick-and-easy way to create a line-drawing effect is to combine a blurred layer with a layer that has had the Find Edges filter applied to it. To accentuate the lines, use the Multiply blend mode on the top layer. This technique works best on images that have plenty of detail and pattern.

1 In the Layers palette, duplicate the original image by dragging the Background layer onto the "Create a new layer" icon. Alternatively, just use the keyboard shortcut Ctrl/Cmd-J. Name this layer "Find Edges."

2 With the Find Edges layer selected, go to **Filter > Stylize > Find Edges**.

3 Desaturate the Find Edges layer by selecting **Image > Adjustments > Desaturate** (Ctrl/Cmd-Shift-U).

4 Assess the Find Edges layer. If the lines aren't clearly defined, use either a Curves or Levels adjustment layer to increase the strength of the lines.

5 Return to the Original layer and duplicate the background image again; call it "Multiply."

6 Drag the Multiply layer to the top of the Layers palette and select Multiply blending mode from the pull-down blending mode menu.

7 With the Multiply layer still selected, go to **Filter > Blur > Gaussian Blur**. Experiment with the Radius slider in the Gaussian Blur dialog box. You'll notice that a greater radius value makes the line work more visible. Choose a setting that you're happy with.

8 Finally, try reducing the opacity of the Multiply layer to accentuate further the line work.

Adding blur

This technique requires two copies of the original. Just in case you need to go back, you can leave the original hidden. Apply some Gaussian blur to the Multiply layer. Here, a radius value of 20 was enough to maintain the blocks of color. You can always reduce the opacity of the Multiply layer to enhance the line work.

Original image.

Using Threshold

Try including a Threshold filter adjustment layer to reduce the line drawing layer to pure black and white. It can be especially helpful when the picture contains a lot of distracting detail such as the ferry's wake.

Original image.

1	A Multiply	B 100	C 100
2	A Threshold Filter	B 100	C 100
3	A Find Edges Filter	B 100	C 100

1	A Multiply	B 70	C 100
2	A Threshold Filter	B 100	C 100
3	A Find Edges Filter	B 100	C 100

Drawing the line

This example is my favorite use of the recipe. The band was playing in a Paris street market. Both the band's instruments and the shoes in the store window created clear line shapes and repeated patterns that remind me of some of Raoul Dufy's paintings. Reducing the opacity of the Multiply layer brought the colors closer to Dufy's soft palette.

Soft lines

A Curves adjustment layer supplied the light tonal balance that most suited this picture. Notice how the Find Edges filter has defined lines around some of the fluffy clouds.

Lightening effect

As an alternative to a Curves adjustment layer, reduce the Multiply layer's opacity. The lines will be more obvious —important here because blurring obscured the stripes of the deckchairs—and the whole image will be brightened by white coming through from the Find Edges layer.

Original image.

Original image.

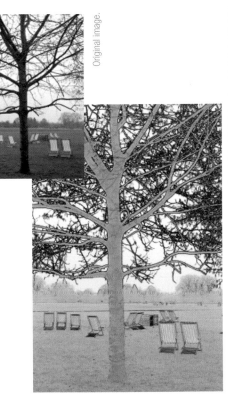

Original image.

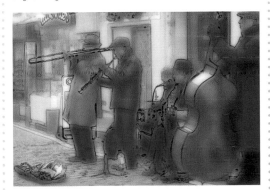

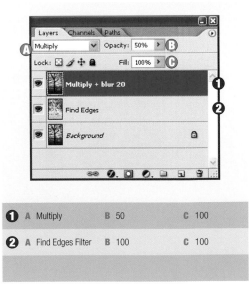

153

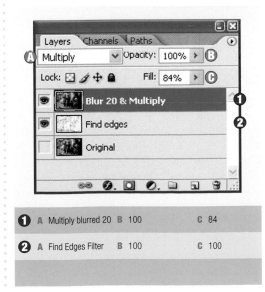

	A	B	C
1	Multiply blurred 20	100	84
2	Find Edges Filter	100	100

	A	B	C
1	Curves	100	100
2	Multiply	100	100
3	Find Edges Filter	100	100

	A	B	C
1	Multiply	50	100
2	Find Edges Filter	100	100

Colored Pen and Ink

While you can use the Find Edges filter to create a line drawing, you can also use blending modes to produce a much coarser drawing that can easily be fine-tuned, even after you've saved the image. On a desaturated original, create a line drawing with a single Color Dodge layer that has been blurred and inverted. You can then stack up a few positive Color Burn copies, and top the image with a blurred version of the color original with its mode set to Pin Light.

1 In the Layers palette, duplicate the original image by dragging the Background layer onto the "Create a new layer" icon. Alternatively, use the keyboard shortcut Ctrl/Cmd-J. Name this layer "Desaturated."

2 With the Desaturated layer active, go to **Image > Adjustments > Desaturate** (Ctrl/Cmd-Shift-U) to desaturate the image.

3 Duplicate the Desaturated layer (Ctrl/Cmd-J) and call it "Color Dodge."

4 With the Color Dodge layer active, select Color Dodge from the blending mode pull-down menu.

5 Invert the Color Dodge layer with **Image > Adjustments > Invert** (Ctrl/Cmd-I). The composite image should now appear white.

6 Apply a small amount of blur to the Color Dodge layer with **Filter > Blur > Gaussian Blur**. Use a small radius value—just enough to bring up a line drawing.

7 Duplicate the Color Dodge layer (Ctrl/ Cmd-J) and call it "Color Burn." Select Color Burn from the blending mode pull-down menu.

8 Invert the Color Burn layer with **Image > Adjustments > Invert** (Ctrl/Cmd-I) to make the line-drawing effect even stronger.

9 Duplicate this Color Burn layer as many times as you want (Ctrl/Cmd-J). Two or three should be sufficient for a strong pen-and-ink effect.

10 In the Layers palette, select the original Background layer. Duplicate it (Ctrl/Cmd-J), and drag the new color layer to the top of the stack of layers and call it "Pin Light."

11 Change the Pin Light layer's blending mode to Pin Light using the blending mode pull-down menu.

12 The final step is to apply Gaussian Blur to the Pin Light layer. Drag the radius slider until you're happy with the result.

Fine detail

Images with lots of fine detail work very well with multiple Color Burn layers. Even digital noise, visible here in the store ceiling, contributes to the grittiness of the final result.

Original image.

Old-fashioned effect

Historical themes can benefit from the Color Burn layers. Here, I added more Color Burn layers. I liked the engraved appearance that resulted from not restoring any color via the Pin Light layer.

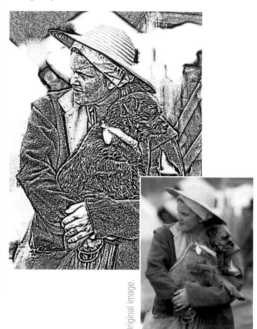

Original image.

154

Fine detail layers

Layers	Channels	Paths
A Pin Light	Opacity: 100% B	
Lock:	Fill: 100% C	

#	A	B	C
1	Pin Light + blur	100	100
2	Color Burn + blur	100	100
3	Color Burn + blur	100	100
4	Color Burn + blur	100	100
5	Color Dodge + inverted + blur	100	100
6	Desaturated	100	100

Old-fashioned effect layers

Layers	Channels	Paths
A Color Burn	Opacity: 100% B	
Lock:	Fill: 100% C	

#	A	B	C
1	Color Burn	100	100
2	Color Burn	100	100
3	Color Burn	100	100
4	Color Burn	100	100
5	Color Dodge	100	100
6	Desaturated	100	100

Rough detail

This recipe often brings out rough detail, even in brightly lit highlights.

Original image.

	A		B		C	
❶	A Pin Light	B	100	C	100	
❷	A Color Burn	B	100	C	100	
❸	A Color Burn	B	100	C	100	
❹	A Color Burn	B	100	C	100	
❺	A Color Dodge	B	100	C	100	
❻	A Desaturated	B	100	C	100	

Cross-processed portrait

I'd always felt that this picture was spoiled by the leather jacket and the plastic sheeting behind the Parisian accordionist, but this recipe's good at using such details.

Original image.

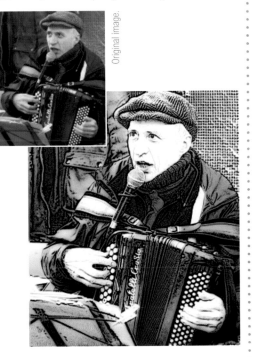

	A		B		C	
❶	A Pin Light	B	100	C	100	
❷	A Color Burn	B	100	C	100	
❸	A Color Burn	B	100	C	100	
❹	A Color Burn	B	100	C	100	
❺	A Color Dodge	B	100	C	100	
❻	A Desaturated	B	100	C	100	

Color uniform

This overexposed image needed a much stronger injection of color, so I set the top layer to Linear Burn instead of Pin Light.

Original image.

155

	A		B		C	
❶	A Linear Burn	B	100	C	100	
❷	A Color Burn	B	100	C	100	
❸	A Color Burn	B	100	C	100	
❹	A Color Burn	B	100	C	100	
❺	A Color Dodge	B	100	C	100	
❻	A Desaturated	B	100	C	100	

Pointillism

ere's another recipe that begins with a line drawing and adds color, but here the ingredient is Dissolve. New layers are set to a low opacity, filled with color, and have their blending modes set to Dissolve. The resulting image contains speckling from all of the colors. With practice, you can produce images with a pattern that is reminiscent of Pointillism.

The speckling occurs because Dissolve randomly shows pixels from the blend layer or the underlying image. Use the Edit > Fill command to paint the Dissolve layers with blocks of color, use layer masks to control where the color is visible, or paint color with the Brush or other tools. The colors can be chosen arbitrarily or sampled from the original image.

1 In the Layers palette, copy the original image layer by dragging the background layer onto the "Create a new layer" icon, or Ctrl/Cmd-J.

2 Invert the new layer using Ctrl/Cmd-I.

3 In the Layers palette or Alt/Opt-Shift-D, change the new layer's blending mode to Color Dodge. The image should be white. Rename "Color Dodge."

4 Apply a small amount of blur to the Color Dodge layer using **Filter > Blur > Gaussian Blur**. Use a small radius—enough for a line drawing.

5 Use Ctrl/Cmd-J to copy the Color Dodge layer and set the new layer's mode to Color Burn using the shortcut Alt/Opt-Shift-B. Rename "Color Burn."

6 Invert the Color Burn layer using Ctrl/Cmd-I. You now have a positive line image.

7 Choose **View > Actual Pixels**. If you are not working at 100%, the preview that may not match the true image.

8 In the Layers palette, click "Create a new layer" or Ctrl/Cmd-Shift-N. Place the new layer at the top of the stack. Set the new layer's mode to Dissolve with Alt/Opt-Shift-I. Name "Dissolve."

9 Reduce the Dissolve layer's opacity to 30%. Set the foreground color to yellow and use Alt/Opt-Backspace to fill the layer. Call this layer "Yellow."

10 Copy the Yellow Dissolve layer and reduce the new layer's opacity to 20%. Ensure that this layer is the top layer in the Layer palette, then fill it with red. Call the layer "Red."

11 Copy the Red Dissolve layer and set the new layer's opacity to 10%. Check that it is now the top layer, then fill it with blue. Call this "Blue."

12 It can be useful to put all the Dissolve layers in a layer set. In the Layers palette, click the "Create a new group" icon and drag the Dissolve layers into the group. You can then adjust their combined opacity with the layer group's slider.

156

Adding pixels

To increase the number of blue pixels in the sky, I added a second blue Dissolve layer and masked out the bridge and river.

Original image.

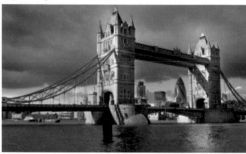

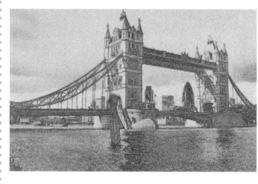

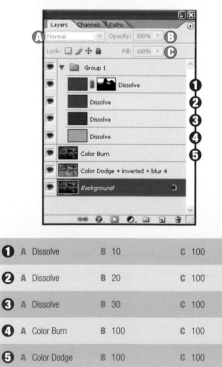

	A		B		C	
1	A	Dissolve	B	10	C	100
2	A	Dissolve	B	20	C	100
3	A	Dissolve	B	30	C	100
4	A	Color Burn	B	100	C	100
5	A	Color Dodge	B	100	C	100

Blue skies

The Pointillist painters would never have chosen such a viewpoint, but the effect works well on blue skies too. I also fine-tuned the contrast with a Curves layer.

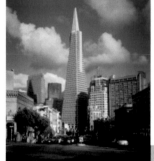

Original image.

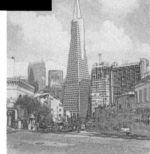

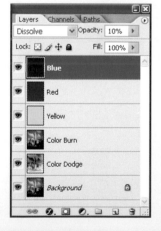

	A		B		C	
1	A	Dissolve	B	10	C	100
2	A	Dissolve	B	20	C	100
3	A	Dissolve	B	30	C	100
4	A	Color Burn	B	100	C	100
5	A	Color Dodge	B	100	C	100

Pointillist portrait

Notice how I included all the Dissolve layers in a layer group (click on the folder icon in the Layers palette to create a group folder) so that I can adjust their combined opacity with the group's opacity slider.

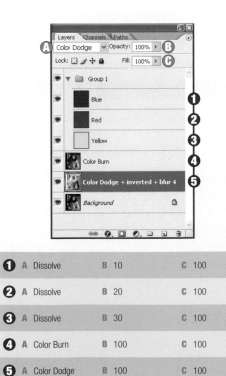

This recipe works on most types of image.

#	A	B	C
1	A Dissolve	B 10	C 100
2	A Dissolve	B 20	C 100
3	A Dissolve	B 30	C 100
4	A Color Burn	B 100	C 100
5	A Color Dodge	B 100	C 100

Blueprint

Here, I chose a blue by sampling the car's paintwork and set blue as the lowest layer. This gave me a base on which to add candy colors.

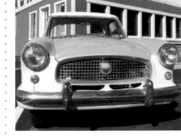

Careful choice of colors can add a period feel.

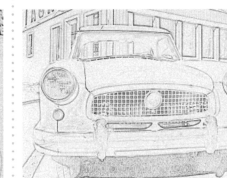

#	A	B	C
1	A Dissolve	B 10	C 100
2	A Dissolve	B 20	C 100
3	A Dissolve	B 30	C 100
4	A Color Burn	B 100	C 100
5	A Color Dodge	B 100	C 100

Illustration effect

For this coastal scene, I chose to add color selectively by masking the Dissolve layers. Blue was added only to the sea and sky, and no red was added in those image areas. Notice that I also added a few identical Color Burn layers to build up the line drawing.

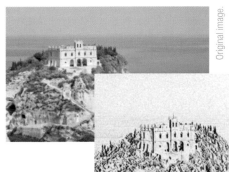

Multiple Color Burn layers build up the line drawing's strength and coarseness.

#	A	B	C
1	A Dissolve	B 10	C 100
2	A Dissolve	B 20	C 100
3	A Dissolve	B 30	C 100
4	A Color Burn	B 100	C 100
5	A Color Burn	B 100	C 100
6	A Color Burn	B 100	C 100
7	A Color Burn	B 100	C 100
8	A Color Dodge	B 100	C 100

Hard Impressionism

HARD IMPRESSIONISM

W henever the Hard Mix blending mode is used in a recipe, it's more likely that the effect will work best with simple, graphic images rather than gentler, more subtle pictures. Combined with blur, Hard Mix produces a drastic sharpening effect, which is balanced in this recipe by an inverted Hard Light layer and a final layer set to the Color blending mode. In some cases, the result is quite natural; in other cases almost painterly.

Hard-edged effect

I liked the harsh result of setting the Hard Mix layer's opacity at 100%. Notice the partial reversal in the clock faces.

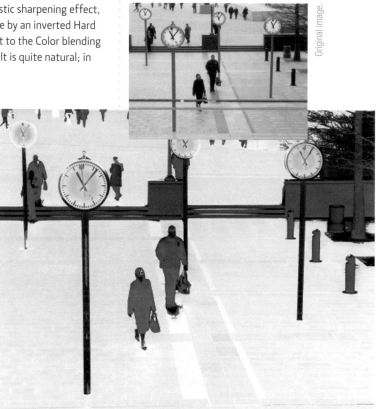

Original image.

Glowing shadows

Images with plenty of clearly defined shapes work well with this recipe.

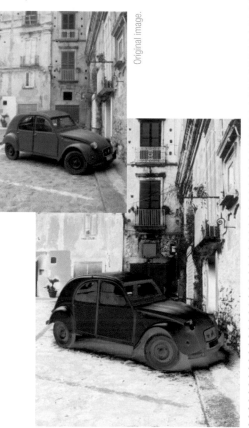

Original image.

158

1 In the Layers palette, duplicate the original image layer by dragging the background layer onto the "Create a new layer" icon, or use Ctrl/Cmd-J.

2 Using the pull-down blending mode menu in the Layers palette or the shortcut Alt/Opt-Shift-L, change the duplicate layer's blending mode to Hard Mix, and rename it "Hard Mix." Reduce its fill opacity to about 75%—at higher percentages the final result is coarse.

3 Add a lot of blur to the Hard Mix layer using **Filter > Blur > Gaussian Blur.** A radius of 50 will be fine.

4 In the Layers palette, use Ctrl/Cmd-J to make another duplicate of the original image layer and drag the new layer to the top of the layer stack.

5 Change the duplicate layer's blending mode to Hard Light using the shortcut Alt/Opt-Shift-H and rename it "Hard Light." Reduce its opacity to below 50%.

6 Invert the Hard Light layer using Ctrl/Cmd-I.

7 In the Layers palette, use Ctrl/Cmd-J to make another duplicate of the original image layer and drag the new layer to the top of the layer stack.

8 Change the duplicate layer's blending mode to Color using the shortcut Alt/Opt-Shift-C and rename it "Color."

	A		B		C
1	A Color		B 100		C 100
2	A Hard Light		B 100		C 45
3	A Hard Mix		B 100		C 100

	A		B		C
1	A Color Blend		B 100		C 100
2	A Hard Light		B 100		C 50
3	A Hard Mix		B 100		C 70

Reflective surfaces

In this example, Gaussian Blur, with a radius of 20, was applied to the Color layer and softened the final result.

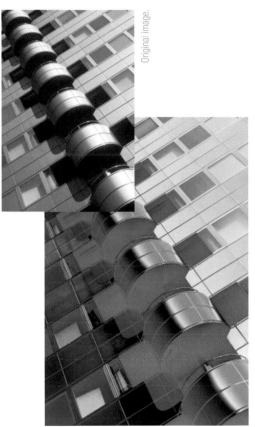

Original image.

Emphasizing detail

Inverting the Hard Mix layer can produce interesting results.

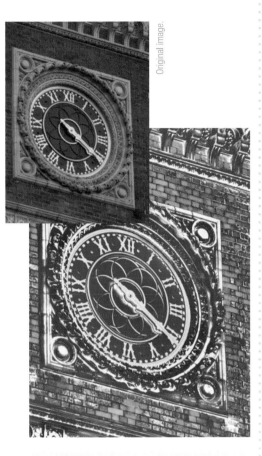

Original image.

Soft glow

With gentler subjects, apply less blur to the Hard Mix layer and reduce its fill opacity percentage.

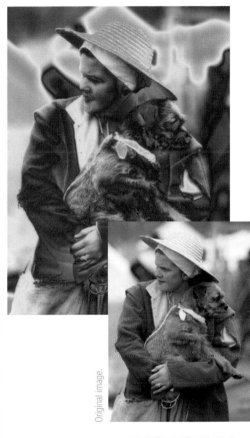

Original image.

Reflective surfaces layers panel

```
000
Layers  Channels  Paths
A Color          Opacity: 100%  B
Lock: ⊠ ✎ ✛ 🔒   Fill: 100%     C
👁 [Color]  Color              ❶
👁 [Hard Light] Hard Light      ❷
👁 [Hard Mix] Hard Mix          ❸
👁 [Background] Background    🔒
```

	A		B		C	
❶	A	Color	B	100	C	100
❷	A	Hard Light	B	100	C	50
❸	A	Hard Mix	B	100	C	70

Emphasizing detail layers panel

```
000
Layers  Channels  Paths
A Color          Opacity: 100%  B
Lock: ⊠ ✎ ✛ 🔒   Fill: 100%     C
👁 [Color]  Color              ❶
👁 [Hard Light] Hard Light      ❷
👁 [Hard Mix] Hard Mix          ❸
👁 [Background] Background    🔒
```

	A		B		C	
❶	A	Color Blend	B	100	C	100
❷	A	Hard Light	B	100	C	50
❸	A	Hard Mix	B	100	C	90

Soft glow layers panel

```
000
Layers  Channels  Paths
A Color          Opacity: 100%  B
Lock: ⊠ ✎ ✛ 🔒   Fill: 33%      C
👁 [Color]  Color              ❶
👁 [Hard Light] Hard Light      ❷
👁 [Hard Mix] Hard Mix + blur   ❸
👁 [Background] Background    🔒
```

	A		B		C	
❶	A	Color Blend	B	100	C	32
❷	A	Hard Light	B	100	C	50
❸	A	Hard Mix	B	100	C	49

Driving Rain

Right now it's a beautiful sunny morning, but we'd miss rain if we never had it, wouldn't we? Sometimes a picture might look better with a dose of rain, and there are also times when you photograph in bad weather, showing people nicely wrapped up in waterproofs and carrying umbrellas, but your picture fails to capture any raindrops. Maybe you used too high a shutter speed or there was a gap in the weather? In any case, Photoshop makes it very easy to add a deluge.

1 In the Layers palette, duplicate the original image layer by dragging the background layer onto the "Create a new layer" icon, or use Ctrl/Cmd-J.

2 Using the pull-down blending mode menu in the Layers palette or the shortcut Alt/Opt-Shift-S, change the new layer's blending mode to Screen and rename it "Screen."

3 Set the foreground color to black by hitting the letter D.

4 With the Screen layer active, select **Filter > Pixelate > Pointillize** and enter a cell size of between 2 and 20. The greater the value, the bigger the raindrops—but you can adjust this later.

5 Select **Image > Adjustments > Threshold** and set a value of 255.

6 Now apply some motion blur using **Filter > Blur > Motion Blur**. Use an angle of around 45 degrees, set a small distance, around 10, and click OK.

7 Apply some sharpening to the Screen layer using **Filter > Sharpen > Unsharp Mask**, and then repeat step 6, but with a larger distance value. You can omit this step if you want a more snowy effect.

8 If you think the rain isn't strong enough, another optional step is to resize the Screen layer. Zoom the image to fit your monitor using Ctrl/Cmd-Zero, then use Ctrl/Cmd-Minus to shrink it into the middle of the document window. Now select **Edit > Transform** or Ctrl/Cmd-T and drag out the handles around the resizing box. When done, press Enter or double-click on the image.

Raindrops

It had been raining on this parade, and you can see umbrellas in the background.

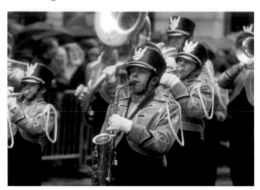

Original image.

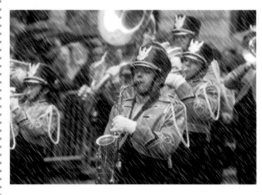

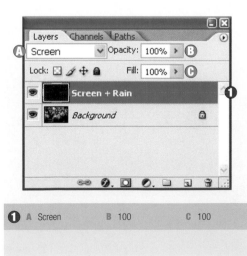

●	A	Screen	B	100	C	100

Hard rain

Duplicate the Screen layer if you want even stronger rain.

Original image.

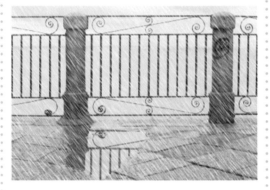

●	A	Screen	B	100	C	100
❷	A	Screen	B	100	C	100

Heavy downpour

If you want to add a real downpour, don't be afraid to use the layer mask to retain important detail.

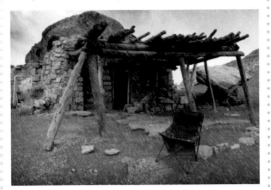

Original image.

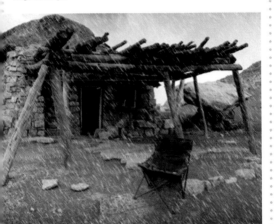

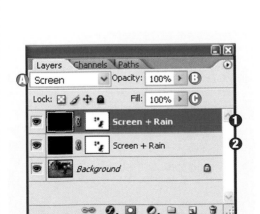

French fog

I added the blurred Lighten layer and painted on its mask to simulate uneven mistiness.

Original image.

Streets of rain

At the same time as I stretched the Screen layer with **Edit > Transform**, I also changed the rain's angle. Once I liked the result, I then saved some disk space by cropping the image—selecting the visible pixels with Ctrl/Cmd-A and then applying **Image > Crop**.

Original image.

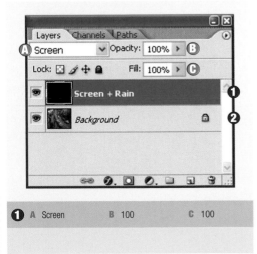

161

Heavy downpour layers panel

Layers | Channels | Paths

A Screen Opacity: 100% ▶ B

Lock: ☒ ✐ ✛ 🔒 Fill: 100% ▶ C

👁 ■ 🔲 Screen + Rain ❶
👁 ■ 🔲 Screen + Rain ❷
👁 Background 🔒

❶ A Screen B 100 C 100

French fog layers panel

Layers | Channels | Paths

A Lighten Opacity: 100% ▶ B

Lock: ☒ ✐ ✛ 🔒 Fill: 100% ▶ C

👁 ■ Screen + Rain ❶
👁 Lighten + blur 15 ❷
👁 Background 🔒

❶ A Screen B 100 C 100

❷ A Lighten B 100 C 100

Streets of rain layers panel

Layers | Channels | Paths

A Screen Opacity: 100% ▶ B

Lock: ☒ ✐ ✛ 🔒 Fill: 100% ▶ C

👁 ■ Screen + Rain ❶
👁 Background 🔒 ❷

❶ A Screen B 100 C 100

APPENDIX

Blending Mode Keyfinder

Group	Blending mode	Short-cut	Short definition	Channel based	Neutral color	Self-blend image	Inverted self-blend image	Inverted blur image
	Normal	**N**	Default blending mode.					
	Dissolve	**I**	Randomly uses the base or the blend color—stipple at less than 100% opacity.	Yes				
Painting	Behind	**Q**	Paints only transparent parts of a layer.	Yes		Not applicable	Not applicable	Not applicable
Painting	Clear	**R**	Make pixels transparent.	Yes		Not applicable	Not applicable	Not applicable
Darkening	Darken	**K**	Selects the darker of the base or the blend—opposite of Lighten.	Yes	White			
Darkening	Multiply	**M**	Multiplies the base by the blend color—opposite of Screen.	Yes	White			
Darkening	Color Burn	**B**	Darkens the base to reflect the blend by increasing the contrast—opposite of Color Dodge.	Yes	White			

Group	Blending mode	Short-cut	Short definition	Channel based	Neutral color	Self-blend image	Inverted self-blend image	Inverted blur image
Darkening	Linear Burn	**A**	Darkens the base to reflect the blend by decreasing the brightness—opposite of Linear Dodge.	Yes	White			
Lightening	Lighten	**G**	Selects the lighter of the base or the blend.	Yes	Black			
Lightening	Screen	**S**	Multiplies the inverse of the blend and base colors.	Yes	Black			
Lightening	Color Dodge	**D**	Brightens the base to reflect the blend by decreasing the contrast.	Yes	Black			
Lightening	Linear Dodge	**W**	Brightens the base to reflect the blend by increasing the brightness.	Yes	Black			
Contrast	Overlay	**O**	Screens the highlights and multiplies the shadows.	Yes	50% Gray			

Group	Blending mode	Short-cut	Short definition	Channel based	Neutral color	Self-blend image	Inverted self-blend image	Inverted blur image
Contrast	Soft Light	F	Dodges the highlights and burns the shadows.	Yes	50% Gray			
Contrast	Hard Light	H	Screens the highlights and multiplies the shadows.	Yes	50% Gray			
Contrast	Vivid Light	V	Burns or dodges by changing the contrast.	Yes	50% Gray			
Contrast	Linear Light	J	Burns or dodges by changing the brightness.	Yes	50% Gray			
Contrast	Pin Light	Z	Darker or lighter of the base or the blend.	Yes	50% Gray			
Contrast	Hard Mix	L	Reduces image to one of eight pure colors.	Yes	50% Gray			

Group	Blending mode	Short-cut	Short definition	Channel based	Neutral color	Self-blend image	Inverted self-blend image	Inverted blur image
Comparative	Difference	**E**	Difference between the blend and base.	Yes	Black			
Comparative	Exclusion	**X**	Similar to Difference but lower contrast.	Yes	Black			
Hue, Saturation, Luminosity	Hue	**U**	Luminosity of the base, colour of the blend HSL.	HSL	None			
Hue, Saturation, Luminosity	Saturation	**T**	Color of the base, saturation of the blend.	HSL	None			
Hue, Saturation, Luminosity	Color	**C**	Luminosity of the base, color of the blend.	HSL	None			
Hue, Saturation, Luminosity	Luminosity	**Y**	Color of base, with luminosity of the blend color.	HSL	None			

Glossary

Adjustment layer A layer that contains no image pixels but affects the appearance of layers below it in the layer "stack." These include changes to levels, contrast, and color, plus gradients and other effects. These changes do not permanently affect the pixels underneath, so by masking or removing the adjustment layer, you can easily remove the effect from part or all of an image with great ease. You can also change an adjustment layer's parameters at a later point, even after restarting Photoshop.

Alpha channel A channel that stores selections.

Background layer The bottom layer in the Layers palette which cannot be moved, made transparent, or have a blending mode or layer style. It can be converted into a regular layer.

Base color The cumulative color information of each pixel in the base layer.

Base layer The layer immediately below the current layer. If that layer is less than 100% opaque or has a blending mode other that Normal, then the base layer is virtual, as if all the lower layers were blended into it.

Black point The point on a histogram that denotes the darkest pixels in an image or selection.

Blend color The color information in each pixel in the blend layer.

Blend If Conditional blending or visibility of the active layer's pixels. They will be displayed if their color values fall within limits defined in the layer style.

Blend layer The current layer. Each layer is a blend layer in respect to those layers below it.

Blending mode The way in which layers interact and how a layer's pixels and color information affect the underlying layers. This produces a result based on the base color and the blending mode.

Brightness The relative lightness or darkness of a color, measured as a percentage from 0% black up to 100% white.

Channels In Photoshop, a color image is usually composed of three or four separate single-color images, called channels. In standard RGB mode, the Red, Green, and Blue channels will each contain a monochromatic image representing the parts of the image that contain that color. In a CMYK image, the channels will be Cyan, Magenta, Yellow, and Black. Individual channels can be manipulated in much the same way as the main image.

Clipping Limiting an image or a piece of art to within the bounds of a particular area.

Clipping group A stack of image layers that produce a image or effect that is a net composite of the constituents. For example, where the base layer is a selection shape (say, an ellipse), the next layer a transparent texture, and the top layer a pattern, the clipping group would produce a textured pattern in the shape of an ellipse.

Color cast A bias in a color image, either intentionally introduced or the undesirable consequence of a mismatch between a camera's white balance and lighting. For example, tungsten lighting may create an ugly yellow cast, or daylight scenes shot with the color balance set for an indoor scene may give a flat blue cast outdoors.

Color temperature A measure of the composition of light, defined as the temperature—measured in degrees Kelvin—to which a black object would need to be heated to produce a particular color of light. A tungsten lamp has a color temperature of around 2,900K, while the temperature of direct sunlight is around 5,000K.

Color wheel The complete spectrum of visible colors represented as a circular diagram.

Complementary colors Any pair of colors directly opposite each other on a color wheel, that when combined form white (or black, depending on the color model).

Contrast The degree of difference between adjacent tones in an image, from the lightest to the darkest.

Crop To trim or mask an image so that it fits a given area or so that unwanted portions can be discarded.

Desaturate A quick way to make a color image black and white by equalising the Red, Green, and Blue channel values.

Eyedropper A tool used to select the foreground or background color from colors in an image or from a selectable color swatch. Eyedroppers are also used to sample colors in other Photoshop dialogs, including the Levels or Color Range dialogs.

Feather An option used to soften the edge of a selection, in order to hide the seams between adjusted or manipulated elements and neighboring areas.

Fill opacity The opacity of image pixels only, affecting their transparency but not affecting any layer styles that may be attached to the layer. Pixels may be made completely invisible by setting the fill opacity to 0%, but drop shadow, glows, or other layer styles will remain visible.

Gradient Tool permitting the creation of a gradual blend between two colors within a selection. Several types exist, including linear, radial, and reflected gradients.

Grayscale A black-and-white image in which pixel brightness values are recorded on a scale of 0 to 255 for black to white. Unlike RGB or CMYK images, a grayscale image has no color information.

Hard light Blending mode. Creates an effect similar to directing a bright light on the subject, emphasizing contrast and exaggerating highlights.

High-key An image comprising predominantly light tones and often imparting an ethereal or romantic appearance.

Hue Color expressed as a degree between 0° and 360° on the standard color wheel or normally referred to as red, orange, or green, etc. *See Saturation.*

Histogram A graphic representation of the distribution of brightness values in an image, normally ranging from black at the left-hand vertex to white at the right. Analysis of the shape of the histogram can be used to evaluate tonal range.

Image size The size of an image, in terms of linear dimensions, resolution, or simple file size. In Photoshop, we mainly talk about image size by describing horizontal and vertical dimensions (e.g. 1,280 x 1,024), qualified with the resolution (72ppi).

Invert To change an image into its negative, or to change a selection into its opposite, selecting the rest of the image instead of the existing selection.

Layer A feature used to produce composite images by "suspending" image elements on separate "overlays." Once these layers have been created, they can be re-ordered, blended, and have their transparency (opacity) may be altered.

Layer mask A mask on a layer that defines which pixels will or will not be visible.

Layer opacity *See Opacity.*

Layer styles or effects A series of useful preset effects that can be applied to a layer's contents. Examples include drop shadows, embossing, tones, and glows.

Low-key A photographic image consisting of predominantly dark tones, either as a result of lighting, processing, or digital image-editing.

Luminosity Photoshop's assessment of the brightness of a pixel.

Mask In conventional photography, a material used to protect part or all of an image from adjustments in the darkroom. Image-editing applications feature a digital equivalent, used to control the effects of adjustments or manipulation and protect specific areas or elements.

Midtones The range of tonal values in an image sitting between the darkest shadow tones and the lightest highlights.

Mixed lighting Lighting in a shot comprised from several different sources with different color temperatures, which may prove a challenge for a camera's white-balance setting and color processing capabilities. An example mix might be tungsten lighting and daylight in an interior scene.

Multiply Blending mode. Uses the pixels of one layer to multiply those below. The final color is always darker, except when white is used on the top layer.

Opacity In a layered Photoshop document, the percentage of transparency that each layer of an image has in relation to the layer beneath. As the opacity is lowered, the layer beneath shows through.

Overlay Blending mode. Retains black and white in their original forms, but darkens dark areas and lightens light areas.

PPI Pixels per inch. The most common unit of resolution, describing how many pixels are contained within a single square inch of image.

Quick Mask A feature designed to rapidly create a mask around a selection. By switching to Quick Mask mode, the user can paint and erase the mask using simple brushstrokes.

Resolution The degree of quality, definition, or clarity with which an image is reproduced or displayed on screen or the printed page. The higher the resolution, the more pixels are contained within a given area, and the greater the detail captured.

Saturation The strength or purity of a color. Saturation is the percentage of gray in proportion to the hue: 100% is fully saturated. On the standard color wheel, saturation increases from the center to the edge. Also called chroma.

Screen Blending mode. Calculates the inverse of one layer and multiplies this with the values of pixels below, bleaching colors except where the color is black. In photographic terms, it's the equivalent of printing a positive image from two negatives sandwiched together.

Self-blend Commonly used to indicate where an image is blended with a copy of itself. The copy is on another layer whose blending mode or opacity may differ. The copy may be inverted, blurred, or changed, but still recognizably the same picture.

Soft light A blending mode similar to Overlay.

Specular highlight An intense highlight, usually resulting from the reflection of an extremely bright light, such as the sun or a metal reflector. Specular highlights are plentiful on photographs of cars, for example, where curved surfaces produce such highlights.

White balance A setting used in a digital camera or video camera to compensate for the varying color temperatures of different forms of lighting. A tungsten preset, for example, will adjust for the amount of yellow light given off by tungsten lighting.

White point The point on a histogram denoting the lightest brightness values in an image or selection.

Index

171

INDEX

Further Sources of Information

Digital photography and digital imaging have spawned communities, websites, and a number of excellent journals, all of which provide useful sources of advice, tips, and information for the Photoshop artist.

Bibliography

Books

Eismann, Katrin, *Photoshop Masking & Compositing*
Huggins, Barry, *Photoshop Retouching Cookbook for Digital Photographers*
Kelby, Scott, *Photoshop CS Book for Digital Photographers*
McClelland, Deke, *Adobe Photoshop CS2 One-on-One*
McClelland, Deke, *Photoshop CS Bible*
Pring, Roger, *Photoshop Filter Effects Encyclopedia*
Shelbourne, Tim, *Photoshop Photo Effects Cookbook for Digital Photographers*

Magazines

Computer Arts
www.computerarts.co.uk
UK publication (though widely available worldwide) specializing in all aspects of digital art, including Photoshop.

Digital Camera
www.dcmag.co.uk
UK magazine with reviews and tutorials on digital photography and Photoshop.

Digital Photo Effects
www.dcmag.co.uk
Sister title to Digital Camera, specializing in digital image-editing using Photoshop and similar packages.

PCPhoto
www.Pcphotomag.com
US magazine covering digital photography and imaging

PHOTOgraphic
www.photographic.com
US digital photography magazine, containing some tips and walkthroughs for Photoshop users.

Photo Techniques
www.phototechmag.com/
Magazine aimed at the serious digital photographer.

Photoshop User
www.photoshop.user.com
The publication of the US-based National Association of Photoshop Professionals.

Web sites

Adobe
www.adobe.com
The home of Photoshop, and a useful source of support, downloads and training files.

Adobe Evangelists
www.adobeevangelists.com/photoshop/

Adobe User Forums
www.adobeforums.com
Thanks to George Austin at Adobe User Forums for helping establish the math behind some of the blending modes.

CreativeCow
www.creativecow.net
Useful forums for design professionals, with a lively following of Photoshop users.

Creativepro.com
www.creativepro.com
News and resources for creative professionals.

DesignerToday
www.designertoday.com
A wealth of tutorials on design applications, including many on Photoshop.

Digital Outback Photo
www.outbackphoto.com

Digital Photography
www.digitalphotography.org
News and product reviews for digital photographers.

Imaging Resource
www.imaging-resource.com
Imaging-related news and reviews.

The Luminous Landscape
www.luminous-landscape.com

O'Reilly Digital Media
www.digitalmedia.oreilly.com
News, features, and links to essential books for digital photographers and Photoshop artist.

Pegtop
www.pegtop.net/delphi/blendmodes
Jens Gruschel documents most blending modes calculations here.

Photoshop Café
www.photoshopcafe.com
Masses of tutorials covering every aspect of Photoshop.

Planet Photoshop
www.planetphotoshop.com/writers/peteback.html
Comprehensive portal for all things Photoshop, but Pete Bauer's articles are particularly useful in this instance.

Russell Brown
www.russellbrown.com

Sitepoint
www.sitepoint.com
Corrie Haffly's blog postings are very useful.

Acknowledgments

This book is dedicated to my family, especially my mother
whose memory continues to inspire, my father for his drive
and scepticism, and my brother and his family for their
hospitality and willingness to put up with my camera's
constant presence. Also to Denise, to Manuela for her
gentle motivation and appreciation of my cooking,
and to my other friends for their encouragement
and patience.

Thanks to the people at Ilex Press and O'Reilly for giving
me the opportunity to write this book.